Shelter in Place photo essay
by Caroline Tompkins.

Prototypes for the *Shelter in Place* project photographed in Stephen Burks's Brooklyn studio, 2022. These prototypes were developed as a response to our collective lockdown during the beginning of the global pandemic. The idea for the project emerged in 2020, the prototypes were developed in 2021, and the final speculative projects will debut in the exhibition.

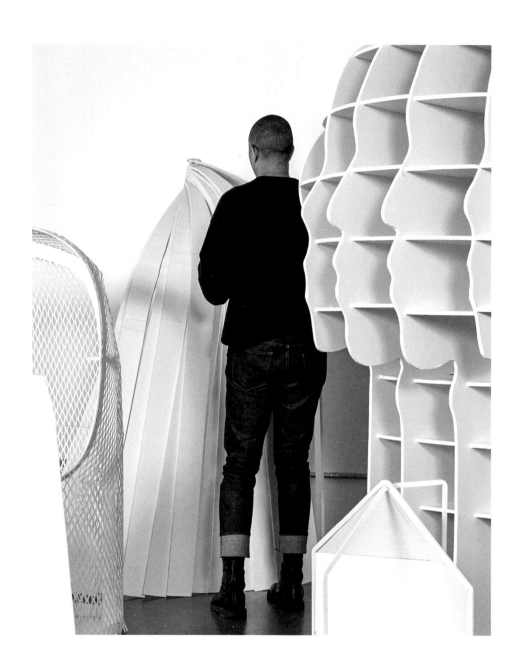

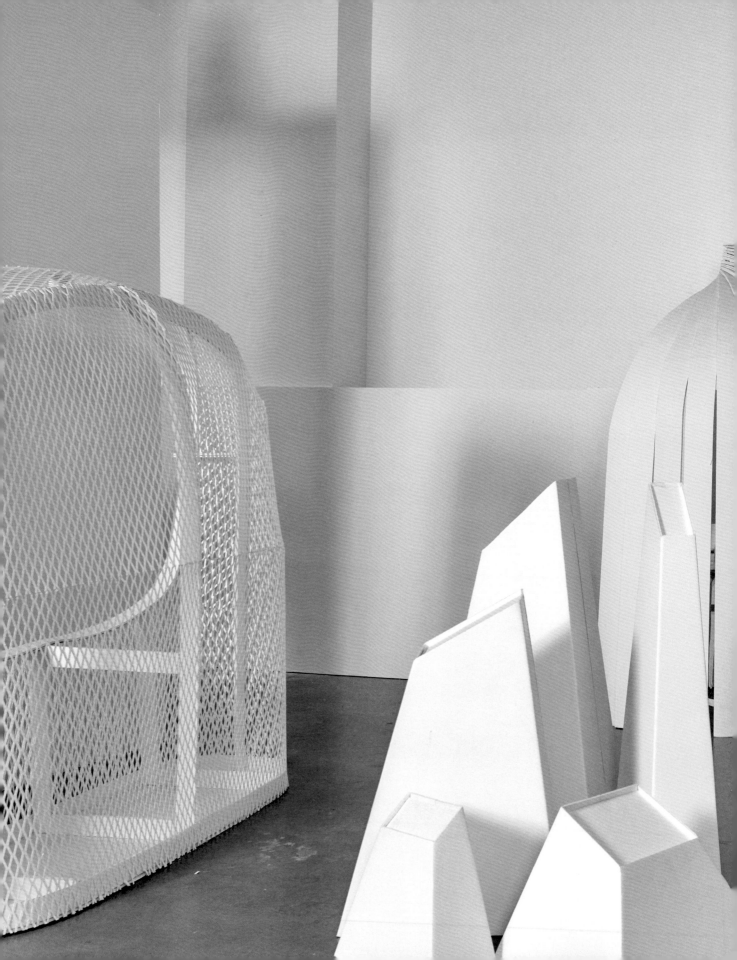

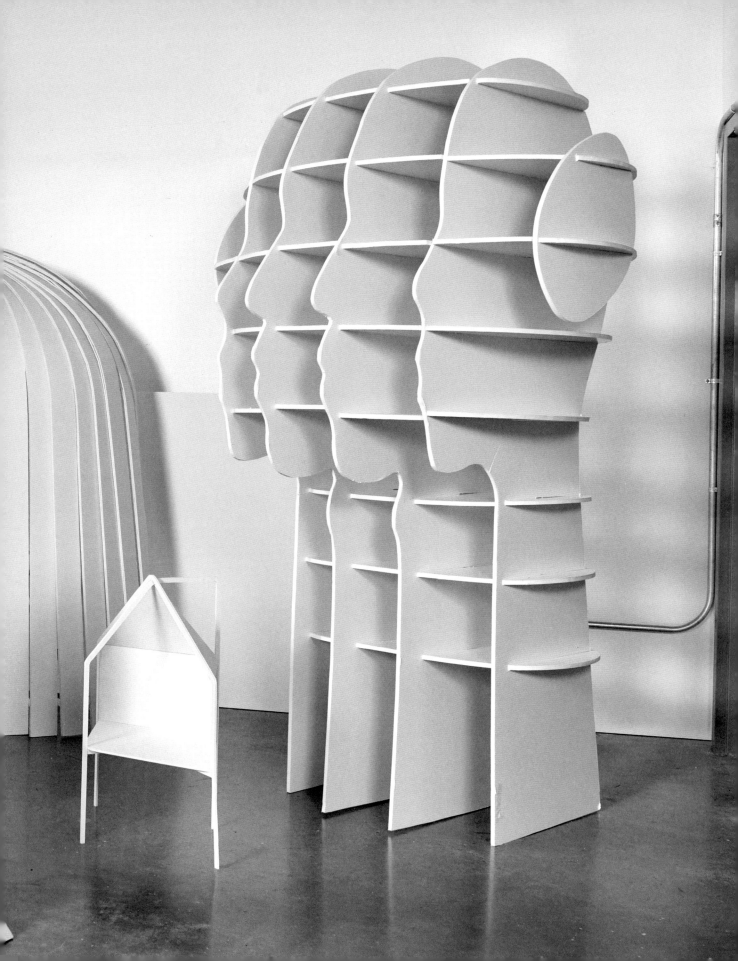

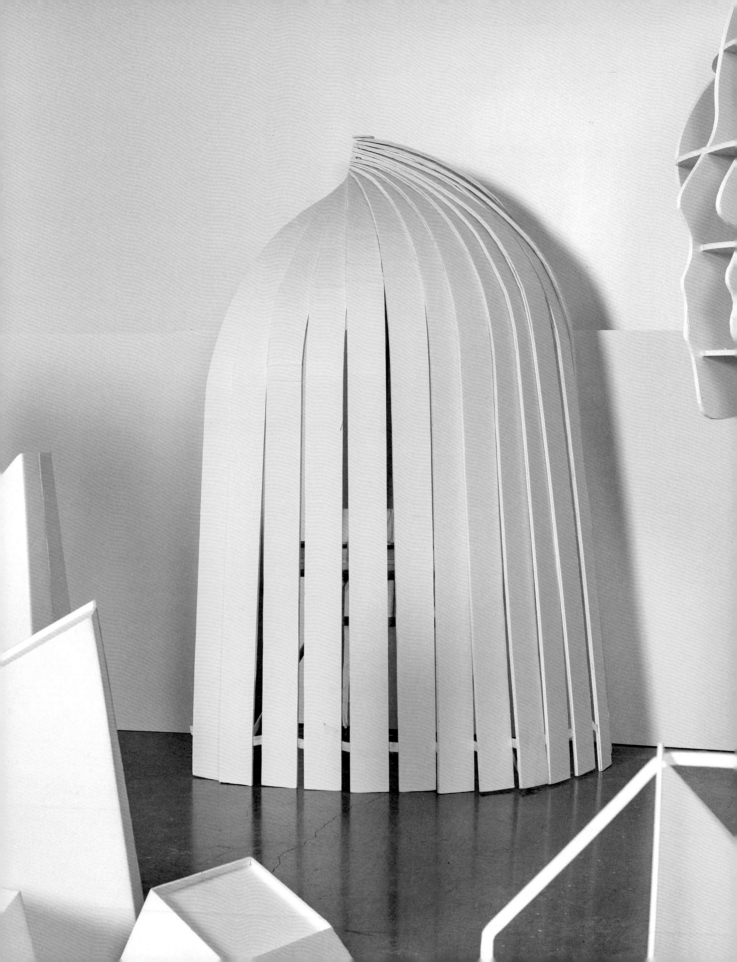

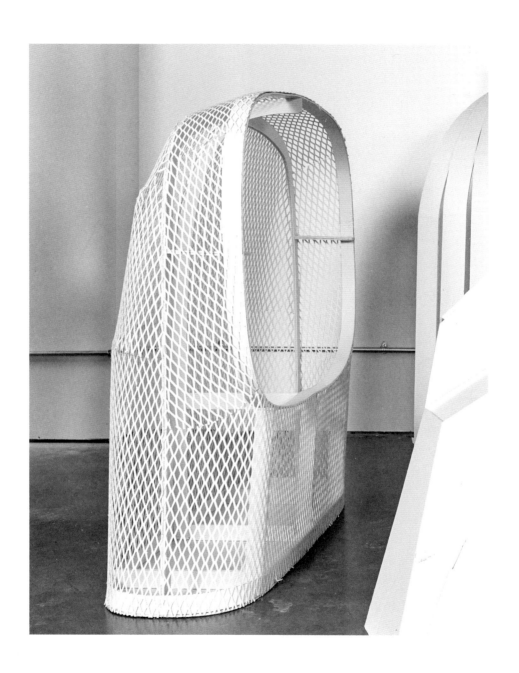

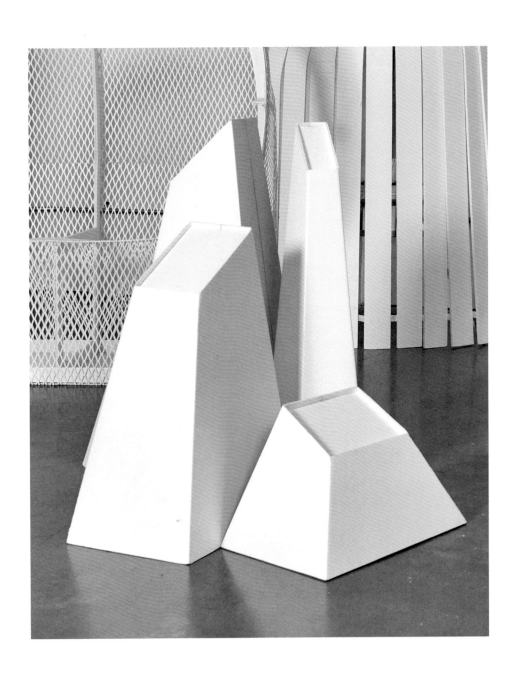

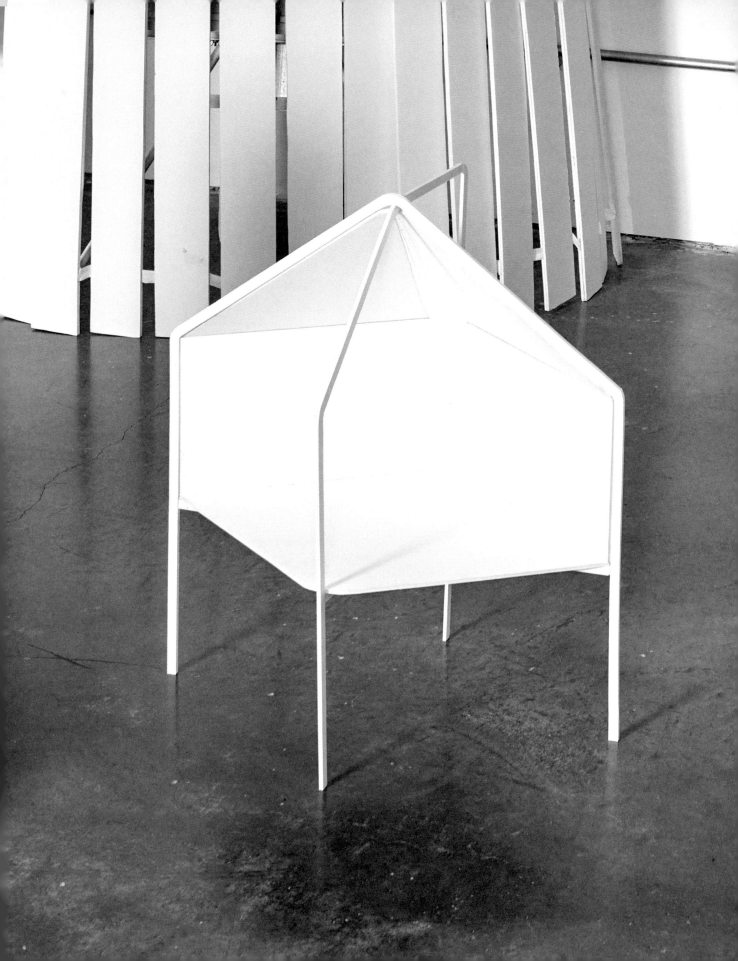

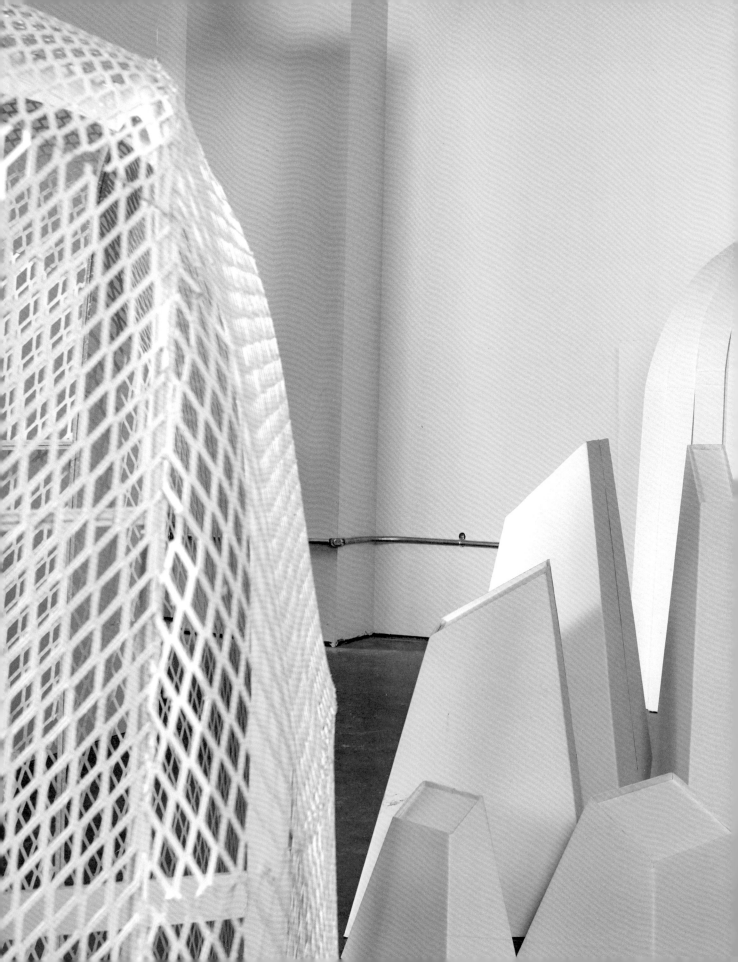

Stephen Burks:
Shelter in Place

Monica Obniski

Published by
High Museum of Art,
Atlanta

Distributed by
Yale University Press,
New Haven and London

Contents

Director's Foreword
Rand Suffolk

Stephen Burks: Shelter in Place is centered on American designer Stephen Burks's workshop-based design practice, highlighting multiple projects from the last ten years as well as new prototypes—also called *Shelter in Place*—which mark a particular moment in time and offer insight into Burks's creative process. As one of the few Black designers to work in this industry, Burks has forged a unique path. On one hand, this has meant respectfully focusing his practice on global collaborators and finding a space for craft within the industry. On the other, Burks has responded to the reality of several global crises—including public health, climate change, and racial inequality—by offering alternative approaches that effectively shift the agency of defining "home," and our relationship to it, to a broader segment of society.

Our presentation of Burks marks more than ten years of his practice since his landmark exhibition *Stephen Burks: Man Made* at the Studio Museum in Harlem in 2011. We believe in supporting designers at pivotal stages in their careers, and Stephen Burks, at midcareer, deserves this opportunity to present his work and ideas to the Atlanta community and beyond.

The High Museum of Art is dedicated to making the world of art, the lives of artists, and the creative process accessible to our visitors via our permanent collections and special exhibitions. Consequently, this project attempts to contribute to ongoing dialogues about how exhibitions give form to, examine, and appraise the times we live in. Ultimately, our hope is that our audience connects with the possibilities that Burks's multidimensional design practice creates.

Finally, I must acknowledge the wonderful work of the Museum's Curator of Decorative Arts and Design, Monica Obniski. Dr. Obniski proposed this project upon her arrival to Atlanta and has shepherded the exhibition and its publication with clarity, passion, and vision. I am grateful to her and to Stephen Burks for entrusting the High with this project.

Rand Suffolk
Nancy and Holcombe T. Green, Jr., Director
High Museum of Art

Curator's Acknowledgments
Monica Obniski

Evolving for over twenty years, Stephen Burks's design practice has crystallized to a place that incorporates diverse cultural perspectives to comment on human connections and the critical need to include multiple voices to communicate global design languages. The larger curatorial agenda for *Stephen Burks: Shelter in Place* is to provide context for Burks's wide-ranging design practice; suggest themes by which to understand his work; and articulate where he is going based on where he has been—a project that is simultaneously about the past and the future in an effort to uncover knowledge.

Stephen Burks: Shelter in Place grew out of conversations that began in March 2020—an auspicious start to a new job at the High Museum of Art and the beginning of a national lockdown that forced a focus on domestic interiors. At the center of this project is the question, "How can we design our interiors to enable joyful living while empowering creativity?" Designers have a role to play in the face of several global crises—public health, climate change, and racism, to name a few. As an African American designer, Stephen Burks has forged a unique path by embracing the challenge to advocate for hand production within the structures of industrial production—and I believe that this is one of the ways in which he is interrogating the modernist trope of better living through design.

It has been more than ten years since his last major museum exhibition, *Stephen Burks: Man Made*, held at the pioneering Studio Museum in Harlem in 2011. Our exhibition highlights and comments on this contemporary American designer's practice since that moment in time. But design does not exist in a vacuum, as politics, society, and culture impact all facets of life. Burks is greatly interested in advancing the agenda of people of color within the design world and addressing the industry's lack of diverse designers. As bell hooks has astutely noted, "if all black children were daily growing up in environments where they learned the importance of art and saw artists that were black, our collective black experience of art would be transformed."[1] Museums are not neutral, and as such, the High Museum of Art is a site for the exploration of diversity within architecture and design.

Projects at the Museum are only made possible with the cooperation of many colleagues across all departments, which starts with the director; I am grateful to Nancy and Holcombe T. Green, Jr., Director Rand Suffolk for his visionary leadership. My curatorial colleagues—Lauren Tate Baeza, Claudia Einecke, Gregory Harris, Stephanie Heydt, Katie Jentleson, Michael Rooks, and Chief Curator Kevin Tucker—offered enthusiastic support throughout the exhibition, and Caroline Giddis provided critical curatorial assistance during the final push. Under the management of Director of Collections and Exhibitions Amy Simon, the High's exhibitions department gave consequential guidance, with Danielle Kiser and Chelsea Morey as project managers and Frances Francis as exhibition registrar. Working with a living designer on an exhibition is an exercise in diplomatic engagement, and exhibition designer Skye Olson was an affable partner. Awot Solomon and head preparator Robert Howells alongside his team—Joseph Hadden, Caroline Prinzivalli, and Tommy Sapp—skillfully installed the complex exhibition. Colleagues in Education, including Hannah Amuka, Mami Fondu, Kate McLeod, and Head of Interpretation Julia Forbes, provided their expertise to ensure an engaging experience for students, educators, and visitors to the exhibition. Erin Dougherty, head of Public

1 bell hooks, *Art on My Mind: Visual Politics* (New York: The New Press, 1995), 3.

Programs and Community Engagement, and Yadira Padilla planned public programs to foster engagement with local communities. Marketing and Communications colleagues, including Kristen Brown, Aishah Davis, Alex Davis, Marci Tate Davis, and Liza Levy, disseminated information thoughtfully. The Membership department, with Nancy Chiodo, Aisha Moss, Emily Roberts, and Shannon Roudebush, ensured that museum members were engaged. The Shop team, including David Perez and Kim Walsh, guided the sales of exhibition merchandise. The Development department, helmed by Allison Chance, with Marlene Alexander, Leah-Lane Lowe, Mark Mills, and Hannah White, provided critical support through corporate, foundation, and individual fundraising, and Rachel Katz organized the opening reception.

The process of making books has become more challenging over the years, and I am thankful to the High for understanding the intellectual value of these endeavors. Angela Jaeger, senior manager of Creative Services, contributed critical support as project manager for the publication, and she was assisted by Laura Malone and Laurie Kind. This book was sharply edited by Emma Simmons, and we are thankful to Katherine Boller at Yale University Press for distribution. Graphic designers Renata Graw and Lucas Reif of Normal in Chicago created a meaningful and distinctive identity for this catalogue. Photographer Joe Coscia, ably assisted by Ellie Coscia during our New York photo shoot, and Justin Skeens at Berea College created brilliant pictures. Caroline Tompkins took captivating photographs of the *Shelter in Place* prototypes alongside some production pieces. I am also deeply indebted to the excellent catalogue contributors, each of whom brought a unique lens with which to view Burks's work—Glenn Adamson, Beatrice Galilee, Patricia Urquiola, Michelle Wilkinson, and the late bell hooks. When we started discussing this project, Stephen told me about conversations that he and bell hooks had been having, including about the idea of a collective imagination among people of color. I am grateful to the inimitable bell hooks (and her family) for agreeing to memorialize the conversations.

Exhibitions cannot happen without the lenders who generously share objects from their collections. We extend our thanks to the individuals, institutions, and manufacturers that made this exhibition and publication possible. Kathryn Hiesinger and Colin Fanning at the Philadelphia Museum of Art and Yao-Fen You at the Cooper Hewitt supported the exhibition through critical loans. Numerous manufacturers enthusiastically supplied objects designed by Burks, including Jordi Arnau at BD Barcelona; Klara Persson at Bolon; Benjamin Baum, Mary Beth Hunsberger, John Romano, Sara Smarr, and Gabrielle Vitel at DEDON; Carola Bestetti and Francesca Sanvito at Living Divani; Paola Balordi and Patrizia Vicenzi at Luceplan; Dina Rosenberg at MillerKnoll; Román Riera and Sara García Olivenza at Parachilna; Viola Margara and Gabriele Salvatori at Salvatori; and Peter and Henriette Simonsson at The White Briefs. Early private collectors of Burks's work include an anonymous lender and Lisa S. Roberts, who kindly shared their work with our audiences.

The larger project benefited from the careful stewardship of Aaron Beale, director of Student Craft at Berea College. Malika Leiper, former cultural director at Stephen Burks Man Made, also deserves special recognition for all her myriad contributions.

I am grateful to the many sponsors at the High who contribute major funding, including Premier Exhibition Series Sponsor Delta Air Lines, Inc.; Premier Exhibition Series Supporters ACT Foundation, Inc., Sarah and Jim Kennedy, Louise Sams and Jerome Grilhot, Harry Norman Realtors, and wish foundation; Benefactor Exhibition Series Supporters Robin and Hilton Howell; Ambassador Exhibition Series Supporters the Antinori Foundation, Corporate Environments, the Arthur R. and Ruth D. Lautz Charitable Foundation, and Elizabeth and Chris Willett; and Contributing Exhibition Series Supporters Farideh and Al Azadi, Sandra and Dan Baldwin, Mr. and Mrs. Robin E. Delmer, Marcia and John Donnell, Mrs. Peggy Foreman, Helen C. Griffith, Mrs. Fay S. Howell and the Howell Fund, Mr. and Mrs. Baxter Jones, Joel Knox and Joan Marmo, Dr. Joe B. Massey, Margot and Danny McCaul, The Ron and Lisa Brill Family Charitable Trust, Wade A. Rakes II and Nicholas Miller, the Fred and Rita Richman Fund, USI Insurance Services, and Mrs. Harriet H. Warren. Generous supporters also include the Alfred and Adele Davis Exhibition Endowment Fund, Anne Cox Chambers Exhibition Fund, Barbara Stewart Exhibition Fund, Dorothy Smith Hopkins Exhibition Endowment Fund, Eleanor McDonald Storza Exhibition Endowment Fund, The Fay and Barrett Howell Exhibition Fund, Forward Arts Foundation Exhibition Endowment Fund, Helen S. Lanier Endowment Fund, Isobel Anne Fraser–Nancy Fraser Parker Exhibition Endowment Fund, John H. and Wilhemina D. Harland Exhibition Endowment Fund, Katherine Murphy Riley Special Exhibition Endowment Fund, Margaretta Taylor Exhibition Fund, and RJR Nabisco Exhibition Endowment Fund. I am also grateful to Sarah Herda and the Graham Foundation for Advanced Studies in the Fine Arts for its support of this meaningful exhibition. Roche Bobois, especially Cindy Susilo, as well as William Banks Jr. Trust and Jones Day also deserve thanks for their sponsorship and major funding.

On a personal note, I am immensely thankful to my husband, Jordan Diab, who has always encouraged me to pursue my dreams. And finally, having both been born and raised in Chicago, I felt a kinship to Burks that only deepened during the global pandemic. I'd like to acknowledge his resolute dedication to this project. In my efforts to get to know him and his practice over the years, he has shared many stories and articulated a position that places him at the forefront of contemporary American design. This project is both an effort to lend critical discourse to the field of contemporary design and an act of creating space for future designers.

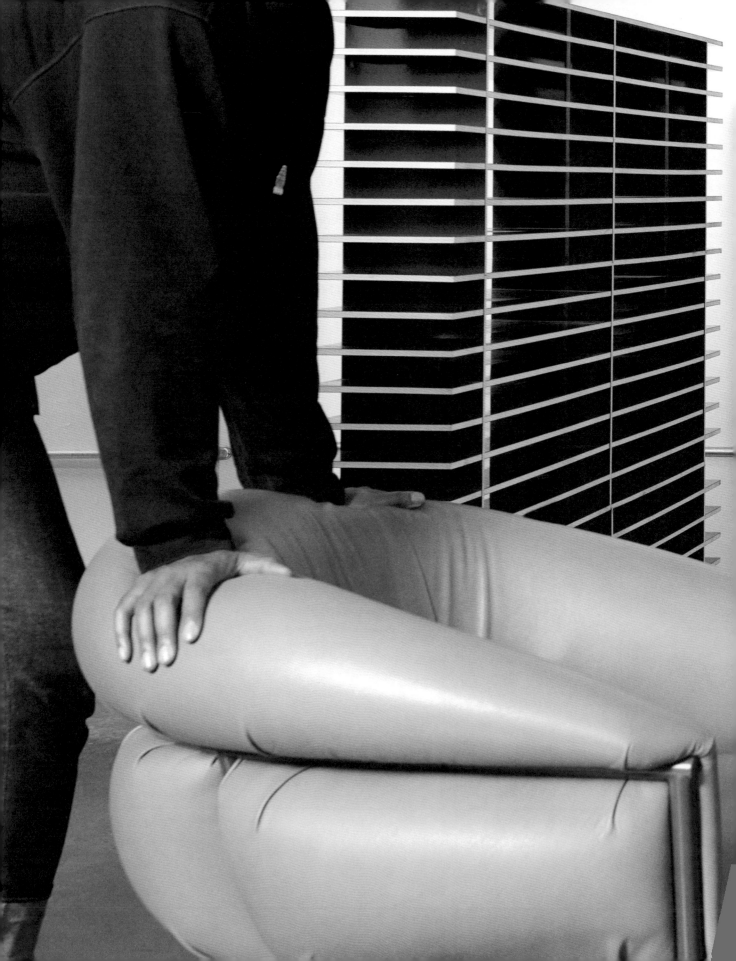

Everything and Nothing
Patricia Urquiola

Everything photo essay
by Caroline Tompkins.

Everything and Nothing

A designer is everything and nothing. Designers must have multiple skills and cannot specialize in only one dimension. They should be curious, looking at things with different lenses. They should have the capability to enter a new field, learn about it, and emerge with solutions that were not evident to people who have been working in that field all their lives. And they must continue to do this, entering and exiting, manifesting a special ability to be independent and interdisciplinary, and adding knowledge from one sector that can be useful in another.

It is a difficult exercise—one that is based on technical knowledge (both analogue and digital), cultural background, and capacity for research and evolution, with personality traits that allow for studied unconsciousness, equilibrium, and expert timing.

All the designer's senses must be open and receptive. They must look, smell, touch, hear, feel, and taste everything surrounding them. It is like walking on a very thin wire while juggling, singing, smelling, looking, and thinking. It is a generalist's sport, and I love it.

The problem, or the opportunity, depending on one's worldview, is that a designer's space is the world. How do designers read and interpret various cultures, messages, and trends? How should they digest them, and when should they predict the future? It takes a designer quite a long time to develop a product, often one to three years. How it will go into the world and hopefully stay on the market for decades depends on one's understanding of society.

As a designer and a traveler, Stephen enjoys the process as much as the result—the arrival of the work. He understands the importance of being out of his comfort zone—removed from a familiar studio, without beloved objects, tools, and safety nets; the significance of being away from home, looking at things with an unusual eye, and creating distance from oneself and one's habitual surroundings; the capability of dealing with different densities of time—knowing when to slow down, when to stop, and when to rush; and the importance of finding metalinguistic ways of communicating.

It may not look like much to have designed and put into production a chair or an object during the last year, but when you are in the process, trying to do something that has never been done before, to make something that must function, be certified all around the world, and hopefully survive for many years, even half a century, it is a remarkable undertaking.

Stephen and I tend to meet during fairs or exhibitions around the world or when he is visiting Milan and passes by my home. We eat—there is always food involved. We talk about our families and what we have done or what we will do.

Stephen is a researcher, an observer, and a seeker. He is finding his way and enjoying the journey.

Patricia Urquiola

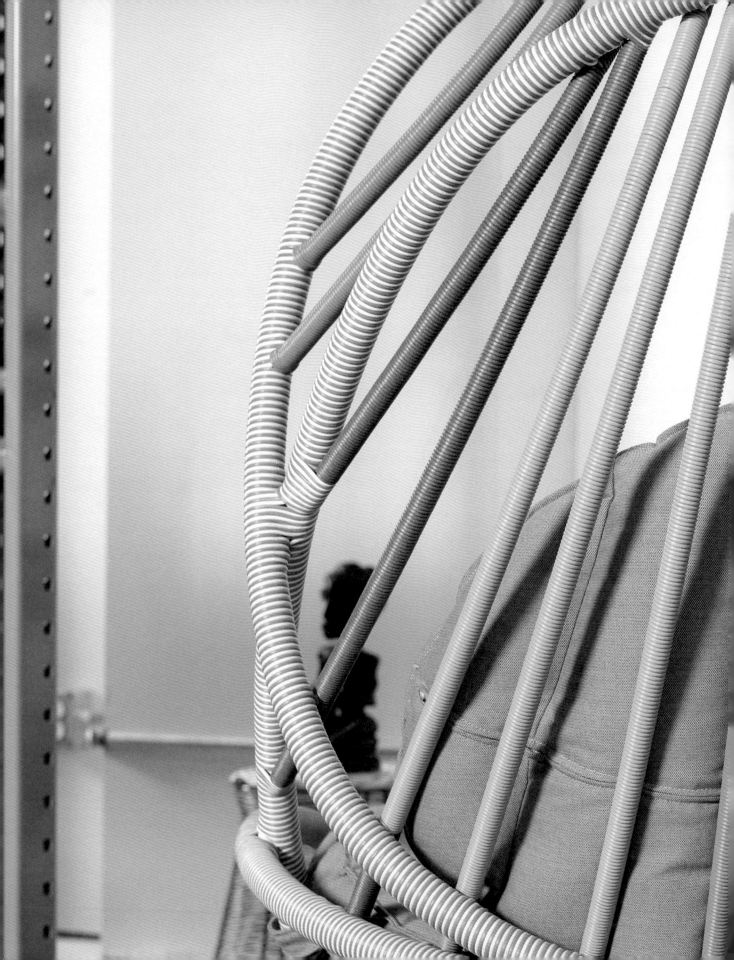

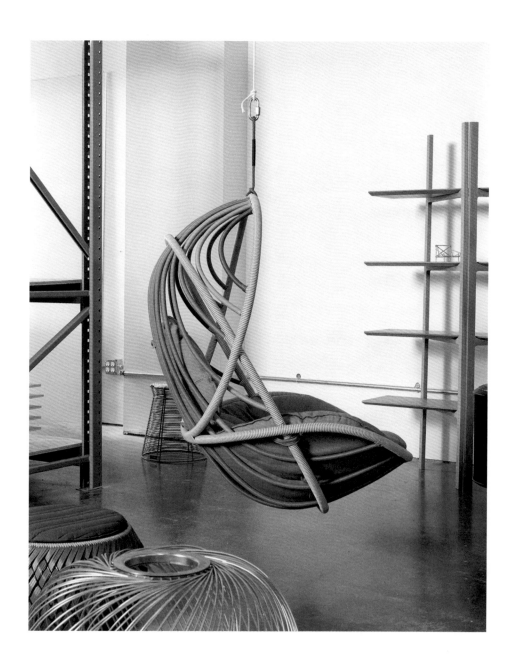

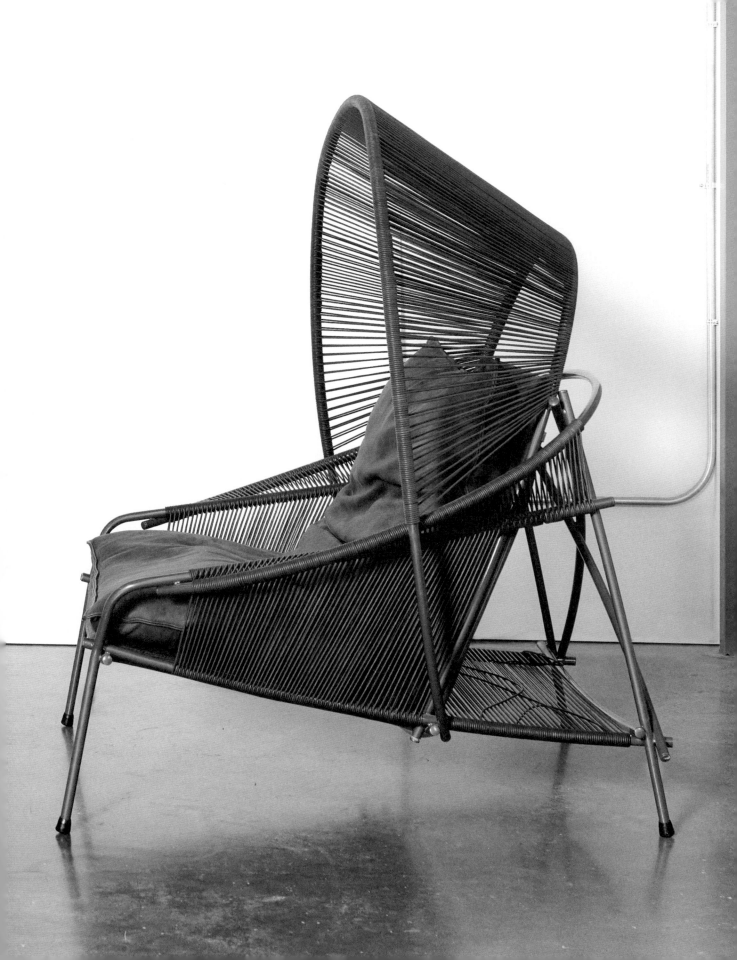

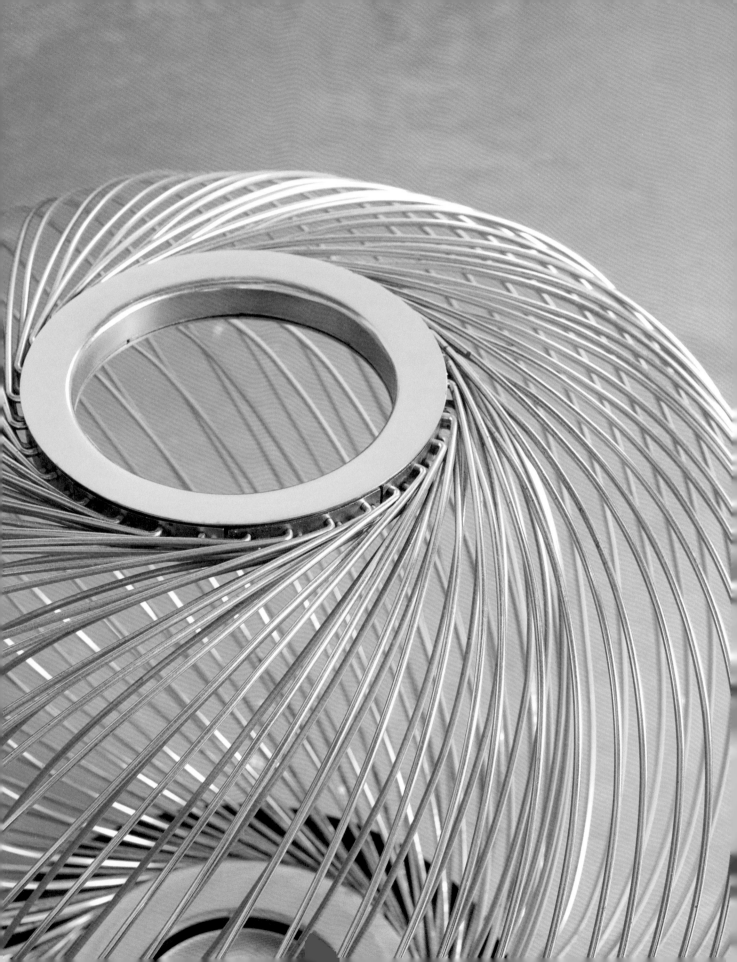

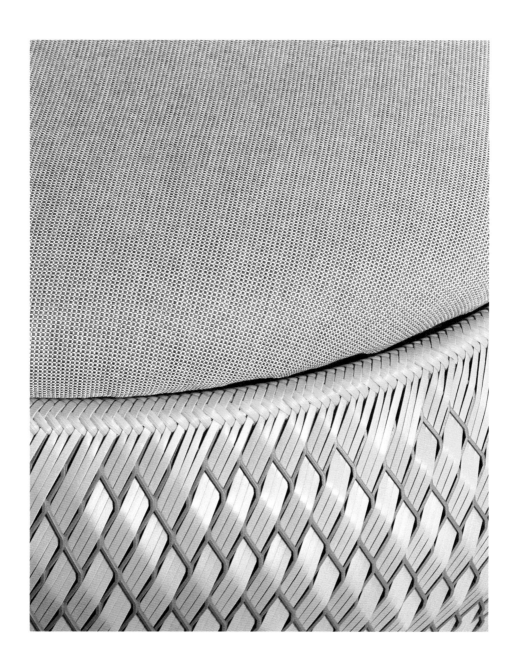

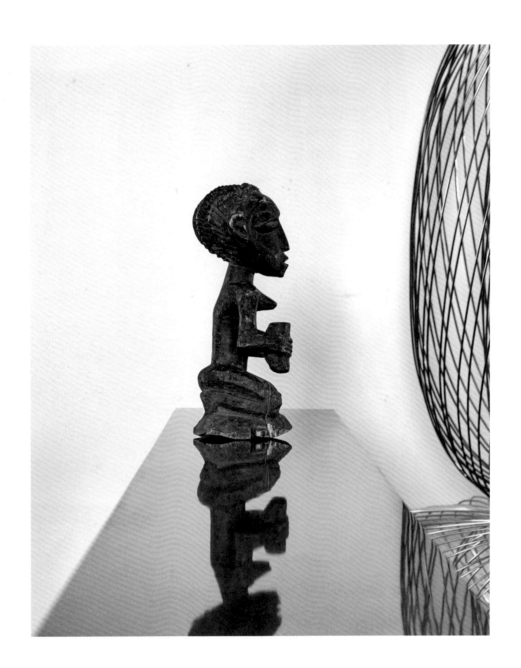

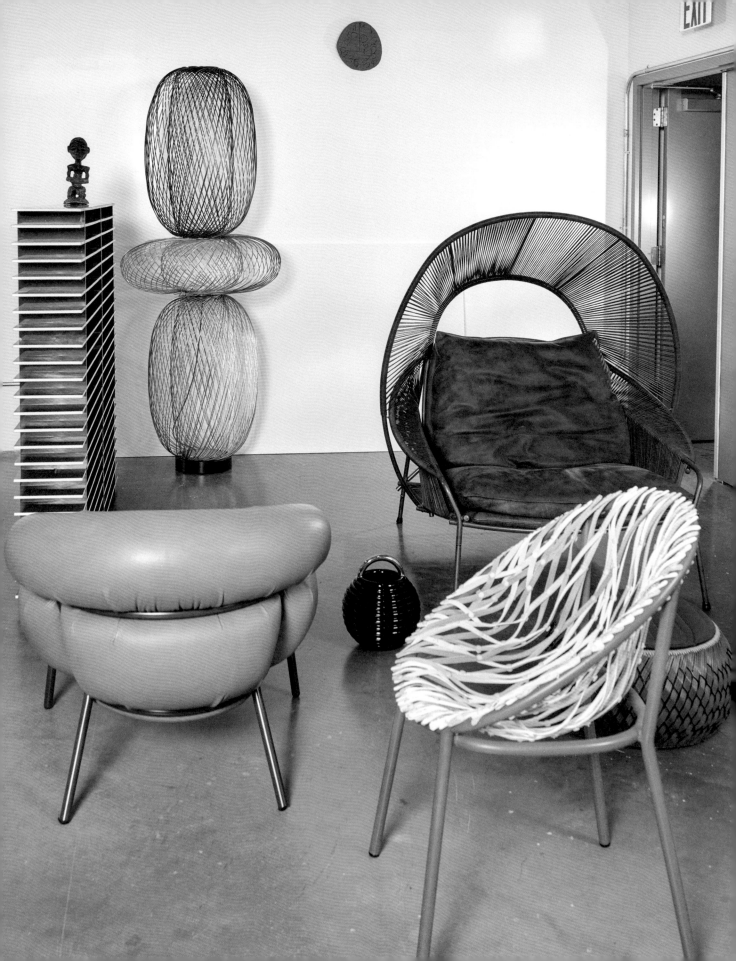

Everything photo essay
by Caroline Tompkins.

Previous pages:
Photographed at Stephen Burks Man Made, Brooklyn, 2022.

Page 20: Stephen Burks, *Grasso* Lounge Chair (2018, BD Barcelona Design) and Stephen Burks, *Horizon* Shelving (2008, Stephen Burks Man Made) in background.

Pages 24–25: Left to right: Stephen Burks, Man Made *TaTu* Stool (material composition; 2009, Artecnica) with personal artifact; Stephen Burks, *Dala* Stool (2012, DEDON); Stephen Burks, *Kida* Swing (2020, DEDON); Stephen Burks, *Anwar* Lamp (2015, Parachilna); Stephen Burks, *Parallel* Shelving (2010, Modus) with *Traveler* maquette, Berea College Student Craft ceramic experiment, personal artifact, and Stephen Burks, *Broom Thing* Ambient Object's core (2020); Stephen Burks, *Islands* Large Cabinet (2019, Living Divani) with Stephen Burks, *Friends* Table Mirror (2021, Salvatori) and *Impressions* Vase prototype (2020, Berea College Student Craft); and Stephen Burks, *Dala* Lounge Chair (2012, DEDON).

Page 26: *Kida* Swing (detail).

Page 27: *Parallel* Shelving, with *Broom Thing* Ambient Object's core, and *Islands* Large Cabinet, with *Impressions* Vase (detail).

Page 28: *Kida* Swing.

Page 29: Stephen Burks, *Traveler* Indoor Armchair with Hood (2014, Roche Bobois).

Page 30: *Anwar* Lamp (detail).

Page 31: *Dala* Lounge Chair (detail).

Page 32: Stephen Burks, *Anwar's Clock* (2012) above *Parallel* Shelving, with *Traveler* maquette, Berea College Student Craft ceramic experiment, and personal artifact.

Page 33: *Horizon* Shelving.

Page 34: Personal artifact with *Anwar* Lamp in background.

Page 35: *Friends* Table Mirror.

Page 36: Background, left to right: *Horizon* Shelving with personal artifact; *Anwar* Lamp; and *Anwar's Clock*. Foreground, left to right: *Grasso* Lounge Chair; Stephen Burks, *Grasso* Vase (2018, BD Barcelona Design); *Traveler* Indoor Armchair with Hood; *Dala* Stool; and Stephen Burks, *Irregular Weaving* Dining Chair (2017, Stephen Burks Man Made).

Speculating Widely
Monica Obniski

Plate 1. Stephen Burks, Stephen Burks Man Made, *Going Nowhere* rendering, 2020.

Cracks in the mid-twentieth century's belief in better living through good design began to emerge in the 1960s. By the time the Museum of Modern Art (MoMA) mounted *Italy: The New Domestic Landscape* (1972), a critical distance had been established. Following a period of tremendous political, environmental, and social upheaval, the exhibition focused on the domestic sphere but proposed an alternative design manifesto. It featured a range of Italian-manufactured objects and environments by twelve Italian designers, who presented radical projects related to future living, some through the lens of cultural or environmental issues. As Zoë Ryan has noted, "the show continues to serve as a model of how to present diverse and provocative concepts about design and its relationship to industry, consumerism, and the communication of ideas."[1]

Fifty years later, that landmark exhibition continues to function as a touchstone. While the exhibition *Stephen Burks: Shelter in Place* explores industrial design and craft collaborations within Burks's workshop-based design practice, it also provides an opportunity to reflect, as *Italy: The New Domestic Landscape* did, on the discursive potential of design in a similar cultural moment—when racial, social, and environmental justice remain in jeopardy. Similarly, just as MoMA curator Emilio Ambasz used *The New Domestic Landscape* as a polemic to question the relationship between design, consumption, and the environment, this exhibition employs the format of a speculative design project (*Shelter in Place*) to question in what type of domestic landscape and with which objects do we want to dwell in the future. The project uses design as an investigatory tool for thinking through ideas, asking whether the user can be a more active participant in the design process.

The exhibition also interrogates how Burks's practice deploys design and craft to propose a better, more diverse future. For generations, architects and designers have imagined a future using visionary architecture as a strategy to make proposals about improving society, from Claude-Nicolas Ledoux's late eighteenth-century ideal city of Chaux to Le Corbusier's Plan Voisin for Paris during the 1920s. For Burks, one way to create a better, more diverse tomorrow is by advocating for the hand—or what he has called the "hand factory"—within industrial production, a deliberate coupling of seemingly contradictory ideas. While this model is not entirely new, Burks has adjusted it by taking a more collaborative approach that brings global artisans into the ideation phase—and not simply, as has been the case within colonial extractive economies, using the labor of non-White artisans as producers to translate the designer's idea. Part of Burks's strategy is to be in dialogue with makers, to learn from them, and then to empower them (see Adamson essay). But this isn't where he started.

Modernist Orthodoxy
In exploring the varied projects of Stephen Burks's design practice, several threads emerge—some are foundational, while others overlap. Burks gained firsthand knowledge of utopian architectural visions from the Illinois Institute of Technology (IIT), where he first trained and acquired an education undergirded by an orthodoxy of modern design.

Initially founded in Chicago in 1937 by László Moholy-Nagy (a polymath who mastered multiple media), the "New Bauhaus" was one of the American successors to the pioneering German

1 Zoë Ryan, "Taking Positions: An Incomplete History of Architecture and Design Exhibitions," in *As Seen: Exhibitions that Made Architecture and Design History*, ed. Zoë Ryan (New Haven, CT: The Art Institute of Chicago, distributed by Yale University Press, 2017), 22.

Speculating Widely

art, architecture, and design school (1919–1933), where material experimentation within various workshops was encouraged.[2] The final Bauhaus director, architect Ludwig Mies van der Rohe, arrived one year later at the New Bauhaus, which became the Institute of Design in 1944 and was later incorporated into IIT; he cast a long shadow on the school, the city of Chicago, and the field of architecture at large. Undertaking the master plan for IIT's new campus, he eventually designed most of the buildings, culminating in the masterwork Crown Hall (1956; fig. 1), where Burks would spend two and a half years studying architecture before transferring to the Institute of Design. Mies's orderly campus was based on the grid, with open-planned buildings composed of contemporary materials (glass and steel) that expressed their time and structure and participated in his ideal of "universal space," which helped define modern architecture for generations.

At Chicago's New Bauhaus, Moholy-Nagy advocated for a design pedagogy that incorporated science and technology, and he successfully partnered with business, demonstrating pragmatism, and as Robin Schuldenfrei has noted, an embrace of a capitalist, business-centered approach (that was antithetical to his position in Germany).[3] Burks entered a program that was steeped in this history alongside the legacy of Jay Doblin, who directed the Institute of Design (1955–1969) and continued to teach afterward; Doblin adopted Moholy-Nagy's Bauhausian ethos of experimentation while pushing for practical research and design theory in equal measure, further professionalizing the field of industrial design. At IIT, Burks learned from industry giants, including Dale Fahnstrom and Chuck Owen, in an industrial design program that innovated structured planning, a precursor to today's design thinking.[4] Owen's Design Processes Laboratory influenced Burks, who saw firsthand this brave new field that used algorithms (and other tools from computer science) to create design outcomes.

As a student, Burks was featured on the cover of *ID: International Design* (1991) for his experimental project *Daily Hygiene Machine*, a winning entry in the Concepts category (fig. 2). Reduced to multiple, simple forms, the *Daily Hygiene Machine*—a class exercise in the use of pneumatics and hydraulics in the home—was a proposition for an all-in-one wall-mounted sink, shower, and medicine cabinet. It is revelatory that at this early age, Burks was thinking conceptually about design and that, as juror Sheila Levrant de Bretteville noted, his "fresh,

2 For more on the German Bauhaus, see Barry Bergdoll and Leah Dickerman, eds., *Bauhaus 1919–1933: Workshops for Modernity* (New York: Museum of Modern Art, 2009).

3 Robin Schuldenfrei, "Assimilating Unease: Moholy-Nagy and the Wartime/Postwar Bauhaus in Chicago," in *Atomic Dwelling: Anxiety, Domesticity, and Postwar Architecture*, ed. Robin Schuldenfrei (London: Routledge, 2012), 87-126.

4 Dale Fahnstrom taught at the Institute of Design (1966–2011) and partnered with Michael McCoy, cochair of Cranbrook Academy of Art's Design Department, on the *Knoll Bulldog Chair* (1990); Chuck Owen taught from 1965 to 2010 as head of design process and was a pioneer in systems design and likely the source for Burks's understanding of Christopher Alexander's concept of a pattern language (at its most basic level, how design responds to relationships). See Charles Owen, "Structured Planning in Design: Information-Age Tools for Product Development," *Design Issues* 17, no. 1 (Winter 2001): 27-43.

Monica Obniski

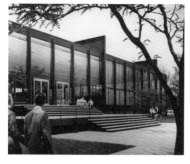

Fig. 1. Ludwig Mies van der Rohe, architect, Illinois Institute of Technology S. R. Crown Hall, 1956, Chicago, Illinois.

Fig. 2. Stephen Burks's *Daily Hygiene Machine*, 1990, cover of *ID: International Design*, July/ August 1991.

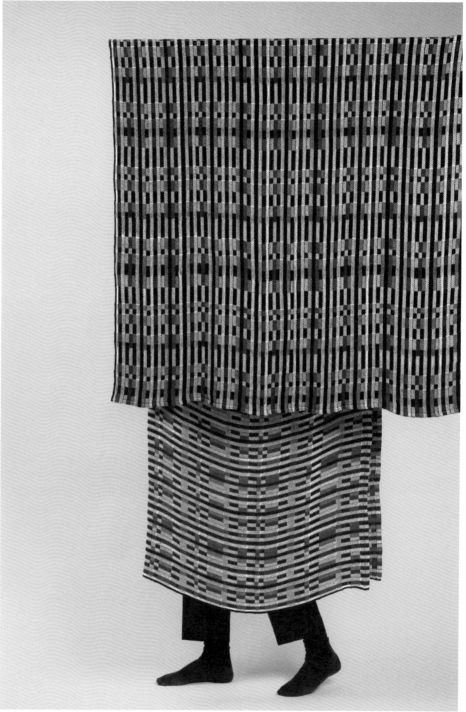

Plate 2. Stephen Burks, Berea College Student Craft, *Pixel* Throws, 2020.

Speculating Widely

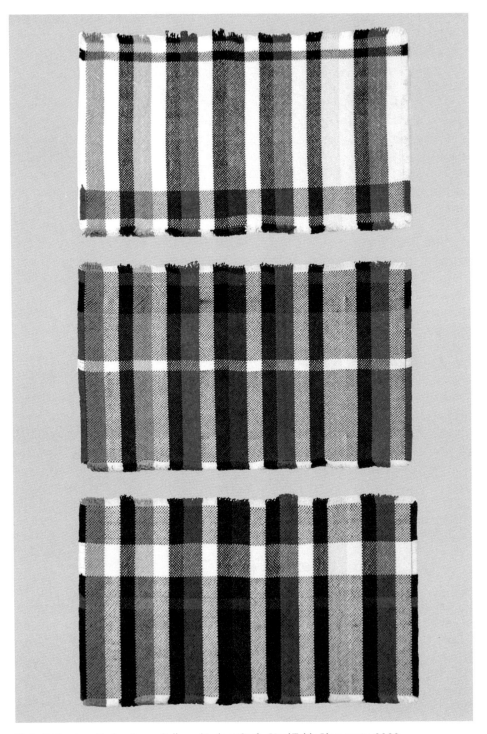

Plate 3. Stephen Burks, Berea College Student Craft, *Pixel* Table Placemats, 2020.

Monica Obniski

open thinking" yielded a design that evoked total living environments (like those of Super Studio or Joe Colombo).[5] Burks has been imagining possible futures, or speculating widely, since his student days.

While IIT's campus, with its modernist orthodoxy, was formally based on the grid, this organizational tool has deeper roots. Long viewed in opposition to nature, the grid reflects logic associated with industrialization, standardization, and mass production. Although it has been associated with modernity—especially given Rosalind Krauss's discussion of the form's ubiquity and mythic power in modern art—the grid is part of a longer history that stretches back to ancient beginnings.[6] The visual manifestation of its form may also be understood as producing a regular pattern; more conceptually, it may be construed as an egalitarian or regularizing tactic, suggesting control and perfection. As part of Burks's *Crafting Diversity* project at Berea, *Pixel* Throws (plate 2) and *Pixel* Table Placemats (plate 3) demonstrate the ability of the grid (and in this case, the warp and weft as organizing parameters for the construction) to give both structure and visual levity to the objects. The grid's persistence demonstrates its ubiquity across time and place, a universal language Burks is interested in probing.

Before experiencing the gridded landscape of IIT, having grown up in Chicago, Burks admired skyscrapers from an early age, including the Harry Weese–designed Time-Life Building (1969), where his mother worked (fig. 3). Although using the same Miesian glass and steel materials, Weese's skyscraper demonstrated more personality, with its COR-TEN steel curtain wall that developed patina over time and its gold-mirrored glass that set the building apart from other Chicago skyscrapers.[7] These memories are manifested visually in the modernist grid that appears in Burks's work. Most poignantly, Burks has transformed the idea of a building into a lamp with works like *Babel* (plate 4), which uses the signs and symbols of architecture. Designed for Parachilna, *Babel* is named for the Tower of Babel, a mythic structure that serves as a metaphor to explain multiple languages and human interaction. Burks's design approximates an abstracted model of a building, with sheets of anodized aluminum that create structures, contributing to a universal language of architecture. The design can be recombined into various totemic forms, with a central cylinder (much like a building core) housing LED as the foundation upon which to build stacks of "floors" at different "levels" to produce dimension.

Weaving as Metaphor

Having recently run an architecture studio (spring 2021) themed around "A Pliable Place" for his second alma mater, Columbia University's GSAPP, Burks was interested in exploring the boundaries of architecture and weaving inspired by Anni Albers, who viewed these two activities—designing and weaving—as inextricably linked. Trained at the Bauhaus, Albers was an artist, a designer for industry, a teacher, and a writer of influential texts on textiles, such as "The

5 "Best of Category: Daily Hygiene Machine," *ID: International Design*, July/August 1991, 158.
6 Rosalind Krauss, "Grids," *October* 9 (Summer 1979): 50–64. See, for example, the brick that originated in 9000 BCE in Hannah Higgins, *The Grid Book* (Cambridge: MIT Press, 2009).
7 Robert Bruegmann and Kathleen Murphy Skolnik, *The Architecture of Harry Weese* (New York: W. W. Norton and Company, 2010), 150–154.

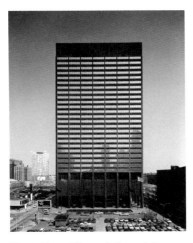

Fig. 3. Harry Weese & Associates, architects, Time-Life Building, 1969, Chicago, Illinois.

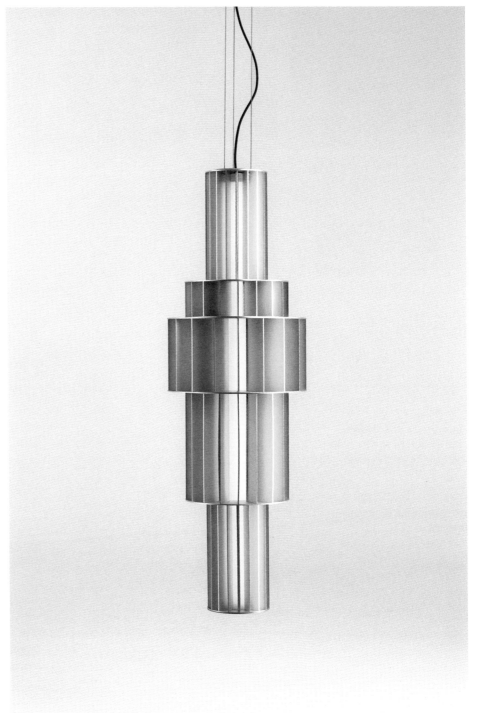

Plate 4. Stephen Burks, Parachilna, *Babel T GR*, 2016.

Monica Obniski

Fig. 4. Stephen Burks Man Made, *A Pliable Place* prototype, 2021.

Fig. 5. Anni Albers (German, 1899–1994), *Under Way*, 1963, woven fabric on cloth, mounted on wood, Hirshhorn Museum and Sculpture Garden, Smithsonian Institution, Washington, DC, The Joseph H. Hirshhorn Bequest, 1981.

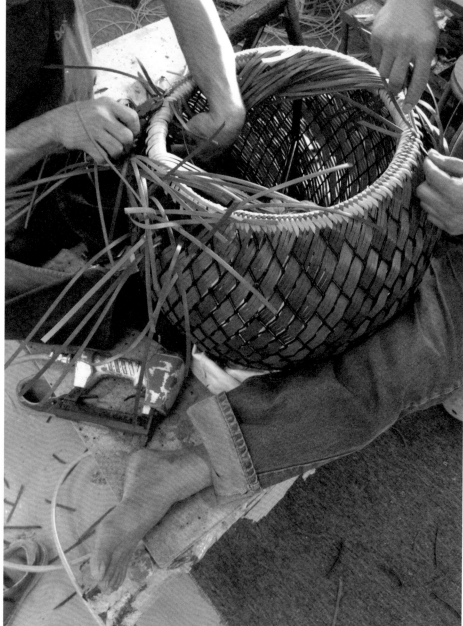

Fig. 6. Craftspeople working on DEDON's *Dala* Stool in the R&D department, Cebu, Philippines, 2012.

Speculating Widely

Pliable Plane," upon which Burks based this studio.[8] In the essay, Albers notes the similarities between textiles and architecture following prevalent ideas from nineteenth-century European architectural theory.[9] She closes the text with a call for collaboration between textiles and architecture—between those building and those weaving—to create new approaches as part of an iterative process.[10] Burks is interested in the ongoing dialogue between these fields, as evidenced in his theoretical project *A Pliable Place*, which functions as a prototype pavilion composed of 3D-knitted surfaces (fig. 4); Albers's essay also underscores the collaborative approach that Burks champions to elicit more knowledge through coauthorship.

Albers's weavings, such as *Under Way* (1963; fig. 5)—which is based on the rectilinear grid, enhanced by threads that communicate tactility and freedom—demonstrate an expression of modernist experimentation from which Burks draws. In *On Weaving* (1965), Albers went beyond discussing designing and weaving, articulating that she makes "no distinction between the craftsman designer, the industrial designer, and the artist" because the fundamentals are the same.[11] While commonplace today, this erasure of boundaries, arguing for a bridge between the handcrafted and machine-made worlds, was a radical concept for the mid-1960s.

Conceptually similar to that of Albers, Burks's practice brings together designing and making within objects, such as *Dala* for DEDON (fig. 6). Also, just as Albers investigated Indigenous craft traditions for traditional expressions (for example, backstrap loom weaving and naturally dyed fibers), Burks is also interested in learning traditions firsthand from craftspeople. For DEDON, Burks had an idea for the object's form, and after carefully considering the materials available and, most crucially, working with weavers to understand limitations, he conceived *Dala* in the province of Cebu (the Philippines) at DEDON's factory—typically a site of mass production but here also one of translated hand production. The customization occurs while making, as the artisan chooses to engage a single, double, or triple stripe while weaving, demonstrating an empowering (and slightly subversive) act of agency.

Of course, *Dala* didn't emerge out of thin air. It is not a coincidence that Burks had been thinking about woven baskets while working on the 2011 Studio Museum in Harlem show, laying the groundwork for the beginning of the *Dala* collection. His work for DEDON was further enhanced when he approached the company to be a partner for a designer-in-residence project at the (now shuttered) design incubator A/D/O in Brooklyn. Called the DEDON *Irregular Weaving* project, it expanded upon Burks's premise that the artisan can be a more active agent

8 Anni Albers, "The Pliable Plane: Textiles in Architecture," *Perspecta* 4 (1957): 36–41. It is also interesting to note that the relationship between language and weaving is also linked through similar linguistic roots—text and textile.

9 For example, German architect Gottfried Semper argued that architecture evolved from handicrafts and that ornament formed a symbolic language intrinsic to the visual expression of a building. Gottfried Semper, *The Four Elements of Architecture and Other Writings*, trans. Harry Frances Mallgrave and Wolfgang Herrmann (Cambridge: Cambridge University Press, 1989). Semper linked the four elements of architecture (hearth, platform, roof, and enclosure) to the four crafts (ceramics, masonry, wood, and textiles).

10 Albers, "The Pliable Plane," 40.

11 Anni Albers, *On Weaving*, new, expanded ed. (Princeton: Princeton University Press, 2017), 61.

Monica Obniski

Fig. 7. Stephen Burks, sketch of *Irregular Weaving* Dining Chair, 2017, paper.

Plate 5. Stephen Burks, Stephen Burks Man Made, Dining Chair (detail), *Irregular Weaving* project, from A/D/O residency, 2017.

Speculating Widely

in furniture production. While seemingly antithetical, the concept of irregular weaving could function as the artisans' ultimate expression by giving them the freedom to pursue creativity within the confines of the design (fig. 7). By creating an open-ended process, the maker has autonomy, and in the case of *Irregular Weaving* Dining Chair, that meant deciding at which angles to cross the DEDON fiber strands to create imaginary wefts—which was structurally unnecessary, as the fibers are strong enough (plate 5). Burks's studio assistants Vara Yang and Júlia Esqué were also heavily involved, as they are at varying stages of every project, demonstrating that supportive structures are necessary for successful practices. Conceptually, *Irregular Weaving* advanced the studio's interest in exploring a material's tactility and design as a means of visual organization, both of which recall Albers.

Recent scholarship on race and architecture has exposed the overuse of local artisanal crafts and its potential to be understood as an "unconscious postcolonial extension of colonial romanticism."[12] It is important to include the members of local communities in the production of their own crafts (as opposed to outsiders imitating patterns, shapes, etc.). Of course, collaborations between global designers and local makers can border on superficial knowledge. Burks has also noted that some attempts with internationally known manufacturers have collapsed because of an "under-investment and a fetishizing of craft instead of a commitment to making things in a new way."[13] One historical example of the translation of global craft skills is the triaxial woven basket that can be found in many places, including Southeast Asia. Visionary inventor Buckminster Fuller believed in a theoretical prehistory of this area of the world, and after witnessing traditional weaving practiced by local craftspeople, he may have had a conceptual breakthrough; Jiat-Hwee Chang recently argued that the "universal structural logic" found in triaxial weaving "could be seen as a precursor to the three-way gridding of a sphere in Fuller's sophisticated geodesic geometry."[14] Several decades later, Burks was also impressed by this ancient form of weaving and worked with artisans in Cebu to use three intersecting fibers to form a triangle—a weaving language based on three directions instead of two (fig. 8). He desired to create an alternate language for the accessories line, and the *Dala* planters that resulted from this experimentation yielded a more open weave structure, also rooted in this location's craft traditions (plate 6).

As an African American designer, Burks is hypersensitive to this discourse, aligning himself as a collaborator instead of a colonizer. For his practice, ideas of cocreation can be understood as a way of finding his own identity within the design world, negotiating an ever-present outsider status. Following one of his art mentors, Isamu Noguchi, whose socially engaged work was informed by his complicated identity, Burks's collaborative design practice cannot be uncoupled from the politics of multiple identities.[15] In fact, as an African American negotiating the international (White) design world, he has noted the powerful concept popularized by W. E. B.

12 Jiat-Hwee Chang, "Race and Tropical Architecture: The Climate of Decolonization and 'Malayanization,'" in *Race and Modern Architecture: A Critical History from the Enlightenment to the Present*, ed. Irene Cheng, Charles L. Davis II, and Mabel O. Wilson (Pittsburgh: University of Pittsburgh Press, 2020), 255.

13 Jennifer Kabat, "Longing & Belonging," *Frieze*, November/December 2012, frieze.com/article/longing-belonging.

14 Chang, "Race and Tropical Architecture," 258.

15 As argued in Amy Lyford, *Isamu Noguchi's Modernism: Negotiating Race, Labor and Nation, 1930–1950* (Berkeley: University of California Press, 2013).

Monica Obniski

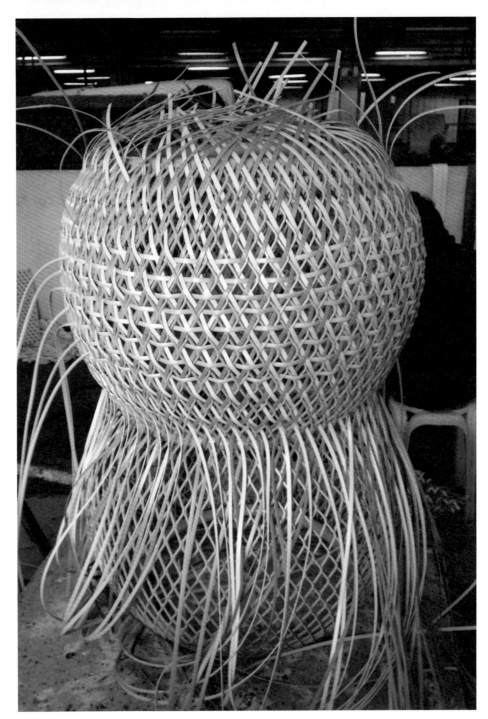

Fig. 8. Stephen Burks, *Dala* Planter prototype, 2012, expanded aluminum and extruded polyethylene fiber.

Speculating Widely

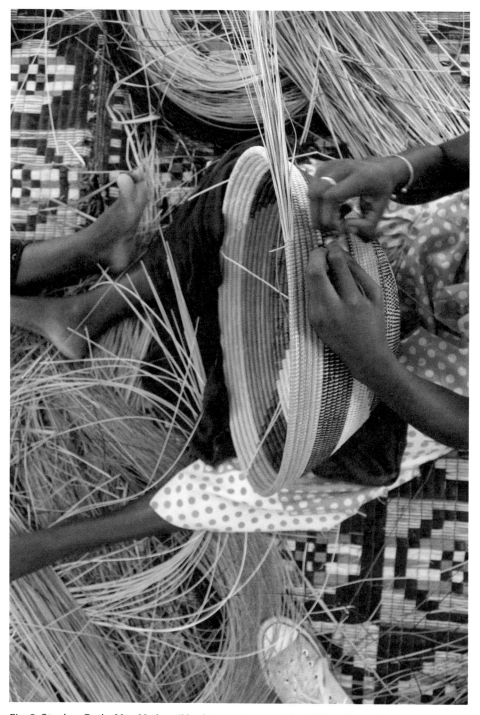

Fig. 9. Stephen Burks Man Made coil basket weaving workshop, Thies, Senegal, 2015.

Monica Obniski

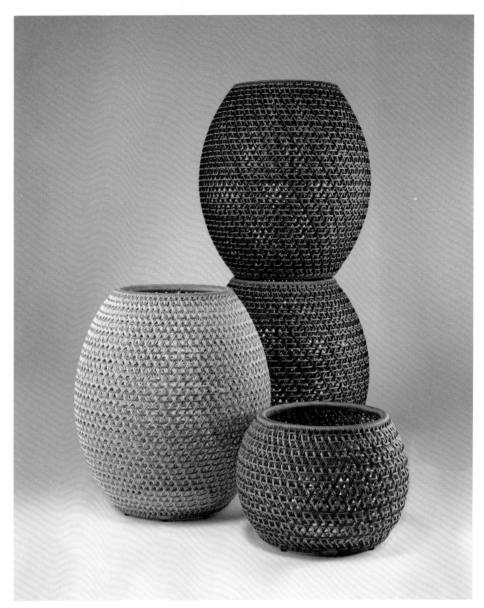

Plate 6. Stephen Burks, DEDON, *Dala* Planters L and M, 2014.

Speculating Widely

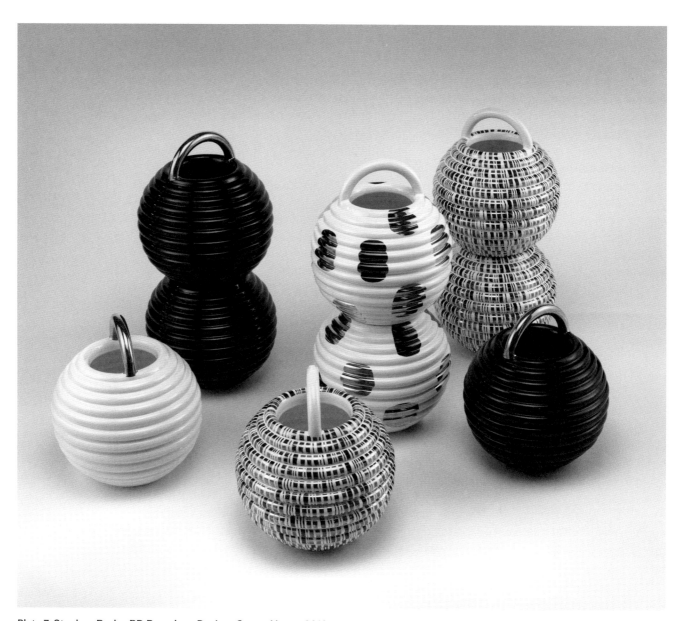

Plate 7. Stephen Burks, BD Barcelona Design, *Grasso* Vases, 2018.

Monica Obniski

Du Bois of "double consciousness," in which one experiences "two-ness" due to political and social oppression within a White-structured society that undervalues Black contributions. Through this lens, Burks maintains a sensitivity and understands that no one owns specific aspects of culture—thereby negating the criticism of cultural sampling that often gets levied against some designers working within this mode—and that it is only through working together through traditional craft and alternative design practices from various parts of the world that a new narrative can be constructed based on generosity and skill sharing.

Inclusivity, or Craft as Collaboration

In considering Burks's relationship to craft, it is as if he has internalized Bauhaus founder Walter Gropius's manifesto that "today the arts exist in isolation, from which they can be rescued only through the conscious, cooperative effort of all craftsmen."[16] Craft is a way to connect to one another and, perhaps through collaborative endeavors, to create a more inclusive design system. After having learned from a community of weavers in Thies, Burks has returned to the Senegalese weavers—physically and conceptually—over the years (fig. 9). In designing the *Grasso* collection of ceramics for BD Barcelona, he noted that the form refers to the coiled basket tradition in Senegal, but visually there is also a direct relationship to coil-constructed ceramics, another example of an ancient, hand-built form of craft that is extolled by this contemporary design (plate 7).

In bell hooks's *Belonging: A Culture of Place*, she connects home with issues of sustainability and the environment, proposing that we use the past to think critically about place and ecology. According to hooks, "nature was the place where one could escape the world of manmade construction of race and identity."[17] hooks articulates a Black relationship with nature, one of symbiosis and respect that is omnipresent, the traces of which can be found imprinted on the objects and artifacts within one's home. These traces can also be seen in the work of David Adjaye, who has also discussed the relationship between architecture and nature, plant life, or a biophilic world, which for him has "always been Black life, the roots of all of our ancestors."[18] Burks has been guided by hooks's writing for years, and her sentiments about cultural and environmental inclusivity, alongside Adjaye's comments about an ancestral rootedness found in nature, provide another pathway for understanding a Black design practice premised on ecological inclusivity.

Burks has engaged with the discourse of sustainability for years, but as a product designer, his use of craft traditions within industrial production is one way of achieving more sincere environmental inclusion. Interestingly, when introduced at the Milan Furniture Fair in 2012, Burks's *Dala* range of garden furniture for DEDON was widely publicized because it was made from woven recycled food packaging (plate 8).[19] The studio experimented with recycled fibers of Tetra Pak (a polyethylene-coated carton introduced in Sweden in 1952 that

16 Walter Gropius, "Manifesto of the Staatliche Bauhaus in Weimar (1919)," in *The Theory of Decorative Art: An Anthology of European & American Writings, 1750–1940*, ed. Isabelle Frank (New Haven, CT: Yale University Press, Bard Graduate Center, 2000), 83.

17 bell hooks, *Belonging: A Culture of Place* (New York: Routledge, 2009), 7.

18 Thelma Golden, David Adjaye, and Rick Lowe, "Space, Place, and Black Social Practice," *Log* 52 (Summer 2021): 16.

19 "Milan Furniture Fair 2012," *The Architectural Review* 231 (June 2012): 22–26.

became ubiquitous across Europe) during the early manufacturing of the product, but it was not sustainable long term because the recycled plastic fiber content was not durable enough to withstand years of usage. Designed around the same time was the *Dedar Roping* stool, a prototype composed of Dedar textile samples and Manila rope (from the abacá plant found in the Philippines)—an example of actively reusing production waste while uplifting global craft traditions in creating a functional work that is respectful of Italian and Filipino textile traditions (plate 9).[20]

Burks would not have been aware of these Asian textile techniques had he not been exposed to them through travel, which facilitates discovery and, for his practice, is a way to advocate for cultural inclusion in design production. In writing about Walter Benjamin and craft, Esther Leslie has argued—noting that the German roots of the word *experience* are found in the word *travel*—that "through travel craftsmen have experience of the world and a world of experience."[21] The transmission and transferal of experience—in other words, knowledge derived from the hand—are critical to understanding the tactile world; Burks helps demonstrate that craft is a form of tacit corporeal knowledge.[22] The designer defines craft as the translation of culture into physical form, tied to the way wisdom is embodied and materials are manipulated by the hand. That much of this knowledge is obtained through travel is important in the context of Burks's practice.

While Burks often works with artisans, he is occasionally involved in the making. The *Missoni Patchwork* Vases were the first craft-centered handmade objects made in Burks's studio (plate 20), and they demonstrate a reverence for Italian textiles while using dead stock in an inventive way.[23] Other examples are the *Cappellini Love* Bowl, composed of silicone and recycled glass-mosaic tiles (plate 10), and an experimental vase that explored the process of interjecting confetti into hand-applied silicone over an existing mold (plate 11). These were created after the Studio Museum in Harlem exhibition when Burks's studio searched for models that replicated the designer's approach with artisans for individuals to pursue on their own. Burks offered a similarly conceived (although differently executed) *Paillettes* Vase to a DIY book project, in which the author argued that design and the DIY approach are inseparable.[24] This premise suggests that the designer can learn through the process of making: about personal labor, materials and materiality, and perhaps the broader implications of consumption (on the environment, for example).

20 Maeve Coudrelle, "Stephen Burks, Roping Stool, Designed 2011, This Example Made 2017," *Looking for Design* (blog), National Museum of African American History and Culture, October 16, 2017, nmaahc.si.edu/blog-post/stephen-burks-roping-stool-designed-2011-example-made-2017.

21 Esther Leslie, "Walter Benjamin: Traces of Craft," in *The Craft Reader*, ed. Glenn Adamson (London: Bloomsbury Visual Arts, 2018), 387.

22 As has been argued in Peter Dormer, ed., *The Culture of Craft: Status and Future Studies in Design and Material Culture* (Manchester: Manchester University Press, 1997), 147.

23 Shonquis Moreno, "Man of the World," *American Craft* (August–September 2014): 44.

24 Thomas Bärnthaler, *Do It Yourself: 50 Projects by Designers and Artists* (London: Phaidon, 2015), 54–57.

Monica Obniski

Plate 8. Stephen Burks, DEDON, *Dala* Stool, 2012.

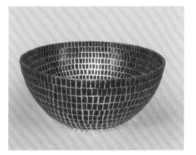

Plate 10. Stephen Burks, Cappellini, *Cappellini Love* Bowl, 2008.

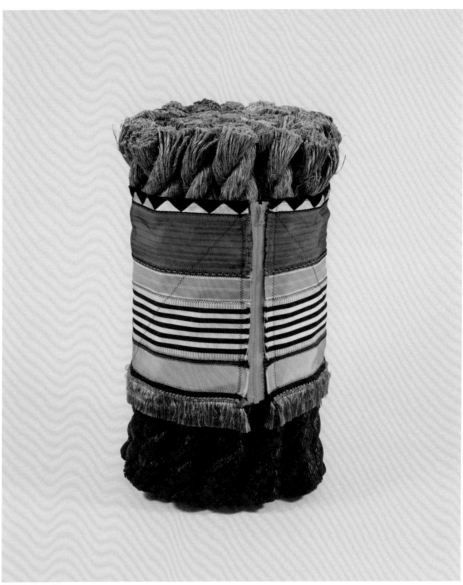

Plate 9. Stephen Burks, Dedar Milano, *Stool: Dedar Roping*, designed 2011, made 2017.

Speculating Widely

Plate 11. Stephen Burks,
Stephen Burks Man Made,
Confetti Bowl, 2014.

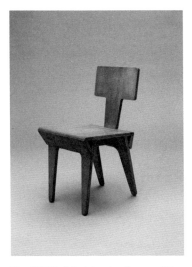

Fig. 10. This "chair in a box" exemplifies
the spirit of DIY in an earlier era.
Nathan Bernard Lerner (American,
1913–1997) and Hin Bredendieck
(German, 1904–1995), designers;
Lerner Design Associates, Chicago,
established 1949, manufacturer;
Chair, ca. 1949, plywood, Milwaukee
Art Museum, purchase with funds
from the Demmer Charitable Trust,
M2015.10.

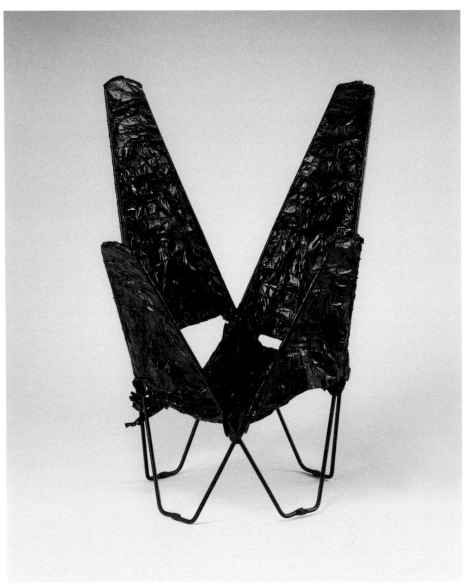

Fig. 11. Stephen Burks, Stephen Burks Man Made, Tape Chair prototype, 2009 (final version
made for IMM Cologne).

Monica Obniski

Creating Home: *Shelter in Place*

Although the notion of a product designer participating in DIY seems like a contradiction in terms, there is precedent. For Burks, one way to ensure that design is relevant in the future is to embed participation. Of course, this idea is not new: Victor Papanek's 1971 *Design for the Real World*, a treatise against consumption-driven design that calls for a focus on environmental and social responsibility; Charles Jencks and Nathan Silver's *Adhocism: The Case for Improvisation* (1972), a populist approach rooted in problem solving with efficiency and materials at hand; and Enzo Mari's 1974 *Proposta per un'Autoprogettazione* (*Proposal for a Self-Design*), a manual that demonstrates how to make one's own furniture using wooden planks and nails, which today remains a classic of open-source design—all of these sources point to this burgeoning global interest during the early 1970s. Some fifty years later, Burks has used these concepts as a starting point for his speculative design project *Shelter in Place*.

Conceptually, Burks's *Shelter in Place* proposals are rooted in Enzo Mari's experimental 1974 *Autoprogettazione*, an early example of DIY design that disrupts the consumption-driven tendencies of industrial design production by placing agency in the hands of the user. Of course, handy people and tinkerers have been designing experimental objects for generations, and the decades immediately preceding Mari's project were full of DIY culture, a mark of expanded leisure time and an ever-present desire to work with one's hands. Naturally, issues surrounding sustainability and environmental unburdening are part of this equation but only if craft is not used as a marketing tool to drive consumption. Instead, craft can be marshaled to advance "self-determination, bodily autonomy and cultural memory intertwined with global citizenship and justice"—in other words, it is critical to a sustainable future.[25]

During periods of upheaval, including the COVID-19 pandemic, a retreat to home (or its ideal) surfaces as a strategy for survival. Taking the viewpoint that interrogating one's surroundings, or how one lives, can disclose meaning about us—a belief shared by many, including bell hooks, who viewed artifacts from home as totems that remind us of who we are and where we came from—*Shelter in Place* reveals information about Burks's practice, what he is thinking about, and where he may be going.[26]

Shelter in Place is rooted in the home, in the creation of new domesticities, and arrives at a critical moment—that of living through a pandemic and environmental emergency while experiencing our own crisis of conscience regarding expanding consumption patterns and issues of racial justice. In an earlier era, designers may have prescribed building DIY projects with materials like plywood (fig. 10), but today, open-source initiatives designed for greater accessibility coupled with the possibilities of digital fabrication portend an alternative future. Burks's *Shelter in Place* projects are proposals, in the spirit of historic ones, that gesture toward a new, diverse future.

And while arranging our spaces at home has taken on new urgency in the last two years, it has been a long-standing occupation. Times of social upheaval also beget new design. The *Shelter in Place* projects explore new social behaviors alongside conventional ones, moving beyond Burks's earlier, more improvisational work—the *Cappellini Love* Table, the "readymade" quality of his initial projects (and the first name of his studio), or an ad-hoc Tape Chair (fig. 11).

25 Anthea Black and Nicole Burisch, "From Craftivism to Craftwashing," in *The New Politics of the Handmade: Craft, Art and Design*, ed. Anthea Black and Nicole Burisch (London: Bloomsbury Visual Arts, 2021), 27.

26 hooks, *Belonging*, 16.

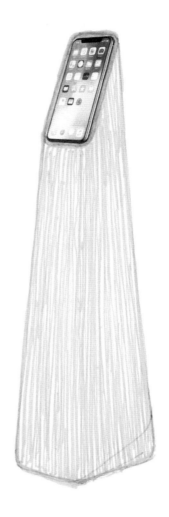

Plate 12. Stephen Burks, Stephen Burks Man Made, *Supports* rendering, 2020.

Monica Obniski

Major constraints of modernism can be enhanced through the power of craft, which revels in the joy of hand-making for its own sake. Burks's *Crafting Diversity* project (2018–ongoing) at Berea College demonstrates that craft can be a more sustainable and inclusive method of production (see Adamson, page 127). While most of the project's products are functional, the sculptural *Broom Thing* Ambient Object (plate 19) also invites speculation—what could happen when a functional broomcorn becomes decorative? If *Broom Thing* is a radical expression of a broom, *The Spruce* (plate 30) is the experimental counterpart for *Community Baskets* (plate 25). Taking the existing parts from *Community Baskets*, Burks wanted to study their limits while generating new ideas for the bands of oak, which only have strength in combination with one another (demonstrating the architectural and collective spirit of this structure). Burks views this conceptual design, in the spirit of *The New Domestic Landscape*, as a confrontation—what could it be?

Shelter in Place has allowed Burks to think beyond the historical nature of the design discipline (and the modernist trope of needing to solve a problem) to embrace its contemporary cousins, speculation and imagination, as relevant tools for inquiry. Some *Shelter in Place* projects empower the user—an important pillar in the designer's belief that more people need to be involved in the design of their lives—while other projects are merely exploratory for the designer, allowing for an unabashed creativity that isn't often accounted for within an industrial or product design process. *Shelter in Place* explores the ongoing project of transforming home and fundamentally asks if people can be more active participants in the design of their lives. Further, can we reconcile our high-technology needs to survive in today's world of flexible work-home life and our desire for expressive objects, things that say something about our personalities (or as Akiko Busch suggests, a "graceful coexistence of technology and nostalgia")?[27] Projects like this are important because, as architect Emilio Ambasz said about his landmark exhibition *The New Domestic Landscape*, designers can "introduce ideas with objects, and [...] objects are the container of ideas."[28] This is the power of design, speculating widely about the future and its possibilities through imagination, alternatives, collaborations, and transfigurations.

The Projects

Beatriz Colomina has called the cell phone "a form of shelter" as it has become, after food and water, conceptually more important than traditional forms of shelter (a bed or a house).[29] This new form of domesticity is enshrined in Burks's *Supports*, which brings the digital space into our corporeal one (plate 12). It is for the new phygital generation, which moves seamlessly between the physical world and its digital other, and fills the need for a purposefully designed place to dock their smartphones so they may be used without interruption or judgment. For a life mediated by screens, this piece of furniture devoted to supporting this lifestyle might have a place in one's living room next to *Private Seat* (plate 13). This ad-hoc intervention transforms existing seating into a self-contained, secluded environment through the addition of a woven canopy. As its name suggests, sometimes the user would like some separation (physical or psychological), and this object functions as a screen surrounding a chair. Additionally, it could also add some personality to a lackluster seat.

27 Akiko Busch, *Geography of Home: Writings on Where We Live* (Princeton: Princeton Architectural Press, 1999), 26.
28 Cynthia Davidson, "The Environments of Emilio Ambasz," *Log* 52 (Summer 2021): 96.
29 Beatriz Colomina, in *Cassina: This Will Be the Place: Thoughts and Photographs about the Future of Interiors*, ed. Felix Burrichter (New York: Rizzoli, 2017), 43.

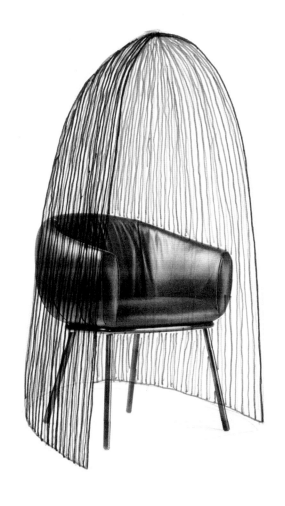

Plate 13. Stephen Burks, Stephen Burks Man Made, *Private Seat* rendering, 2020.

Monica Obniski

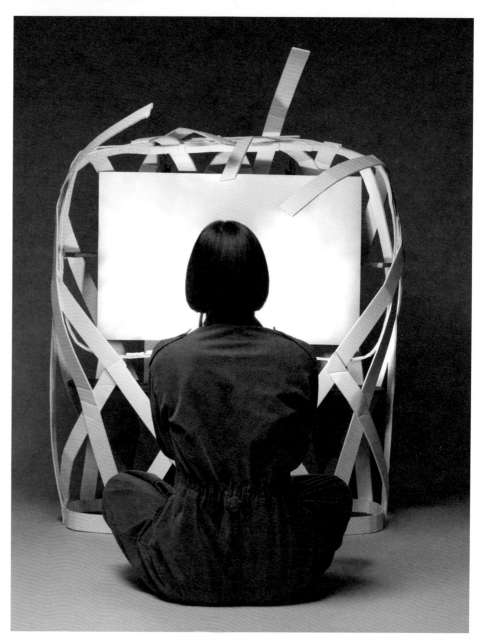

Plate 14. Stephen Burks, Stephen Burks Man Made, *Woven TV* prototype, 2020.

Speculating Widely

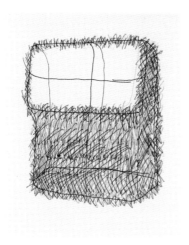

Fig. 12. Stephen Burks, *Furry Woven TV* sketch, 2020, pen on paper.

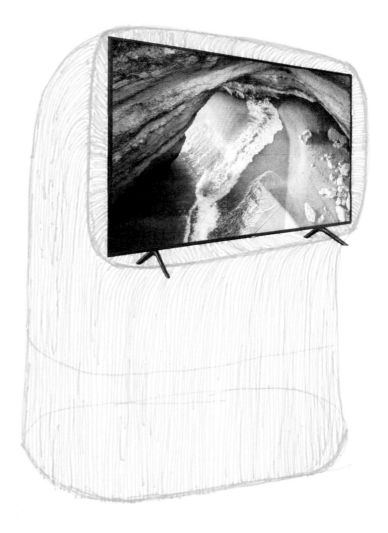

Plate 15. Stephen Burks, Stephen Burks Man Made, *Woven TV* rendering, 2020.

Monica Obniski

Similarly, *Woven TV* adds dimension to a preexisting television, which is not only a long-standing form of entertainment, but as Oli Stratford has noted, it also importantly serves to combat loneliness—a specific condition that has been exacerbated these past two years.[30] Like *Supports*, *Woven TV* uses the infrastructure of television to encourage viewing images on a screen. As Justin McGuirk has suggested, the flat-screen TV replaced the twentieth-century "television-as-object," leading to a dematerialization of the form as it gradually became thinner and larger (adding to the compounding abundance of screens in our lives).[31] But Burks didn't redesign the form of the TV; instead, he has facilitated a DIY spirit of individualized ornamentation. The early form of *Woven TV* (plate 15) was conceptually similar to *Supports*, with a similar architectural language constructing the base. Using the framework of irregular weaving, Burks mocked up a physical model (plate 14) with woven patterning that could be prototyped for production. The goal is for users to add their mark by incorporating decorative elements—leftover ribbons, newspapers, or perhaps potential waste fibers—into the woven structural base, essentially creating a weaving over a weaving that can change on a whim (fig. 12). *Woven TV* can also function as a witness or physical record of material consumption over time.

In addition to the more technologically driven objects, Burks proposed *Spirit House* (plate 16), revealing a spiritual aspect to *Shelter in Place*. The original concept was designed as an homage to Japanese architect Shigeru Ban, whom Burks became aware of as an architecture graduate student. Ban's architectural career is multifaceted, but Curtain Wall House (1995; fig. 13) may be viewed as an ancestor to *Spirit House* when the barrier curtains are opened up to reveal its corner and interior living spaces, which formally connect it to Burks's architectural object. As a domestic intervention, *Spirit House* functions as a portable altar, similar to a mantel that holds photographs or urns of passed loved ones. In this modern version, as opposed to candles that might illuminate the altar, an electric bulb provides light for the spirit world (fig. 14). There is a human need to experience ritual, and the form of *Spirit House* may be found in various cultures as a ceremonial altar for spirituality, meditation, and ancestral reflection.

What's Next?

In thinking about American design today, Jonathan Olivares (who worked for Burks in the 2000s) commented that a new American design perspective is emerging in spaces (especially contemporary work spaces) where "architects and designers collaborate to address the shifting social landscape."[32] This is a profound observation because it acknowledges the long history of collective learning from American design, and it also suggests that the favored collaborative approach of Burks (and others, to be certain) is catching on.[33] Like many estab-

30 Oli Stratford, "The Only Thing Left to Design Is the Foot," *Disegno* 28 (Spring 2021): 84.

31 Justin McGuirk, ". . . the television?" in *Home Futures*, ed. Eszter Steierhoffer and Justin McGuirk (London: Design Museum Publishing, 2018), 30.

32 Jonathan Olivares and Robert Stadler, "The American Object," *Harvard Design Magazine*, Spring/Summer 2021, 177.

33 For example, Nordic designers came to the United States during the mid-twentieth century to gain knowledge about industrial design practices. Bobbye Tigerman and Monica Obniski, eds., *Scandinavian Design and the United States, 1890–1980* (Los Angeles: Los Angeles County Museum of Art, 2020).

Speculating Widely

Fig. 13. Shigeru Ban (Japanese, born 1957), architect, Shigeru Ban Architects, Curtain Wall House, 1995, Tokyo, Japan.

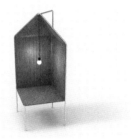

Fig. 14. Stephen Burks Man Made, *Spirit House* digital rendering, 2021.

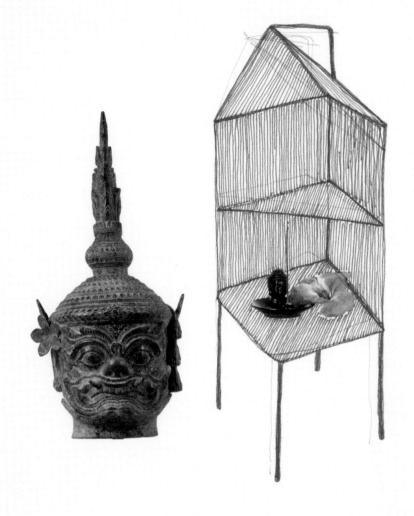

Plate 16. Stephen Burks, Stephen Burks Man Made, *Spirit House* rendering, 2021.

Monica Obniski

lished designers, Burks has several projects at various stages of the design process, from pitch to production. *Anywhere Kitchen* is a recent collaboration between USM and Stephen Burks Man Made that allows for conversations about the future of food and design through salon-style discourse and the prototyping of product designs. The studio is experimenting with URBAN-X director of design Johan Schwind on a project known as *Self-Conscious*, with theoretical objects such as a planter that follows the sun and a chair that uses the ergonomics of an Eames chair combined with pneumatics, a topic that recalls Burks's IIT days. Additionally, MASS Design approached the studio to develop a new collection of lighting and seating made by artisans using local materials in Rwanda and to assess and identify opportunities on the African continent.

Artist Jeffrey Gibson commented about the need to shift one's perspective, writing, "if I continued to identify as alternative, outsider, minority, and brown, then I would always have to observe the mainstream, the popular, the majority, and white people in order to place myself."[34] Using Gibson's critical framework, Burks's work can take on new meaning within the design world if his practice *isn't* compared to others, such as Jasper Morrison or Patricia Urquiola. Gibson's comment is important in establishing a centering perspective—that it is okay to understand Burks's design work on its own terms, not necessarily in relation to his peers. In our numerous conversations, he has recounted how his heroes rejected him, whether it was Kengo Kuma for an architecture internship in Tokyo; Ron Arad, who dismissed him; or Jasper Morrison, who appreciated his work but suggested he continue independently. In the face of such adversity, most people would have given up, but denunciation, coupled with blatant racism, has fortified Burks's resolve. He has positioned himself as the consummate collaborator over the course of his career. There isn't a signature look but a predilection for collectivity that characterizes his projects. The foundation for great design lies in skilled craft, with an eye toward the future—which doesn't necessarily imply a technological future but one that might be more generous, socially driven, and diverse.

Part of Burks's holistic approach, pulled from the disciplines of art, architecture, and design, may relate back to his education at IIT and the Bauhaus principles of synthesizing craft, community, and industry. Parsing these principles yields an understanding of the fundamentals of Burks's design practice—a deliberate relationship between craft and industry, conscientious creation of diverse communities and collaborators, and success that is measured by working through ideas and speculating widely about the future.

34 Jeffrey Gibson, "Acting As If," in *Saturation: Race, Art, and the Circulation of Value*, ed. C. Riley Snorton and Hentyle Yapp (Cambridge: MIT Press, 2020), 76.

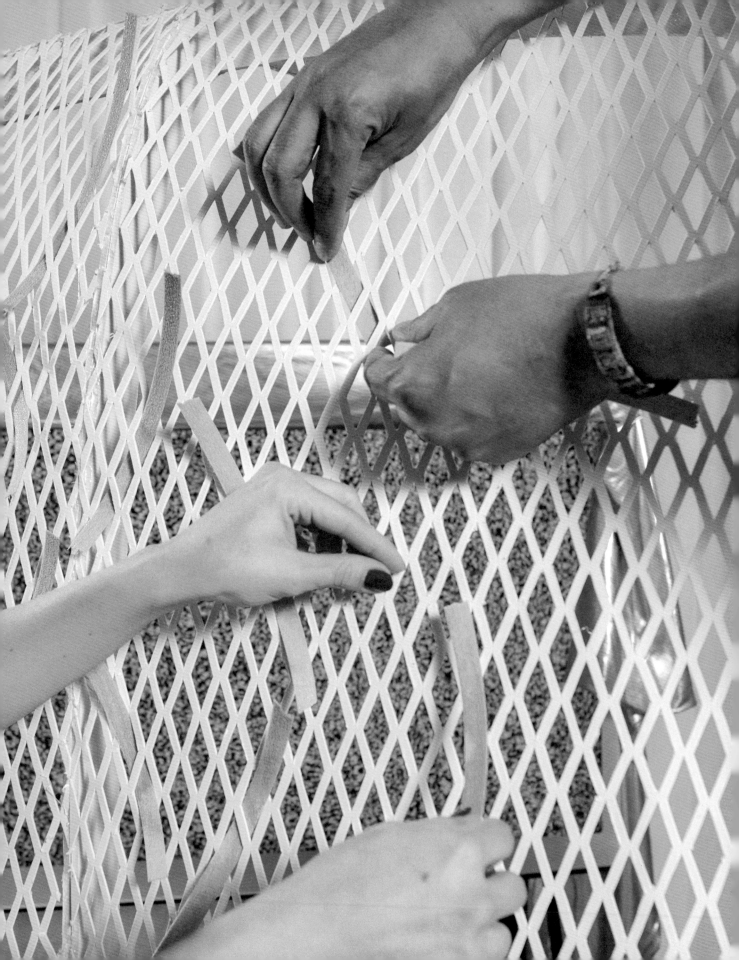

Prototyping in Place
Stephen Burks

Prototyping photo essay
by Caroline Tompkins.

In the spring of 2020, when the pandemic began, we were relieved. Despite the obvious health crisis, lockdown couldn't have come at a better time for us as a family. Relations were still quite new between my millennial partner, Malika, and my gen-Z son, Anwar (fig. 1), so we were looking forward to the prospect of settling into a round-the-clock transgenerational existence together. The sudden change of pace we soon experienced felt as if someone had opened our parachutes at 30,000 feet and we could now gently float down to a comfortable family life below.

Sheltering in place, we began to see our lives differently, and consequently, our physical surroundings also became different and mutable. The dining table became the school, the office, and the studio. The living room morphed into the cafe, the cinema, the garden. Anwar studied while I worked and Malika read. I Zoomed while Malika cooked and Anwar played. Malika drew while Anwar slept and I watched TV. The general response was both surprise and anxiety at the number of overlapping activities that awkwardly took place.

Without jobs, school, or social functions to attend, our schedules collapsed, and soon we found ourselves languishing almost full time. I embraced finally having time to slow down, think, and even dream. Despite a later *New York Times* article that aptly described the condition as not quite burnout, nor depression, but a general sense of aimlessness, I hadn't realized that being stripped bare of the pretensions and pressures of success could be generative.[1] Who would have thought that lying around for hours on end might be a productive, integral part of our new domestic design process?

Cutting mats, drawing pads, and hot glue quickly came out. As if enlightened, we were reminded that we were free to make anything our neglected art supplies and collected piles of recycling would allow. Most of the time we didn't have a clue what we were making; we just wanted to have fun, and it was therapeutic to play again.

Every designer we knew reacted differently. Some wanted to save the world with a well-sewn mask. Others thought up elaborate contraptions for avoiding masks altogether. Working from home and loving it, we designed whatever we thought could make languishing more accept-able. Was this a legitimate response to the pandemic? Could design show us a way out of the crisis? For some of our peers in the industry, design's response amounted to wearable high-tech air-filtering gear, fitted to the body as a pseudo shield to purify what was once a welcoming environment that had now become harmful, even fatal. None of us knew which response was the appropriate one, but we had a feeling that isolated responses to our physical well-being weren't enough. What about our psychological or spiritual welfare? Could design also create solutions to sustain us on a deeper level?

In the spring of 2020, my son lost both of his maternal grandparents. He was certainly not alone. In the first year of the COVID-19 pandemic, one in five families lost either a family

1 Adam Grant, "There's a Name for the Blah You're Feeling: It's Called Languishing," *The New York Times*, April 19, 2021, nytimes.com/2021/04/19/well/mind/covid-mental-health-languishing.html.

Prototyping in Place

member or a close friend.[2] Collectively, we mourned the loss of millions of loved ones worldwide. Without the ability to grieve publicly or gather in our communal places of worship, we wondered, where do we place our feelings of loss? Where do we house our private spirituality? And how do the hardest-hit communities of Black and Brown people cope with this deadliest of inequities?

Stephen Burks Man Made was founded on the notion that everyone is capable of design. We believe that design is cultural production, and like art, literature, and music, it has the opportunity to represent everyone's culture. With this in mind, we try to use design as a language capable of speaking about more than color, form, materiality, and process. This broad approach to object making allowed us to navigate the difficult issues we faced as a family and use design as a physical manifestation of strategies that helped us cope.

Spirit House was the earliest speculative concept to come out of our initial months at home. Through a portable, lightweight house-like form, *Spirit House* was intended to express the Southeast Asian traditions of remembrance. Two walls, a partially pitched roof, and an altar where objects of meaning can be softly illuminated paid homage to the more elaborate spirit houses Malika had grown up with in Cambodia (fig. 2). Like miniature rooms in the sky, traditional spirit houses stand upon pedestals and define ritual spiritual space by keeping offerings and mementos present, often by ceremonial candlelight.

Similarly, *The Ancestors*, another speculative concept, attempts to make space for a more abstract relationship with one's forebears. Rooted in the Afro-diasporic ritual of keeping symbolic statuary at home, the concept refers to how these objects of often unknown origin carry immeasurable meaning for a people who cannot trace their ancestry but who undoubtedly feel spiritually connected to precolonial African histories and ways of being. Dr. Jacob K. Olupona, professor of African Religious Traditions at the Harvard Divinity School, writes, "African cosmologies portray the universe as a fluid, active, and impressionable space, with agents from each realm bearing the capabilities of traveling from one realm to another at will. In this way, the visible and invisible are in tandem, leading practitioners to speak about all objects, whether animate or inanimate, as potentially sacred on some level."[3]

As a means of examining our physical relationship to these sacred objects, once back in the studio, we reinterpreted them through sketching, 3D modeling, and physical models (fig. 3). In a sense, we creatively ingested them, output them at human scale, and in the process made them feel more real. These life-size memorial companions offer a sense of belonging. They remind us of the need for communion: to be amongst like-minded others, share values, and be accepted as cosmopolitans seeking our place in the world. And yet, the questions remain. How do we incorporate the spiritual side of our lives into contemporary design? Can we transcend time and space and nod to ancient traditions while staying in touch with our own?

2 Lauran Neergaard, Hannah Fingerhut, and Marion Renault, "AP-NORC Poll: 1 in 5 in US Lost Someone Close in Pandemic," *AP News*, March 11, 2021, apnews.com/article/ap-norc-poll-1-in-5-us-lost-someone-pandemic-211cc9f31d859fb3a7c7c4d487ba65a9.

3 Jacob K. Olupona, "Rethinking the Study of African Indigenous Religions," *Harvard Divinity Bulletin* (Spring/Summer 2021), bulletin.hds.harvard.edu/rethinking-the-study-of-african-indigenous-religions/.

Stephen Burks

Fig. 1. Stephen, Anwar, and Malika, 2021.

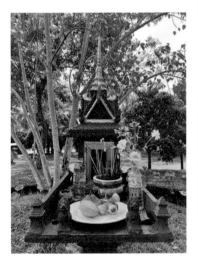

Fig. 2. Spirit house dedicated to Scott Leiper, Kampot, Cambodia, 2016.

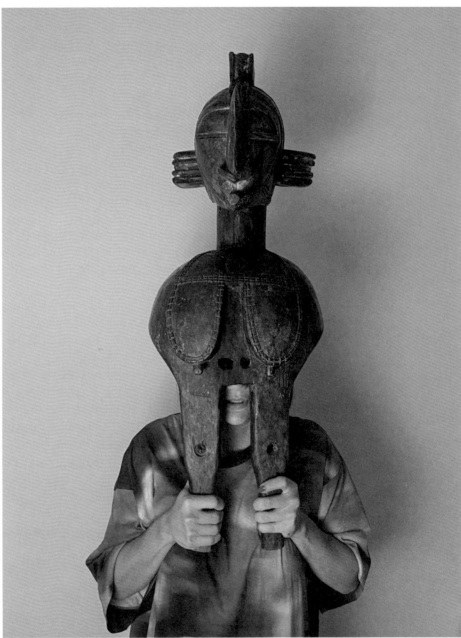

Fig. 3. A West African Nimba, an agricultural fertility headdress in the designer's collection, became a model for *The Ancestors* prototype, 2022.

Prototyping in Place

In many ways, most design practices never address the existence of spiritual sensibilities that are clearly fundamental to the essence of life around the world. Superficially, cars are named *Jaguar*, helicopters are called *Apache*, bikes are called *Impala*, missiles are named *Tomahawk*, and so on; this practice is oftentimes quite problematic, aiming at a rather misguided spiritual belonging that erases the people, the struggles, or the histories from which the products are inspired.

As Americans, we cannot afford to leave our history behind, but we can be in control of how we carry it forward with us. As African Americans, we must continue to rely on our collective imagination to design new ways of being in community and society with each other as well as our past, present, and future.

During that volatile summer of 2020, as we all marched in solidarity for racial equity around the globe (fig. 4), once again, we looked back to the necessary social unrest of the civil rights movement to look forward and to better understand the uprising we found ourselves in, with the hope of laying the groundwork for a more balanced future.

It was around this time that we began our fruitful conversations with curator Monica Obniski. Even before the idea of an exhibition began to take shape, she greatly helped us frame our experiments, situating them historically in a trajectory of prototyping and radical design while reminding us that it was okay for these new ideas to remain conceptual.

About his hypothetical installation for MoMA's seminal 1972 exhibition *Italy: The New Domestic Landscape* (fig. 5), Ettore Sottsass remarked, "my pieces of furniture on view in this exhibition can be nothing more than prototypes, or perhaps even pre-prototypes, and thus, if you approach them, you realize that hardly anything works, [. . .] that no water flows through the pipes, that the stove doesn't heat, that the refrigerator isn't cold [. . .]; you realize that no 'product engineering' [. . .] has been done. These pieces of furniture, in fact, represent a series of ideas, and not a series of products [. . .]."[4] Sottsass and the other eleven designers in the show were conceptualists interested in design as a tool for social transformation, and exhibitions were one way of communicating creative intention. The prototypes they generated were not just gestures but ideas on the way to becoming products that could have a real effect on people's lives. They were more than mere placeholders for the commercial industrial objects to come; they were experimental suggestions of a new way of looking at the future through the lens of design. It was in this spirit that *Shelter in Place* came to be.

The unfinished experimental studies exhibited in the High Museum of Art's galleries are intended to give us a starting point from which to reconsider, to wonder, and to dream of a new way forward through craft, design, and participation that hasn't been imagined before. For a practice predicated on travel like our own, prototyping in place was a kind of radical reawakening—one desperately needed, although it took us by surprise. The public trauma of the global pandemic has transformed the way we live, work, and socialize forever. It has created unprecedented challenges and opportunities alike, as we all struggle to find our way back to normalcy.

4 Ettore Sottsass, Jr., in *Italy: The New Domestic Landscape, Achievements and Problems of Italian Design*, ed. Emilio Ambasz (New York: Museum of Modern Art, 1972), 162.

73 Stephen Burks

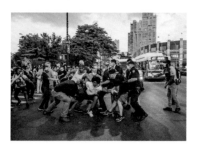

Fig. 4. Malike Sidibe, Protest following George Floyd murder, Brooklyn, 2020.

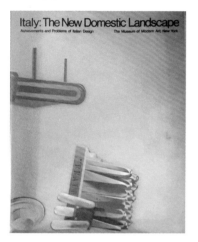

Fig. 5. Cover of *Italy: The New Domestic Landscape*, ed. Emilio Ambasz (New York: Museum of Modern Art, 1972).

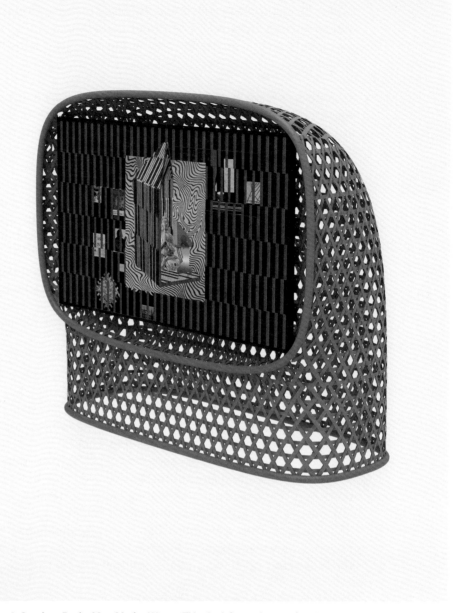

Fig. 6. Stephen Burks Man Made, *Woven TV*, triaxial weaving study, 2021.

Prototyping in Place

Our nuclear family disbanded soon after lockdown, leaving me and Malika circling each other in feverish boredom. The designer ideal of living and working with one's partner in the tradition of Charles and Ray Eames is overrated. After months of doing everything together, we began seeking refuge in different parts of the apartment. The prototypes quickly began to express our need for independence while also supporting a newfound interdependence on the broadcasting of the outside world in.

I spent my days on Zoom constantly trying to be present while trying to shield my personal space unsuccessfully from colleagues and audiences alike. *Private Seat* was born of these desires to be alone together, as I imagined how effective a temporary micro-architectural enclosure might be in providing a modicum of visual and acoustic repose in an otherwise perpetually invasive homelife.

When I wasn't seeking privacy, I was fighting for my fair share of the closest thing I could get to *Private Seat*, which was our (designed for two, but truly comfortable for one) *Traveler* chair (plate 28). Malika dominated its feather-filled, cocoon-like surface most hours of most days. It was her throne, and since I had my own "home office" (albeit without a door), how could I force her out of it? In fact, I began studying her, wondering how best to improve upon her superior level of comfort in the *Traveler*. Occasionally, she'd balance her laptop on her knees and try to really work from the chair, but mostly, she juggled her phone from hand to hand, clearly tired of holding it herself. It was from this observation that *Supports* was born. Why at this stage of the twenty-first century should anyone have to hold their phone, tablet, laptop? There really should be a support for those, so we made several.

Considering how much time we spent together, we began to look forward to our end-of-the-day laptop binge watching. We didn't look forward to the constant repositioning of the laptop to accommodate two people on a carpet, chair, or sofa made for one. Then it occurred to us that somewhere deep in the clutter of our closet was someone else's tennis rackets, cable box, and TV. After all, did a true Brooklyn apartment ever come completely clean and devoid of a prior resident's personal belongings or e-waste?

Our inherited flat-screen television had lived under our bed for months and had never been used. The question was not whether we were going to use it, but how. We refused to hang it on the wall, creating a hideous black mirror effect, so we laid it on the floor and craned our necks over the sides of beds and sofas to see it. Then, finally, after long nights of bad posture, we turned our creative attention to the problem and got to work making an architecture for it, to give it the kind of cultural importance it had previously assumed. What kind of home did we want to give this most seductive of devices, when it felt unnatural to even have a TV? When did TVs become eyesores? Had they been miniaturized and minimized a bit too much? Why weren't they beautifully integrated pieces of furniture like they used to be? What did normal people do with all those cables? Did we really want to make our TV a DIY project?

Of course, we did, and the *TV Thing* (later to be known as the *Woven TV*) (fig. 6) was born! As fun as it was, we questioned if there could be another way of engaging with this black box, to make it come alive and reflect our consumptive practices in the same way that the "recently

Stephen Burks

watched" tab on Netflix or YouTube indicates our digital preferences. Although it began as an exercise in the structural integrity of weaving a cabinet, many iterations later it became a vessel of material culture. With a transparent, open, expanded aluminum surface as its shell, the *Woven TV* could not only accept objects of meaning suspended from its customized open fuselage, but it could also literally collect the week's recycling in its lattice woven through with paper, plastic, or anything in between, inviting active participation from all family members in reincorporating the TV into our homelife as a unique centerpiece.

Through *Spirit House*, *The Ancestors*, *Private Seat*, *Supports*, and the *Woven TV*, the pandemic made visible how much we need one another and collectively signaled a new direction for our practice, which we're still reflecting on.

It's now been two years since our transformative month under lockdown, and although the pandemic persists, we feel freer than we have in a long time. Today, our prototypes fill our studio on industrial pallet racks that have been hacked into desks and product displays so we can have the luxury of working amongst our archive. No longer sheltering in place, we find the separation of home and office refreshing. We enjoy going to work and are back to a hectic travel schedule in search of the right balance of our workshop-based practice and homelife. It's probably too early to say what we have learned from this life-altering experience. However, it's safe to say that we're approaching the profession a bit wiser, with a lot more kindness, respect, and empathy, as we hope to find the same in a landscape whose domestic approach will be nothing if not new.

Prototyping in Place

Prototyping photo essay
by Caroline Tompkins.

Prototypes for the *Shelter in Place* project photographed in Stephen Burks's Brooklyn home, 2022.

Page 68: Stephen Burks, *Woven TV* prototype (detail), 2021.

Pages 78–79: *Woven TV* prototype.

Pages 80–81: *Woven TV* prototype.

Pages 82–83: Stephen Burks, *Private Seat* prototype (2021), with Stephen Burks, *Ahnda* High-Back Wing Chair prototype (2014, DEDON), Stephen Burks, *Grasso* Ottoman (2018, BD Barcelona Design), and Stephen Burks, *Pixel* Pillow (2020, Berea College Student Craft).

Pages 84–85: *Private Seat* prototype.

Pages 86–87: Stephen Burks, *Spirit House* prototype, 2021.

Pages 88–89: *Spirit House* prototype.

Pages 90–91: Stephen Burks, *Supports* prototype, 2021.

Pages 92–93: *Supports* prototype.

Pages 94–95: Personal artifacts, Stephen Burks, *Friends* Table Mirror (2021, Salvatori), and Stephen Burks, *The Ancestors* prototype (2021).

Page 96: *The Ancestors* prototype.

Page 97: Personal artifacts with *The Ancestors* prototype.

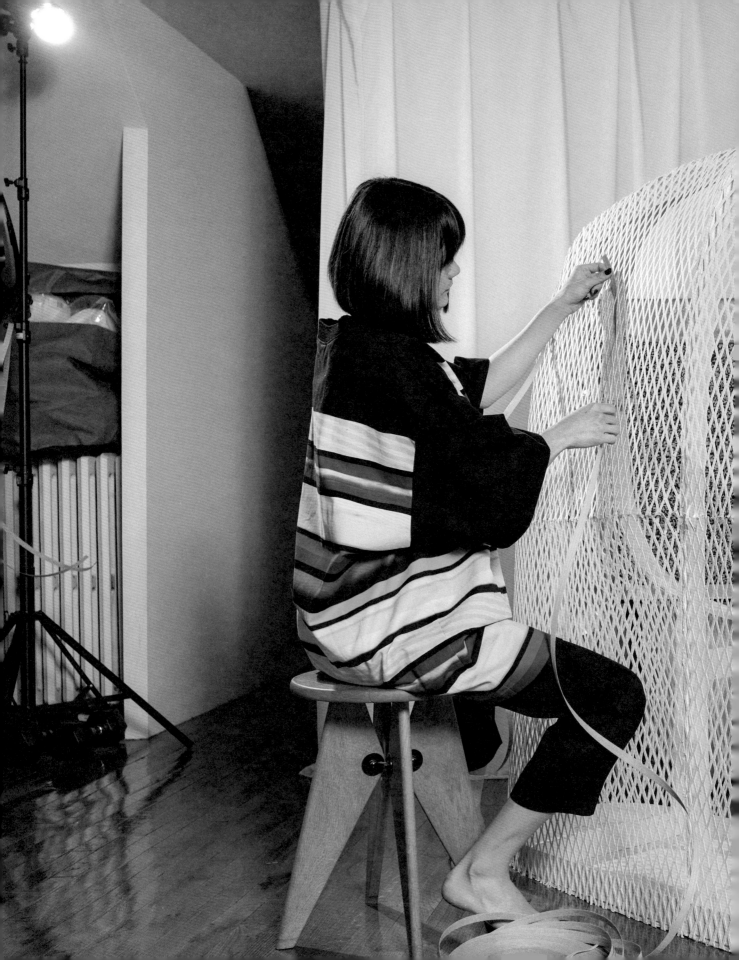

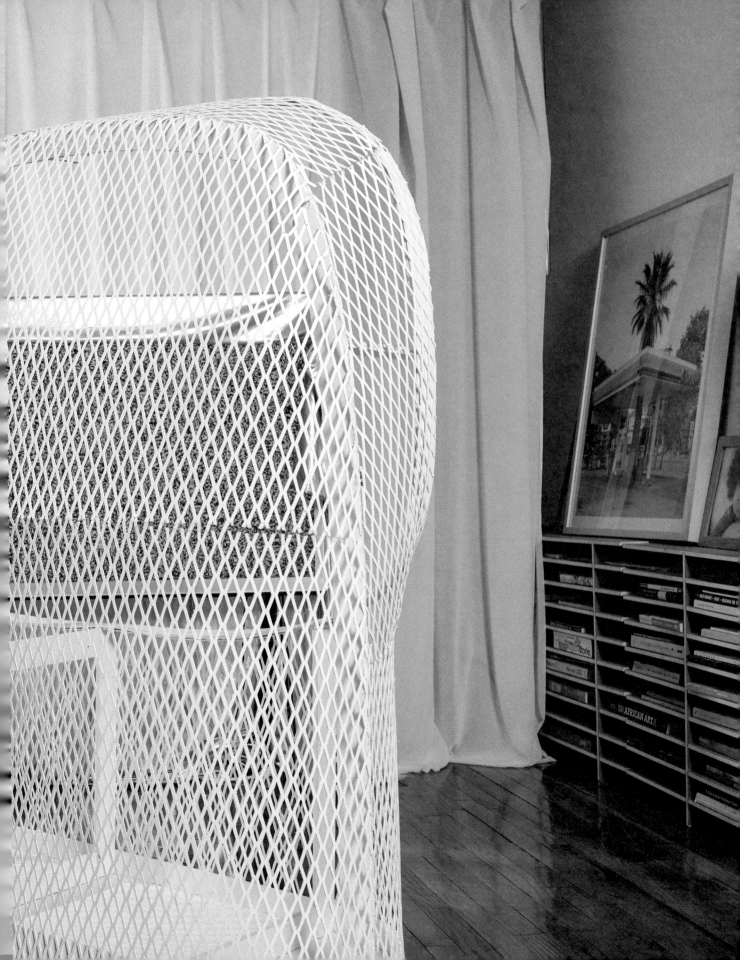

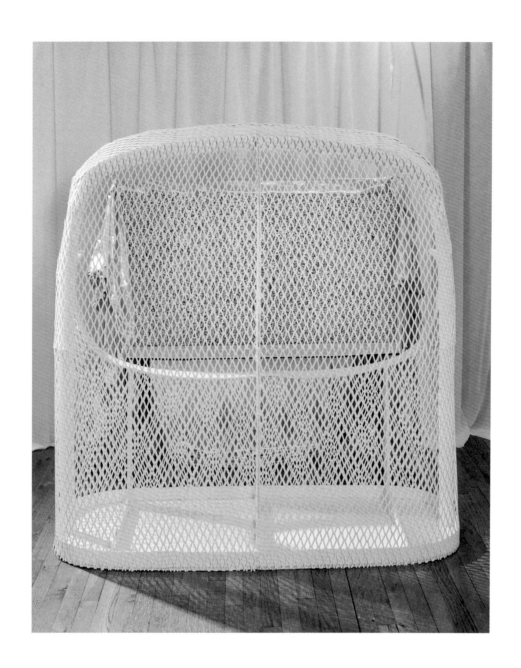

80

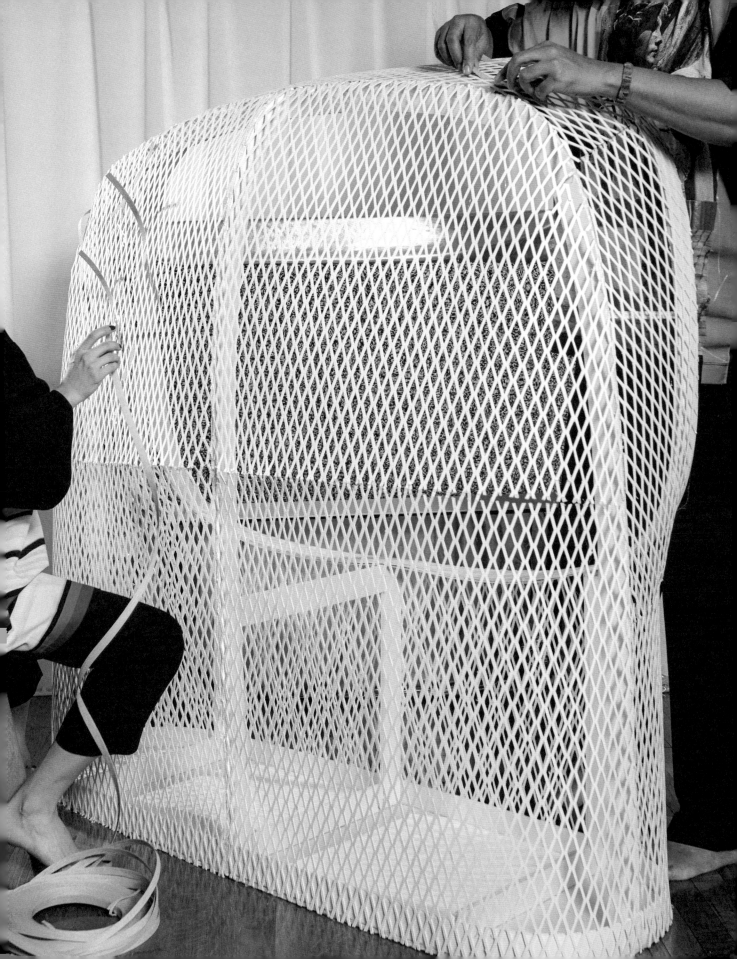

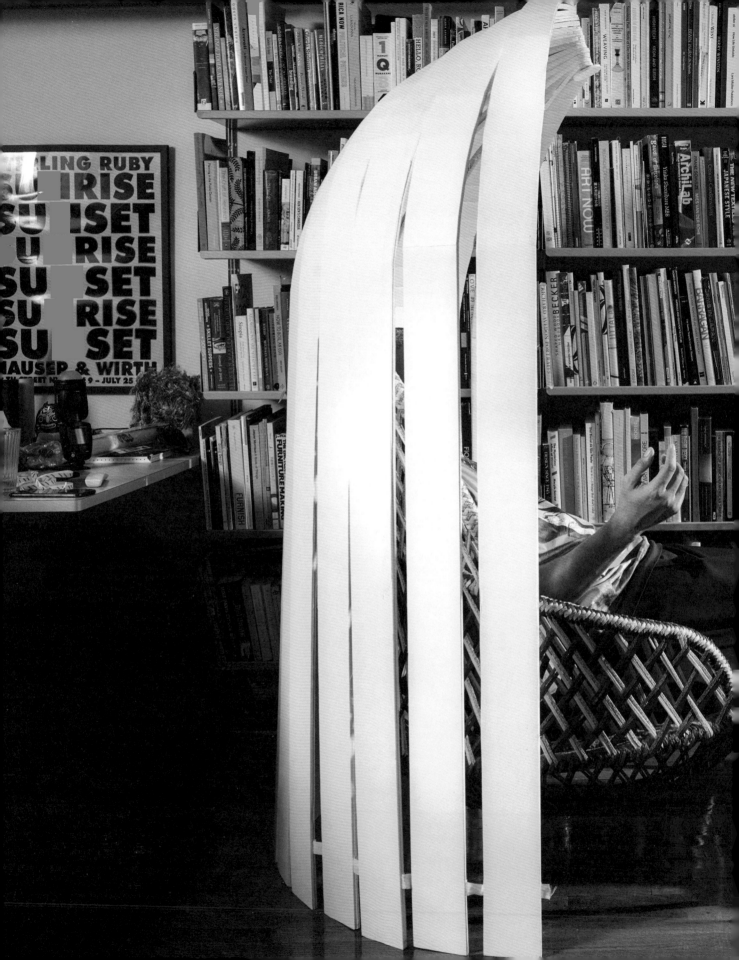

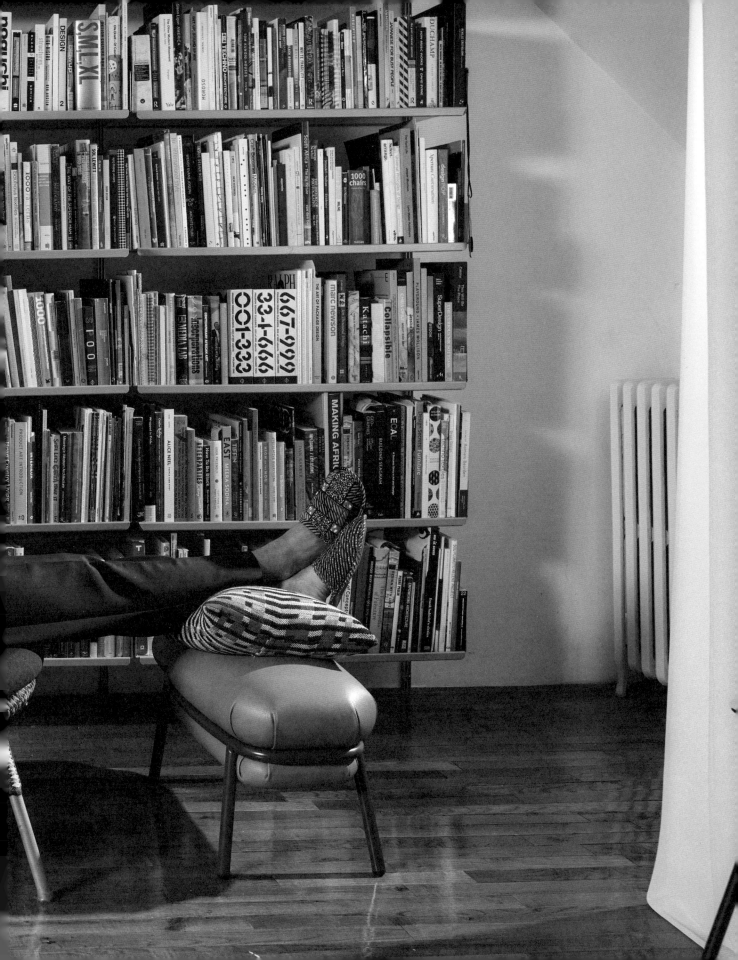

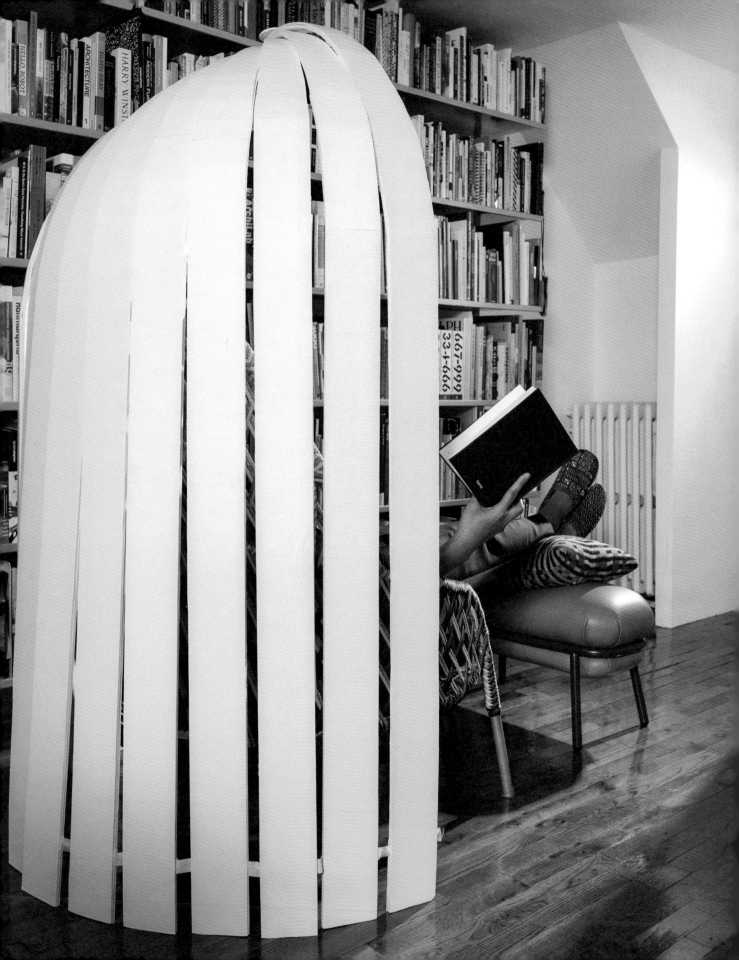

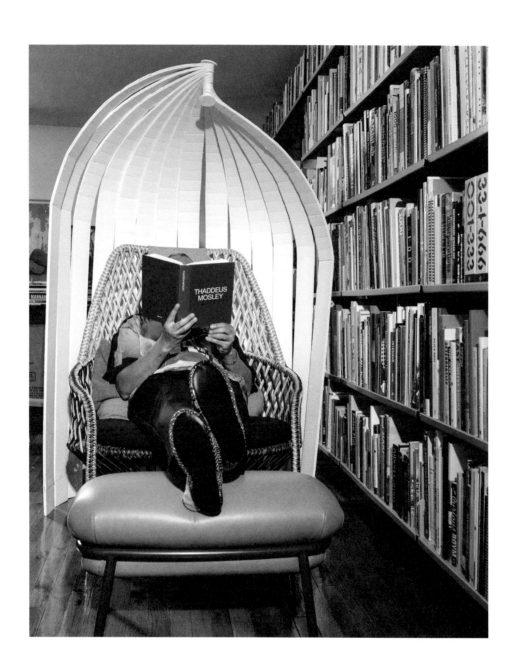

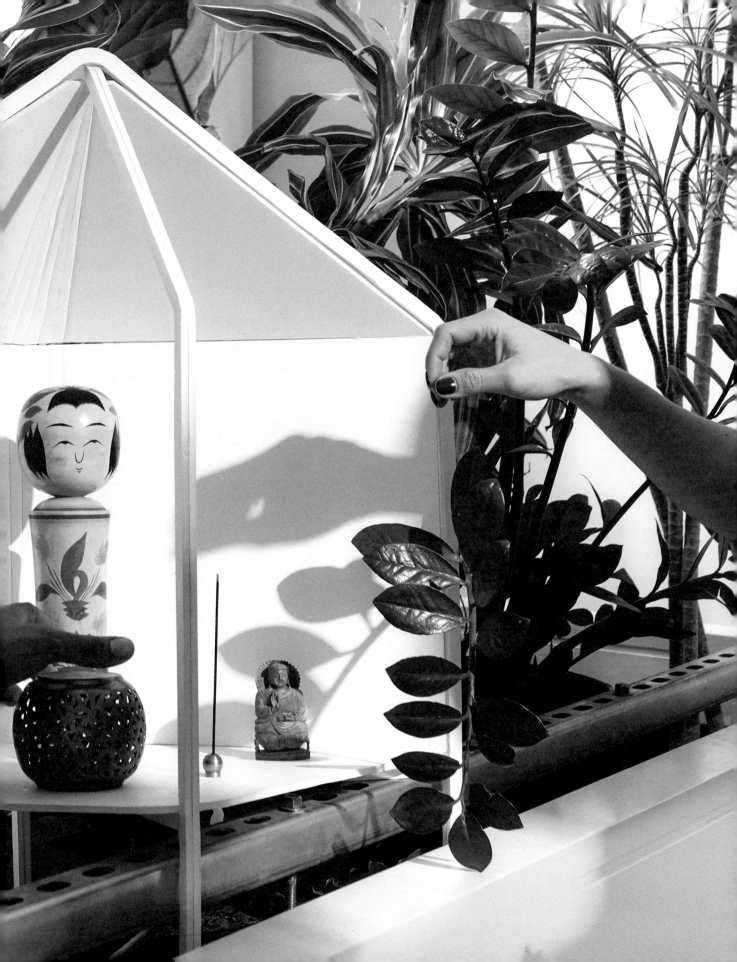

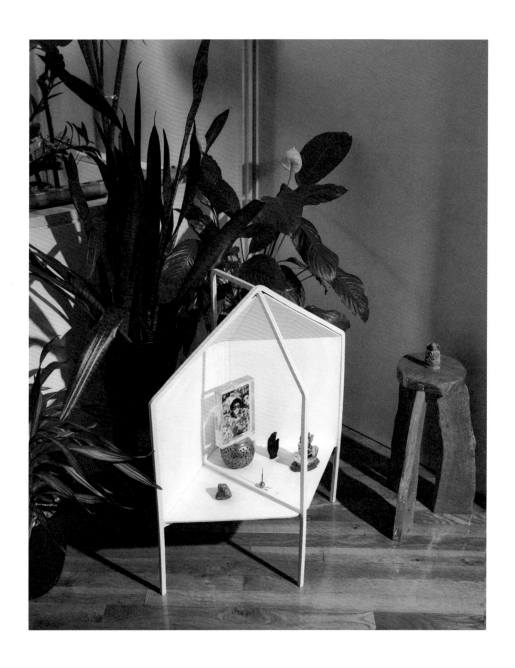

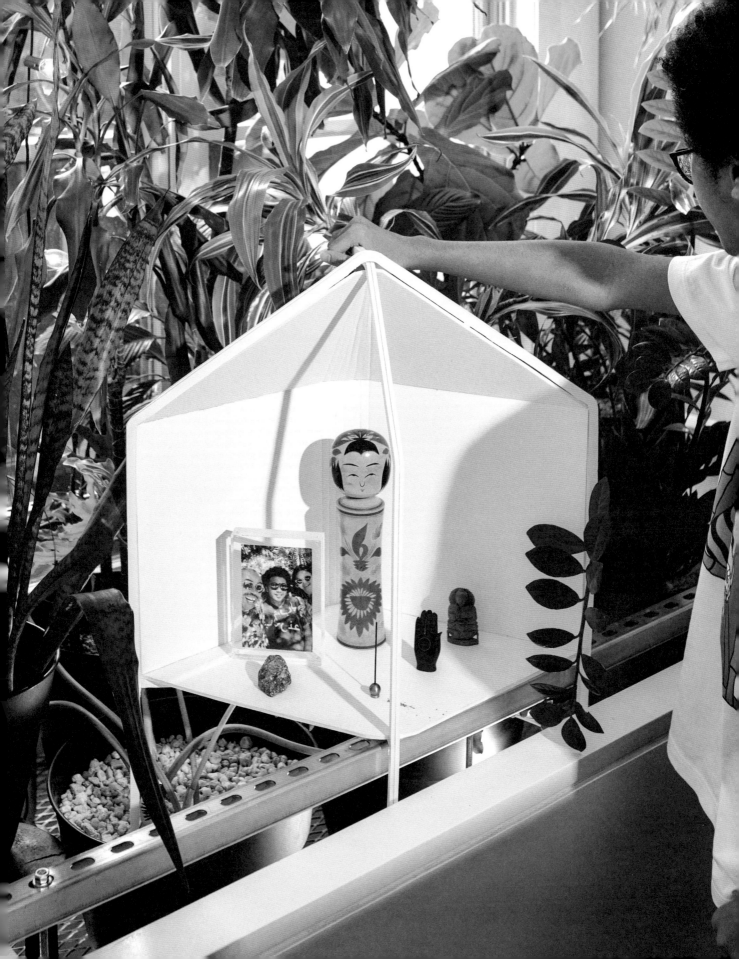

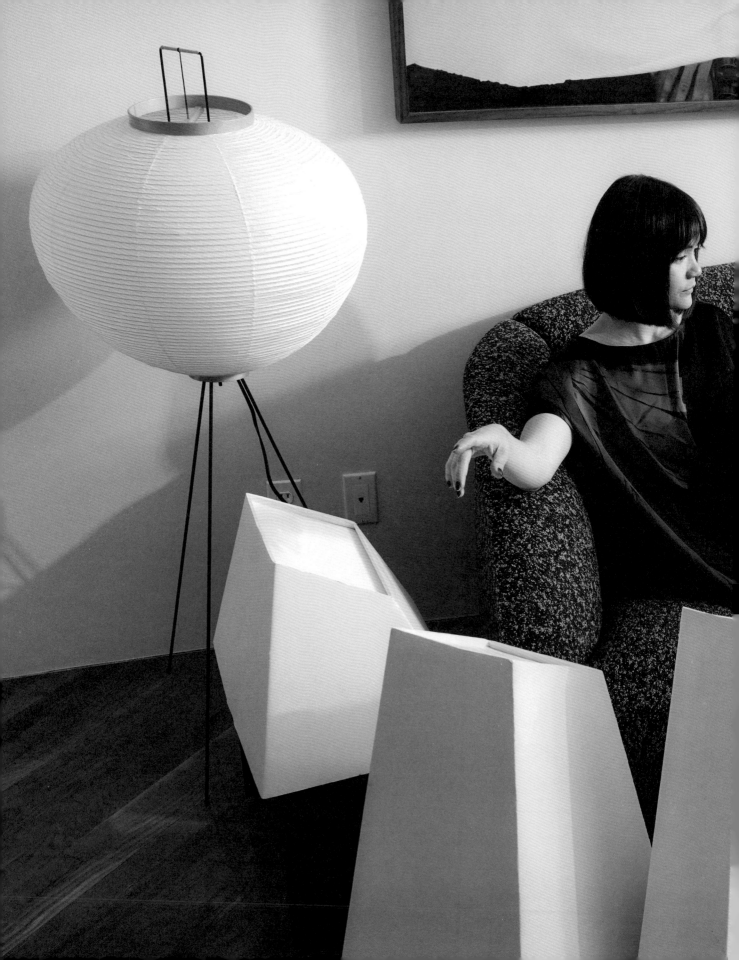

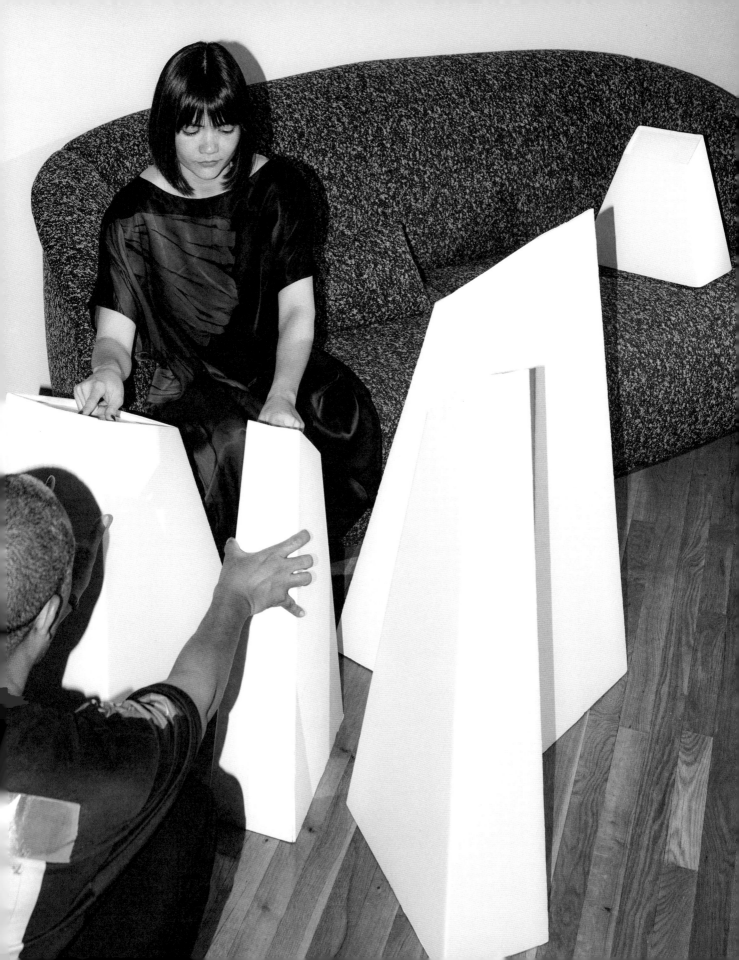

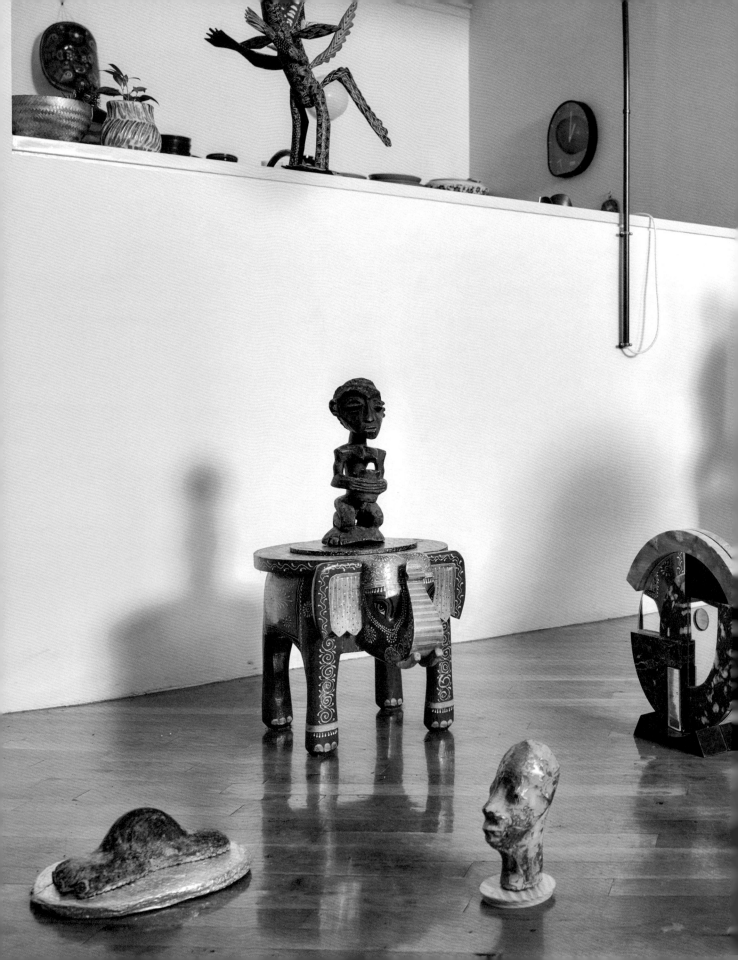

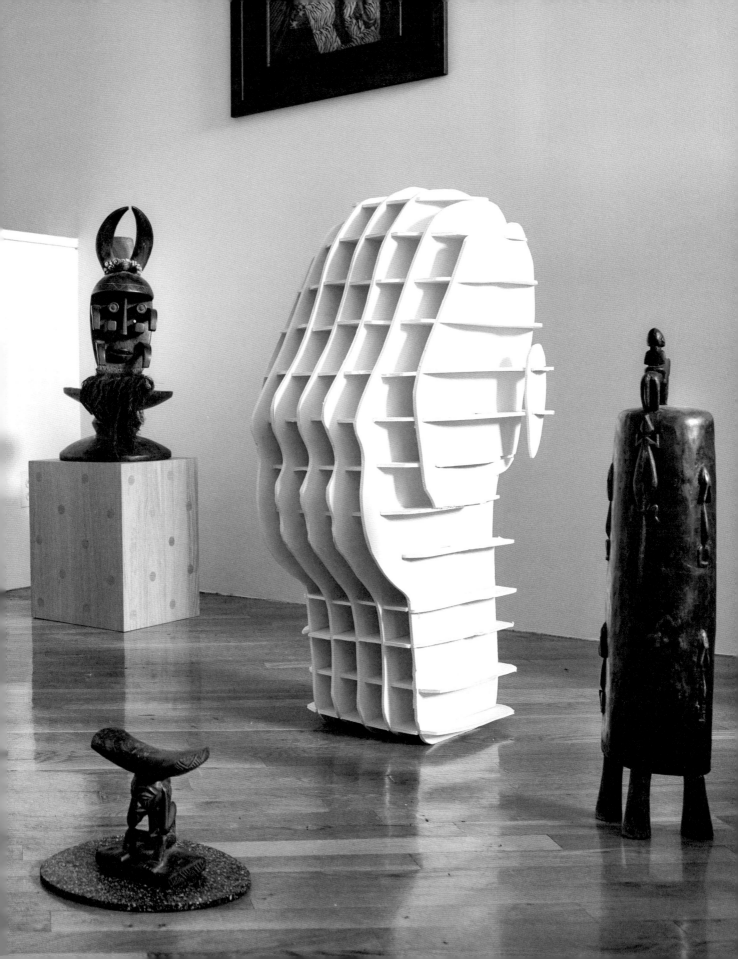

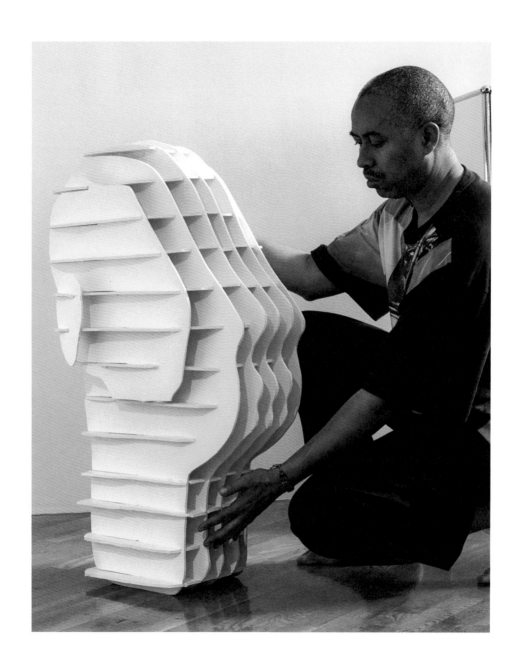

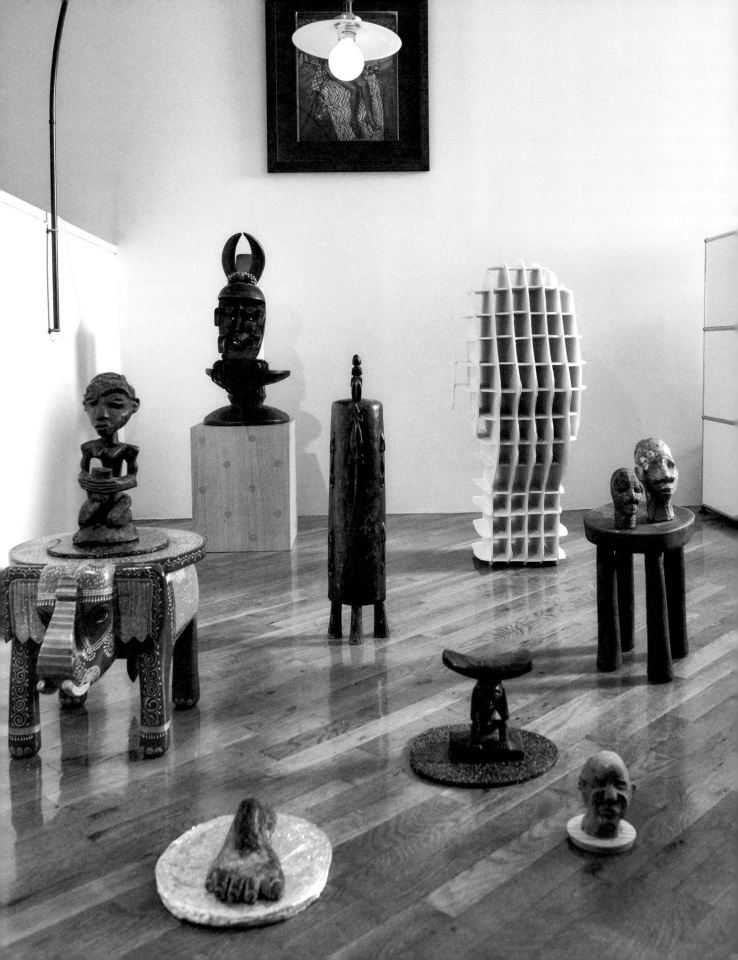

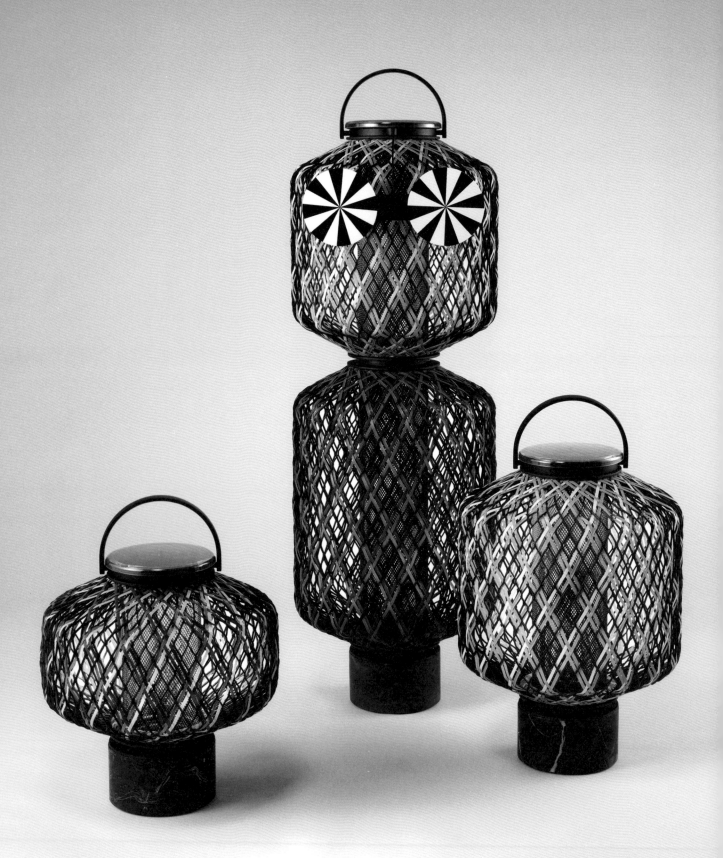

Speaking of Design
Michelle Joan Wilkinson

"The Black soul, if there is such a thing,
belongs in modernism."
—Frank Bowling

Speaking of Design

Occasioned by this exhibition, I had the opportunity to interview Stephen Burks about his development as a designer. I was especially interested in hearing how his engagement with design started and how he has forged a path in the field of industrial design for two decades now. As a curator at the Smithsonian's National Museum of African American History and Culture, I was also interested in Stephen's sometimes singular position as a Black American working in an international luxury design market.

In our exchange, we discuss Stephen's trajectory, from his early interest in sculpture, to training in architecture, to pursuing a career as an independent designer. We delve into the motivations and inspiration for his work as well as the situations and challenges his chosen profession has presented. Some of the work Stephen has undertaken aims to contest the exclusive canons of design by modeling practices that are inclusive and by engaging with diverse communities of creatives across the African diaspora and beyond. As a modernist, an American, an African American, and a Chicagoan, Stephen's various identities inform his work in design.

Alongside foregrounding a commitment to racial equity and social justice in the ethics of his practice, Stephen has also facilitated dialogues with designers that advance and expand thinking about the possibilities of the field. In light of the nationwide reckoning with race and racism happening in the United States—catalyzed by the murder of George Floyd and others in 2020—conversations in the arts, at museums, and in the creative industries have shifted to more explicitly address histories of racism and exclusion. We discuss why it is important to recognize such histories, despite the limitations design may have in addressing these inequities. Undeterred, Stephen shows us how design has the power to generate ideas about outsiderness, togetherness, and ultimately, the wisdom of the human experience.

Michelle Joan Wilkinson

Fig. 1. Photograph of collaborators of Smash, curated by Emmanuel Babled for Covo, ca. 2000. Front row, left to right: Marre Moerel, Stefano Giovannoni, James Irvine, Atsuko Yamagishi, Richard Hutten, Tomita Kazuhiko, and Emmanuel Babled. Back row, left to right: Ritsue Mishima, Jerszy Seymour, Jeffrey Bernett, Stefano Fragapane, Pierre Staudenmeyer, Stephen Burks, and Massimiliano San Felice.

Fig. 2. Stephen Burks in conversation with Carla Fernández and Pedro Reyes, Friedman Benda's Design in Dialogue #58, September 11, 2020.

Speaking of Design

Michelle Joan Wilkinson
What is your first memory of design as a thing—a designed object, a designed space, or something else?

Stephen Burks
My sisters and I went to Catholic school. Growing up on the South Side of Chicago, the gothic interior of St. Francis de Paula made an impression on me. I didn't define it as design at the time, but I recognized it as an intentionally different kind of space from what I was used to. The order and peacefulness of that space calmed me and gave me space to think.

I was surrounded by the legacy of modernism. The Chicago skyline seen at a distance from the South Side was a reminder that I lived in a designed city with certain privileges and limitations. In my youth, crossing that racial dividing line, I felt liberated. In fact, there was a concept store my friends and I used to visit that was named City. It was groundbreaking because they sold a mix of fashion, magazines, books on design, furniture, and accessories. It was there that I encountered for the first time the work of designers like Philippe Starck, Le Corbusier, and Shiro Kuramata.

MJW
It's interesting that you mention Gothic architecture as an early memory. I had a similar experience in my teens, when I began to take notice of that style as particularly distinct and evocative.

I've observed that attention to the handmade and an artisanal quality are attributes often applied to your work. Is there an early experience in your creative development that led you to emphasize "the hand"?

SB
I wanted to be a sculptor before I discovered architecture and design. The idea of manipulating or defining space with objects always struck me as a powerful means of expression. I can remember once watching a documentary on the building of the Watts Towers on PBS, and the literal translation of garbage into art always stayed with me.

Of course, at the time, I had no idea that my interests would move from architecture to design. I didn't even know what design was until late in high school when I wrote an essay comparing and contrasting Mies van der Rohe and Frank Lloyd Wright and stumbled upon the New Bauhaus and its existence on the South Side of Chicago.

Much later, in 2004, my *Missoni Patchwork* Vases (plate 20) would become my first handmade object. My nearly decade-long relationship with such an esteemed Italian family piqued my interest in the origins of postwar Italian design, and I grew to understand what was possible through hand techniques and traditional crafts in relation to industry.

Subsequently, I was invited to work as a product development consultant in South Africa with Aid to Artisans. It was there that I collaborated with craftspeople for the very first time. Their immediacy of making and the use of hand techniques as a primary means of personal expression resonated with me. Witnessing the direct translation of raw material into useful objects was, for me, evidence that everyone is capable of design.

Hands have power. Hands have imaginative power. Hands have communal power. Hands have political power. And hands

have economic power. Even today, the hand is capable of doing things that machines cannot. My work is about finding opportunities for innovation in the space between hand craft and industry while hopefully extending craft traditions into the future.

MJW

You have shared that for many of the design and manufacturing companies you have worked with, you have been the first Black American industrial designer they have engaged to create a product. How did you become the first, and how have the numbers changed (or not) since you began working with these brands, many of them in the luxury market?

SB

In the late nineties when I began working in Europe (fig. 1), I had no role models apart from the European designers that I read about in the design magazines of the day. Jasper Morrison and I became acquainted through his sister Miranda Morrison, who owned a shoe shop in New York filled with her brother's furniture, all manufactured by Cappellini. A year later when I was showing with a French gallery in New York, Giulio Cappellini, Jasper Morrison, and Ronan Bouroullec came to my exhibition. Giulio bought my Display Shelving prototype, and the following year, at the start of the millennium, I was showing in Milan at Cappellini alongside Ronan and Erwan, Jasper Morrison, Marcel Wanders, and Barber Osgerby as the third American, and as the first African American designer ever, to work with Cappellini. I would later realize that I was the only African American designer working in the European contemporary furniture design world internationally.

Of course, looking back twenty years later, I see how the careers of my European peers accelerated very quickly while my own took another ten years to really begin. As an American attempting to work abroad, I struggled to find the resources for travel back and forth to visit the factories, push my projects, and develop the relationships necessary to make my work known in a predigital age. Today, borders are less relevant given how connected we all are. Technology and social media have enabled great strides for designers all around the world, and yet the numbers of designers of color are still incredibly low.

MJW

Indeed. I'm curious if the uptick in media attention to Black designers will have an influence on who believes they can be a designer. You've been called a modernist designer. I'm reminded of artist Frank Bowling's comment [in a 1976 *Art International* interview] that "the Black soul, if there is such a thing, belongs in modernism." What do you think of this statement as it relates to your own work and the various discussions of "Afro-Modernism" by scholars like Robert Farris Thompson?

SB

It's true. I've always considered myself a modernist. If we consider modernism as a critical rethinking of everything we knew in the early twentieth century— from literature, to the arts, to architecture— then clearly we can imagine how all people during that time may have seen it as an opportunity to reinvent themselves. To break free from classical traditions and find new expressions of materiality, spirituality, and philosophy were not just the goals of early twentieth-century

Speaking of Design

modernist thinkers of European descent but were also the goals of recently freed people of the African diaspora all over the world. Not just to play an expected role in society, but to be able to create one's own role and define one's own contribution and be accepted for it were and still are the aspirations of all people.

For me, it's conflicting and complicated because I was born and raised in Chicago and felt an immediate kinship to the monuments of modernism that define the city skyline, but at the same time, I understood that this was modernism dictated by a European perspective. The resolution of this conflict I've tried to express in my work by, at once, being of those teachings while simultaneously pulling in global cultural references that clearly were not accepted or regarded as part of the modernist canon. This is probably why many people have referred to my work as a hybrid project.

There are systems at work that are part of the canon of a European-based education that can be subverted and improved through dialogue with the other. For example, I often use pure geometric forms clothed in layers of handcrafted texture as a means of speaking both languages, distinctly, as one. Some people consider this a maximalist approach, while others categorize it as "ethnic." As scholars today continue to interrogate the modernist project, I hope that more complexity can be found. I think of someone like Isamu Noguchi, who never described himself or his work as *either-or* but instead as *all*.

MJW
You just touched on the role of dialogue. In addition to your work as a designer, you have also been actively contributing to conversations on design, such as Design in Dialogue (fig. 2). What conversations are most needed in the design world now, and why?

SB
We need to talk about inequality, lack of diversity, access, sustainability, ownership, responsibility. In the age of globalization, how do we restructure the balance of power through the advancement of design? Design in Dialogue was created by Friedman Benda gallery in response to our communities being disconnected due to the pandemic. The over two hundred recorded Zoom conversations began with a selection of people already recognized, established, and in a position of power. During our struggle for racial equity in the summer of 2020, I was asked to help give voice to alternative perspectives. These conversations only scratched the surface of what needs to be discussed globally at all levels of society.

I'm not sure how to start the bigger conversation. But having one foot on the inside and one on the outside, I recognize the ineffectiveness of the echo chamber that we've created. Now that we've admitted to the problems of inequality and diversity, how do we begin to formulate solutions, especially in a world where so few make design decisions for so many? One obvious way is to include everyone in the conversation and not just allow the existing structure to attempt to redefine itself.

MJW
I saw you beginning to tackle these intersections on your previous website, where you listed resources for learning about and supporting racial equity (fig. 3). Names like Bryan Stevenson, Ta-Nehisi Coates, and the 1619 Project were referenced. Why was

Plate 18. Stephen Burks, Salvatori, *Friends* Table Mirror (left) and *Neighbors* Wall Mirror (right), 2021.

Speaking of Design

it important or necessary for you to share this content with visitors to your site?

SB

As we progress in the world, we can never leave our history behind us. My identity contributes to and informs my work and life in society. Design must be recognized as one aspect of society that's as much connected to life's most important issues as any other pursuit.

I want people to acknowledge the context in which we're working. On the one hand, we're operating with the greatest of privileges, while on the other hand, we're failing to make a difference at all. What does it mean to be designing luxury furniture for one tenth of one percent of the population when people in our communities are fighting for their lives? My work may not be the solution, but I recognize the problem and acknowledge my participation in it.

MJW

I can appreciate that. I'm fascinated by the narratives embedded in design, such as how your collection of lanterns *The Others* (plate 17) speaks to issues of outsiderness. How have you used design to convey personal or social narratives? Is there a story you haven't been able to tell yet through design, or ideas that you choose to explore outside of your design practice?

SB

It's challenging to communicate big and important ideas through a floor lamp. And it's not always appropriate. If I'm lucky and determined, some of my collaborators (such as DEDON) allow me to also consider each product holistically, to think about the space around the object and not just the function itself. To design a point of view and not just respond to a brief but truly create the object and its narrative underpinnings. I think we have the opportunity to consider the influence objects can have outside of their physicality.

During the pandemic, as we worried about our immediate families, we may have forgotten how our friends and neighbors were affected. Living in lockdown, we may have lost sense of our own complex relationship to one another. A mirror may not bring you closer to those you care about, but it has the potential to remind you of all the people you are connected to and can have a positive influence on. This was the rationale behind the work for Salvatori, for example. I've always believed that no man is an island. And I hope that a mirror made up of different types of stone, with their own unique qualities of color, texture, and depth, may also communicate all the ways that we are shaped by our surroundings and the people in them (plate 18).

Design is more than giving form to something. It has to do with being part of society and witnessing its interactions. There's so much that I'm curious about outside of how people live with things that maybe has more to do with how people live with each other. And I'm not sure if design will ever allow me the depth of expression necessary to communicate it. Maybe I've accepted the fact that design is a form of art, but I'm not sure how to speak in both languages. Lately, I've been experimenting with making objects without function as a means of saying things that I haven't been able to say through design.

Michelle Joan Wilkinson

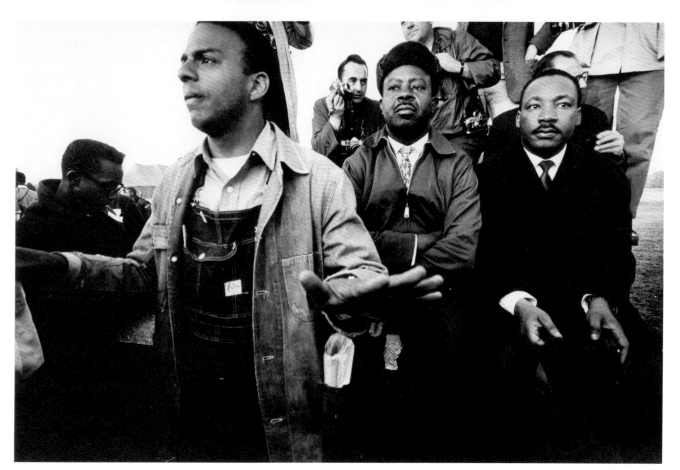

Fig. 3. As a relative of Ambassador Andrew Young, Stephen Burks feels connected to his mission and legacy. Steve Schapiro (American, 1934–2022), *Andrew Young, Rev. Ralph Abernathy, and Dr. Martin Luther King Jr., Selma to Montgomery March, Alabama*, 1965, gelatin silver print, High Museum of Art, Atlanta, purchase with funds from the H. B. and Doris Massey Charitable Trust, 2007.223.

　　　　　Speaking of Design

MJW

Interesting. I look forward to seeing what you create through that process of experimentation. What is the biggest misconception about your work or about the design field in general?

SB

The most common misconception is that, as a designer, simply having a good idea equals success. The reality of the industry, like innovation itself, is that success is based on the acceptance of the right idea at the right time with the right partners. Ideas are cheap; it's how you manifest them that matters. And implementing them requires support in the form of design directors, engineers, skilled fabricators, brilliant marketing, PR, and distribution. This explains why there are so few great companies at the top and so few successful designers working with them. Having a great idea and a great relationship with manufacturing partners as well as proximity to the factory is critical. It took me a long time to realize that the closer the designer gets to the act of making, the more potential there is for innovation. If I couldn't be as proximate or successful by flying back and forth to work with European manufacturers, I could align myself with artisans and product development partners that would allow me to develop a workshop-based practice, studying local craft techniques and working in the field with communities all over the world.

Most of us don't realize that design is a Western concept. The idea of someone studying various methodologies, working with industry to produce a particular product for mass distribution, was very much invented in Europe. In the rest of the world, people have been making things for centuries related to their culture without Western education. This wisdom is passed down through generations, often without written records, as a community-based project. This way of making is the foundation of all human civilizations. Why isn't this considered design? And how do these people begin to have access to the possibilities of a designed way of living today?

MJW

Why did you become a designer? Why do you love it?

SB

Design is a celebration of our creative existence. Few things are more exciting to me than to experience someone expressing their creativity through design. Making things is what we do. It's my goal to participate in that process in as many ways as possible for as long as I can.

Michelle Joan Wilkinson

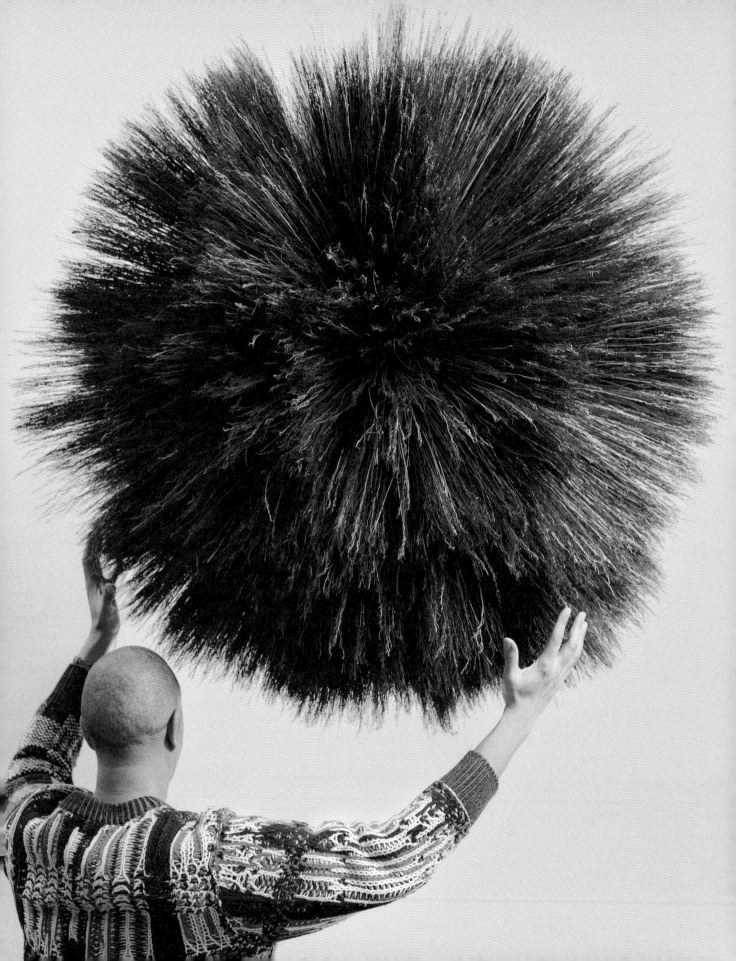

Another Way:
Collaborative by Design
Glenn Adamson

DISTRIBUTOR

NOT FOR
PROFIT

ARTISAN

DESIGNER

Fig. 1. Stephen Burks, Development Triangle and Economic
Model for Aid to Artisans, 2006, illustration.

Another Way

Design, conventionally, is a directive discipline. Its shape is top down, and its historical origins invariably seem to involve a privileged White man telling groups of makers what to do (think Hans Holbein at the Tudor court, Christopher Dresser in the Victorian period, or Raymond Loewy during the Jazz Age). The roots of the term lie in the Italian word for drawing, *disegno*, because it was primarily through drawings that artists communicated their ideas to artisans.[1] Within that exchange, authorship is positioned on one side and execution on the other. Thus, design, in this standard scenario, is inherently asymmetrical. It replicates in miniature other kinds of power relations—of class, gender, ethnicity, and political hegemony—and indeed, often serves those hierarchies directly, providing them with a visual lexicon.[2]

There are, of course, many other ways to think about design. It has been theorized along alternative pathways from the vernacular to the subcultural.[3] It has been reinvented as radical critique, neo-alchemical experimentation, speculative tool, social practice, and individualistic pursuit (where the designer and maker are one and the same). And its history has been rewritten in a newly decentered and global fashion.[4] None of this, however, has fundamentally altered the nature of the profession. Today, just as in the fifteenth century, to design something usually means to draw it (albeit with digital tools) and then hand it over for others to make. A division of labor still prevails, reflecting the age-old hierarchical arrangement of head over hands.

Stephen Burks has devoted his career to finding another way. He often says that "everyone is capable of design," and he has put that principle into practice, undertaking collaborations with artisans worldwide. The long list of places where he has worked—Italy, France, South Africa, Peru, Colombia, Mexico, the Philippines, Indonesia, India, Senegal, Rwanda, Kenya, Ghana, and several parts of the United States—is an indication of his ambition. For him, it is never a matter of "parachuting in," as the saying goes. When working with artisans, he always looks to cultivate "relationships rather than transactions."[5] For Burks, it's about accreditation, not appropriation; trade not aid. And though Burks, like any industrial designer, does work within

1 Clive Ashwin, "Drawing, Design and Semiotics," *Design Issues* 1, no. 2 (Autumn 1984): 42–52. On drawing as a means of exerting power over craftspeople, see Glenn Adamson, *The Invention of Craft* (London: Bloomsbury, 2013), 18–23.

2 For a recent study on design's normative role in relation to class, gender, and race, see Kristina Wilson, *Mid-Century Modernism and the American Body: Race, Gender, and the Politics of Power in Design* (Princeton: Princeton University Press, 2021).

3 Early statements include Charles Jencks and Nathan Silver, *Adhocism: The Case for Improvisation* (New York: Doubleday, 1972; expanded and updated in 2013), and Dick Hebdige, *Subculture: The Meaning of Style* (London: Methuen, 1979).

4 Glenn Adamson, Giorgio Riello, and Sarah Teasley, eds., *Global Design History* (London: Routledge, 2011); Pat Kirkham and Susan Weber, eds., *History of Design: Decorative Arts and Material Culture, 1400–2000* (New Haven: Yale University Press/Bard Graduate Center, 2013); and Victor Margolin, *World History of Design* (New York: Bloomsbury, 2015).

5 Quotations from Stephen Burks throughout are from conversations with the author in 2021.

Glenn Adamson

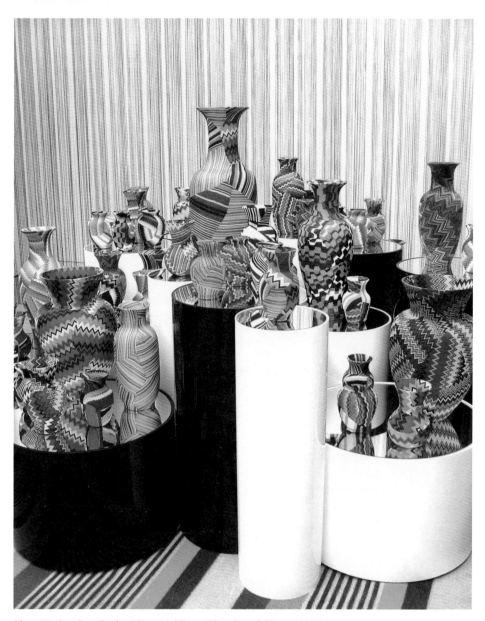

Plate 20. Stephen Burks, Missoni, *Missoni Patchwork* Vases, 2004.

Another Way

necessary technical specifications, the heart of his process is shared experimentation, ongoing and open ended. His practice evolves in workshops, alongside artisans and craftspeople, on a level creative field.

Rather than using the problematic language of "third-world" countries—a holdover from the Cold War; though few now remember this, the "second world" was once used to designate the Communist bloc—Burks thinks instead in terms of the "majority world," a phrase originating from Bangladeshi photographer Shahidul Alam.[6] This is, of course, simply factual—White people are very much in the minority worldwide—but it is also a statement of intent. Burks is determined to "invert the pyramid," as he puts it. Instead of cultural sampling, he works to foster a mutuality in which artisans, wherever they may live, are understood not as subservient fabricators but as creative guides.

Clearly, this is not a straightforward proposition, and in pursuing it, Burks has had to be both entrepreneurial and imaginative. He is no utopian. He has no illusions that he alone can, by making the right kind of chair in the right kind of way, reset the parameters in which manufacturers, makers, and markets interrelate. Instead, he sees himself operating tactically within a "development triangle," in which the brand, the artisan, and the designer are positioned relationally and are mutually implicated (fig. 1). Shift one vertex of this geometry, and the others are necessarily displaced as well. The trick is to do this consciously, effectively, strategically. And over time, he's gotten better at it.

His first concerted attempt was in 2005, when he had the chance to travel to South Africa with support from the nonprofit group Aid to Artisans—also his first trip to the continent, an important event in his life and career. The opportunity came as a result of his *Patchwork* (2004; plate 20) project with Missoni, made using cutoffs of the brand's fashion collections. Inspiration for that project had come both from Missoni's earlier designs—"the patchwork sweaters I knew back in the 1970s," as he put it—and from the Missoni family's own sources of inspiration, their travels to such places as South America, Mexico, and Africa. The project was a foretaste of things to come in his work, particularly in his smart repurposing of underexploited craft materials. It was also very media friendly, the design equivalent of a pop song with a killer hook, and anchored readily into conversations around recycling and sustainability, just then emerging in the design field.[7]

The *Patchwork* collection was initially modest in scale—a few furniture prototypes and a run of sixty vases, which Rosita Missoni kept—but it won Burks an unprecedented amount of attention, including a profile by Pilar Viladas in *The New York Times*'s *T Magazine*, then edited by Stefano Tonchi, that rightly noted a conceptual underpinning to the project, linking Burks's use of found objects back to Marcel Duchamp.[8] Burks had encouraged this connection, going so far as to call his studio Readymade Projects, thereby positioning himself in relationship not

6 Shahidul Alam, "Majority World: Challenging the West's Rhetoric of Democracy," *Amerasia Journal* 34, no. 1 (2008): 88–98.

7 See Victor Papanek, *The Green Imperative: Ecology and Ethics in Design and Architecture* (London: Thames and Hudson, 1995).

8 Pilar Viladas, "Puff Dada," *The New York Times*, September 18, 2005. The slightly cringe-inducing title, which implied a relation between Burks and a certain hip-hop star, was also intended to emphasize the link to Duchamp.

Glenn Adamson

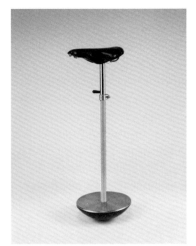

Fig. 2. Achille Castiglioni (Italian, 1918–2002) and Pier Giacomo Castiglioni (Italian, 1913–1968), designers; Zanotta, Italy, founded 1954, manufacturer; *Sella* Stool, 1957, leather, steel, and iron.

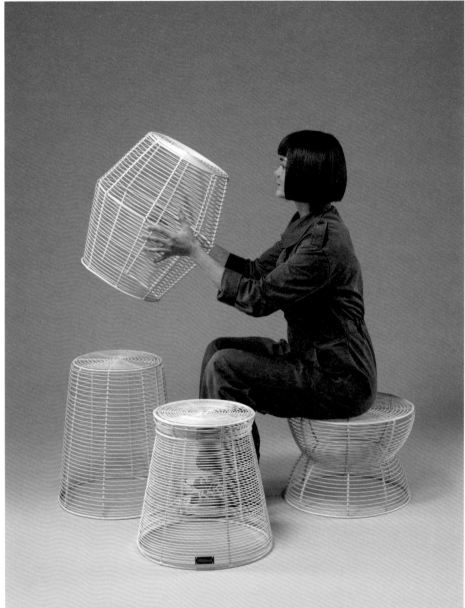

Plate 21. Stephen Burks, Artecnica, *TaTu* Stool, alongside prototypes, 2007.

Another Way

only to Duchamp but also to more recent designers who incorporated found objects into their work, such as Ron Arad or the Droog Collective (fig. 2). To the extent that Burks was engaging in appropriation, though, he certainly was not adopting an anti-aesthetic. On the contrary, it was precisely the material and visual qualities of Missoni's fragments that appealed to him: the way that a knit fabric (unlike a woven textile) can stretch over a compound curve; the collision of the company's signature stripes, resulting in something like a crazy quilt; the infinite possible manifestations that a single design gesture can have. In his subsequent work, Burks has often looked for similar opportunities to bring something new to existing craft vocabularies while also respecting their integrity.

It was at the Milan Furniture Fair, where the *Patchwork* collection was on display, that Enrico Bressan of the Los Angeles–based firm Artecnica approached Burks. Would he like to be part of an ongoing initiative called Design With Conscience (founded a few years earlier, in 2002), which paired designers with artisan communities from around the globe? Burks readily agreed, and soon he was bound for Cape Town, sponsored by Artecnica in partnership with Aid to Artisans. This situated him within a trajectory that had begun four decades earlier, in 1964, with the founding of the World Crafts Council. That organization had been beset from the start with fraught questions about scope and mission: would it recognize high aesthetic achievement, like the Japanese Living National Treasure program, or would it be principally devoted to economic development? Aid to Artisans was the direct outgrowth of this debate. Founded in 1976 by the World Crafts Council's former secretary general, it set out to provide commercial avenues for craftspeople to sell their wares. Initially, the target was high-end retail—museum shops and the like—but the nonprofit gradually shifted into something like a small business bureau, offering grants and skills training.

This somewhat paternalistic structure is what Burks encountered in South Africa, "a country that had invested greatly in maintaining and developing their craft traditions," as he says, "but almost as a touristic pursuit, attempting to bring economic transformation to Black South Africans." In his time there (accompanied by his assistant Jonathan Olivares), he met with about a dozen artisans working in different disciplines and worked with them to cocreate experimental prototypes. At Mandela Mosaic, he created a kind of reverse slip-casting technique using household plastic wrap, Vaseline, and silicone inlaid by hand with recycled mosaic glass tile over an inverted glass bowl or vase, which allowed the artisans to make as many new wobbly hybrid bowls and vases as they liked; plastic chairs wrapped with brightly colored plastic left over from parade floats; and in collaboration with a basketry firm called Kunye African Trends, furniture surfaced with shredded *Domus* and *Wallpaper* magazines. These projects ultimately became *Cappellini Love* (2008), a limited-edition collection for Burks's primary furniture client at the time, marking the first time Cappellini explored the notion of eco-sustainability or social design (plate 10). Thelma Golden, the pioneering director of the Studio Museum in Harlem, spotted the pieces, which helped pave the way for Burks's first solo exhibition there, *Stephen Burks: Man Made* (2011). Burks developed another furniture line in powder-coated wire, called *TaTu* (2007; plate 21), in collaboration with the craftsman Willard Musarurwa from prototypes they made together in Cape Town in 2005. It was adopted by Artecnica for the Design With Conscience project, alongside designs by the Campana Brothers and Hella Jongerius, among others.

Glenn Adamson

Despite these successes, Burks looks back on this early venture with some frustration. In South Africa he was obligated to serve as "export manager, business person, and communications director, and no one was thinking about the distributor at all." After one cycle of media promotion, Cappellini and Artecnica quietly dropped his collections. The most significant positive long-term impact was arguably for Musarurwa, who proved a capable entrepreneur. Before encountering Burks through the Cape Town Craft and Design Institute, he had spent five years selling his wares on the street. Thanks to the visibility of the collection they developed together, he was able to start up a viable company called Feeling African, with ten employees; it is still in operation today, producing variants on the original *TaTu* designs (fig. 3).

What Burks was learning was that good intentions were no substitute for long-term commitment. He had a similarly inconclusive experience with *Design for a Living World* (2009), a partnership between the Cooper Hewitt Museum and the Nature Conservancy. Ten designers, among them Jongerius, Yves Béhar, Maya Lin, and Christien Meindertsma, were invited to develop products with Indigenous communities using sustainable materials. Burks worked with the Noongar, an aboriginal people of Australia, and developed a series of pieces—most strikingly, a giant pepper mill—made from turned mungat, or "raspberry jam wood," so called because of its fruity sweet scent when freshly cut (fig. 4). Noongar artisans had historically used this timber to make hand tools such as pestles, though the resource had more recently been exploited primarily to mass manufacture fence posts. As he had in South Africa, Burks worked alongside the craftspeople to extend their craft into the future, learning and building upon their traditions. In this case, mass-produced products were not the goal of the initiative, and though pleased with the results they were achieving together—and despite approaching companies like Aveda and Clinique—the experiment did not go any further than the exhibition gallery.

It may seem unusual to recount what Burks thinks of as "failures" in a designer's monograph. Yet this is the reality of such cross-cultural collaborations, and he is commendably transparent about the challenges involved. Even when the aim is genuine, too often these initiatives amount to little more than promotional opportunities or thought experiments for their minority-world sponsors. For this reason, Burks has become more committed to advocating for change, not just on the artisanal side of the equation but on the side of the branded manufacturer as well. Indeed, such tactical displacements must occur in a multivalent and interlocking way.

Design history deeply informs Burks's approach to these matters. He was educated at the Illinois Institute of Technology's Institute of Design (ID) in Chicago, founded in the 1930s as the New Bauhaus by László Moholy-Nagy, who was the head of the Bauhaus metal shop and the originator of its famous *Vorkurs*, or "preliminary course."[9] Moholy-Nagy's core principle of experimentation through making was still prevalent at ID when Burks finished his studies there at the end of the millennium, and Burks has continued to apply it: his work reflects many of the core qualities of Bauhaus design, particularly from the school's foundational period when its involvement with folk craft, abstraction, and expressionist color was at its height. He has also engaged with this modernist legacy through his extensive experience with Italian furniture firms (B&B Italia, Boffi, Calligaris, Cappellini, Missoni, Moroso, and Zanotta), most of which, as he points out, "began as family-owned businesses rooted in craft production and

9 On Moholy-Nagy in Chicago, see Thomas Dyja, *The Third Coast: When Chicago Built the American Dream* (New York: Penguin, 2013).

Another Way

Fig. 3. Stephen Burks and Willard Musarurwa, Capetown, South Africa, with Artecnica, *TaTu* prototype, 2005.

Fig. 4. Stephen Burks in collaboration with Noongar people of southwestern Australia, Raspberry Jam Wood Commission, from *Design for a Living World* (2009), with Ellen Lupton and Abbott Miller, The Nature Conservancy, and Cooper Hewitt, Smithsonian Design Museum.

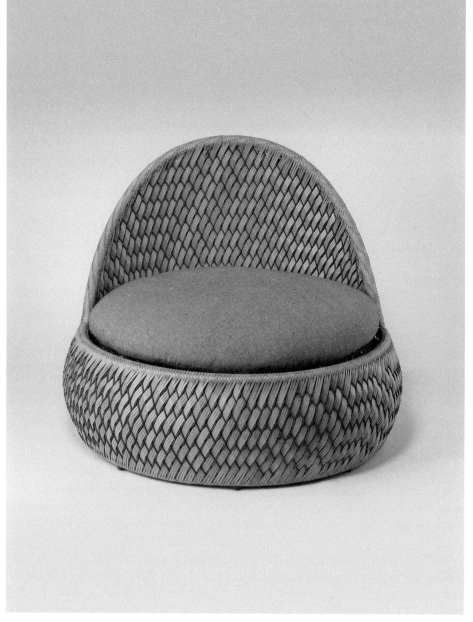

Plate 22. Stephen Burks, DEDON, *Dala* Lounge Chair, 2012.

Glenn Adamson

the learnings of the Bauhaus. After the Second World War, with investment, they grew into the major companies we know today." So, he remains optimistic: "Why can't that happen in Senegal, Colombia, the Philippines?"

Burks has continued to prioritize artisan collaborations in his work, despite all the challenges that entails—and it is in the Philippines, as it happens, that he has had one of his most sustained successes. Since 2011 he has been working with DEDON, a manufacturer and innovator of luxury woven outdoor furniture known for popularizing the use of extruded polyethylene; though headquartered near Hamburg, most of its production facilities are in Cebu, in the heart of the Philippine archipelago. There is huge capacity there—at peak, the workshop employs over a thousand weavers who can produce about three hundred pieces of furniture a day—and though it would be cheaper for the company to relocate to Vietnam or Indonesia, it remains in the Philippines because of the higher standard of craftsmanship. (Burks likens this to another of his clients, the France-based firm Roche Bobois, which has its furniture made in Italy because of the quality and culture of craftsmanship there.) During his visits to Cebu, Burks collaborates mainly with a research and development group of about twenty-five highly skilled weavers, aluminum framers, and product developers; in addition to the personnel, there is also a materials library.

Dala (2012; plate 22), the first collection he made for DEDON using these diverse resources, has low-slung lines that take inspiration from the floor-based, improvisational seating arrangements common throughout Asia. Yet it's made in a high-tech way, a tricolor weave through expanded aluminum; the process, which Burks developed alongside the master weavers, has since been patented. It is intended as outdoor furniture, a specialist area for DEDON, which further increases technical demands, as every component must be extremely durable in all weather conditions. A subsequent project, the lighting collection called *The Others* (2017; plate 17), was still more ambitious in its requirements. Its component parts are modular, allowing for mix-and-match compositions, a multiplicity that is reflected in its diversity of materials (metals, fiber, marble, acrylic, and lighting components), which are sourced both from Germany and locally in the Philippines. Each light is a global assemblage. This idea of transnationality is communicated through the anthropomorphism of the collection, which, in combination with the sci-fi-tinged title, suggests a diverse cast of diasporic characters.

In Burks's most recent design for DEDON, the *Kida* Swing (2020; plate 23), high-level craft technique is again married to industrial materials. The design marks a shift away from the company's usual look, in which the whole surface is densely woven, instead articulating an oversized basket or open structure floating in midair. While the *Kida* was developed during a weeklong workshop in the Philippines, it has its conceptual roots in Japan: Burks was originally inspired by the ribs of a fan he had recently acquired in Tokyo, and the name invokes that of the celebrated editor of *Elle Decor Japan*, Ryuko Kida. According to Sonja van der Hagen, former director of R&D at DEDON, the collaboration with Burks is special not just because of his close working relationship with the artisan workforce but also because of the effects this has on the products themselves. "The company has to be more flexible about the outcome," she says, "not designing 100% to a specific timeframe, market position, or price target." The *Kida* exemplifies this inventiveness, with DEDON's signature fiber repurposed for wrapping rather than weaving, establishing a tactile ribbing across the arcing form.[10]

10 Sonja van der Hagen, interview with the author, October 20, 2021. This passage also draws on an interview with Hector A. Mendoza, former product developer at DEDON, October 12, 2021.

Another Way

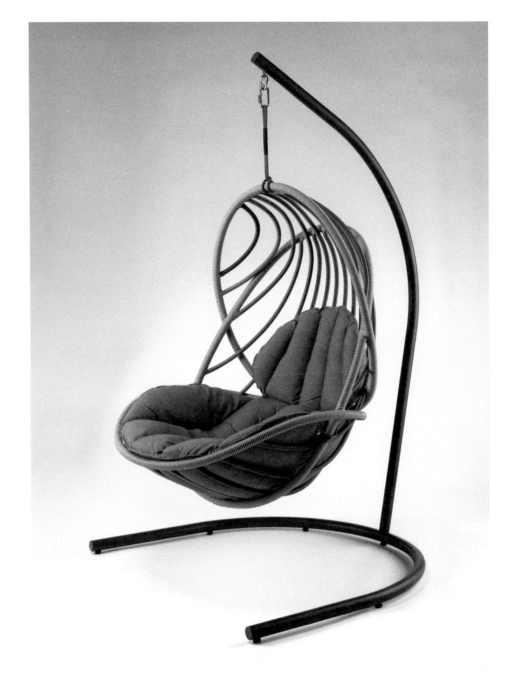

Plate 23. Stephen Burks, DEDON, *Kida* Swing, 2020.

Glenn Adamson

Fig. 5. Isamu Noguchi (American, 1904–1988), designer; *Akari* 8A, 9A, and 10A, and early versions of 30A and 45A, ca. 1950s, The Noguchi Museum Archives, 03580.

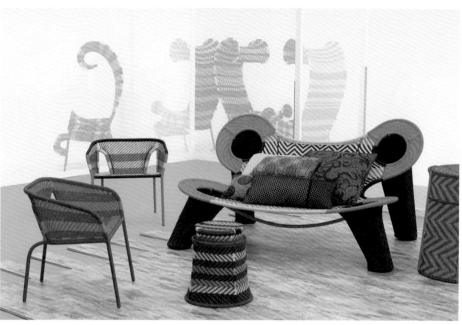

Fig. 8. *M'Afrique* Café Chairs and Table for Moroso.

Fig. 6. Charlotte Perriand (French, 1903–1999), designer; Les Ateliers Jean Prouvé, France, established 1931, manufacturer; Bookcase from the Maison du Mexique, Cité Universitaire de Paris, 1952, wood and enameled steel, Harvard Art Museums/ Fogg Museum, bequest of Grenville L. Winthrop, by exchange, 2001.142.

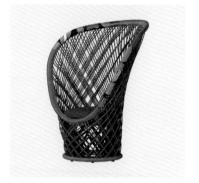

Fig. 7. Patricia Urquiola (Spanish, born 1961), designer; Driade, Italy, established 1968, manufacturer; *Pavo Real*, 2011, tubular aluminum and woven plastic.

Another Way

Burks's relationship with DEDON finds intriguing parallels in design history. Isamu Noguchi's iconic *Akari* lamps (fig. 5), made in *washi* paper and bamboo, originated with his invitation to collaborate with a workshop in Gifu, Japan, in 1951, to revive its fortunes. They are still in production today, "a primary example of what's possible," in Burks's view.[11] Charlotte Perriand, who also worked in Japan at midcentury, cultivated relationships with craftspeople throughout her long, globetrotting career in Vietnam (known in her day as Indochina), Brazil, and her native France (fig. 6).[12] More recently, the aforementioned Campana Brothers have drawn much of their imagery and technical resources from artisans in Brazil, while Patricia Urquiola has developed craft-intensive lines for such companies as B&B Italia (fig. 7).

Burks is unsurpassed, however, in the range and depth of his attempts to "bring the hand to industry," experimenting with many approaches in search of a transformative model. One such instance was his curation of a collection and exhibition called *M'Afrique* (2009) for Moroso. The company had an earlier success with Tord Boontje's Shadowy Chair, an adaptation of a Senegalese seating form with the striking addition of a high, curved back. When Patricia Moroso asked Burks to take the lead on amplifying this connection to Senegal, he initiated a wide-ranging project, designing his own products, acting as a production liaison for other designers while managing initial production in Senegal, and sourcing complementary artworks for the presentation. He even selected Dutch wax fabrics for upholstery (fig. 8) and exhibited Ghanaian architect David Adjaye's *African Cities* project for greater urban context. In 2012, he took on a similarly expansive role when he journeyed to Bogotá under the auspices of Artesanías de Colombia. There he worked with five groups of craftspeople specializing in cabinetmaking, weaving with wool and palm, and two distinctive local crafts: Tamo, an inlay made using tinted wheat chaff, and Barniz de Pasto, a varnish made from the resin of the mopa mopa tree.

These ventures saw Burks integrating curatorial and strategic aspects into his practice. Increasingly, he was embracing the "total package" approach that had seemed so unmanageable to him at an earlier stage of his career and was acknowledging design's role as cultural production. This meant navigating the whole development triangle, flexing and reshaping it, thinking through every aspect of each project with his partners—"not just how an object looks, but how we're going to package, sell, even talk about it." These efforts sometimes have an aspect of activism: during the pandemic, for example, he wrote an open letter to a number of international brands that currently lack diversity in their roster of designers, inviting them to

11 See, for example, Hayden Herrera, *Listening to Stone: The Art and Life of Isamu Noguchi* (New York: Macmillan, 2015).
12 See Glenn Adamson, "Charlotte Perriand's Handmade Modernism," in *Charlotte Perriand: The Modern Life*, ed. Justin McGuirk (London: Design Museum, 2021), 158–167.

Glenn Adamson

Plate 24. Stephen Burks, Bolon, *Floats* Textile (detail), 2017.

Another Way

begin dialogue.[13] Whenever possible, he seeks high-profile contexts for the work to elevate awareness: he has developed lighting, made with his partners in Senegal, for architects, brands, and private collectors alike; arranged for presentations of many of his projects at the Milan Furniture Fair; and generally serves as an eloquent translator between "majority world" craft and "minority world" media. Even when he's not acting in this capacity, his designs wear their hybridity as a badge of honor.

A good example of this impetus is the *Grasso* Lounge Chair (2018; plate 27) that he developed for BD Barcelona Design, a juxtaposition of supple, overstuffed leather upholstery and a skeletal steel frame. (It received an ADI-FAD award in 2020—Spain's highest honor for design, given annually by the country's Industrial Design Association and received by Burks as the first American to be honored in such a way.) BD has an unusual history and position, having been founded in 1972 as Ediciones de Diseño by a group of leading designers; the intention was to make a creative space, distinct from the usual imperatives of the furniture industry. The company still prizes this freedom and contracts production for specific projects rather than maintaining its own factory. In practice, this meant that Burks—in this instance, working with his assistant designer Júlia Esqué, who established herself in Barcelona for the duration of the project—did not work directly with artisans, instead responding to prototypes as they were prepared.

However, the *Grasso* Lounge Chair was also the basis for an unusual partnership between BD and the Swedish textile company Bolon, which specializes in woven vinyl floor coverings. As part of an experimental expansion of their activities, Bolon has undertaken a series of collaborations with individual designers, who have explored new applications of their weaving capabilities. Burks and Esqué traveled to Bolon's weaving facility and there developed a distinctive version of the *Grasso* with a wrap of space-dyed wool around the back, with weft floats—hand cut by Burks—hanging loose, communicating the idea of craft's uncontainable individuality. They worked not with hand weavers but with experts in digitally driven looms, allowing for an extremely rapid turnaround of samples. "We tend to forget they are artisans too," comments Klara Persson, product strategist at Bolon. "They work with huge machines, but they have the same touch with their hands" (plate 24).[14] This collaborative remix of the *Grasso* Lounge Chair exemplifies a key principle in Burks's design thinking, in that each iteration is slightly different. Handcraft is, after all, the original mass customization.

13 In 2019, a census conducted by the AIGA determined that, out of 9,429 professional designers surveyed, only three percent are Black, compared with thirteen percent of the overall population. Jenny Brewer, "How Much Designers Earn and Other Data from the AIGA Design Census 2019," September 23, 2019, It's Nice That, itsnicethat.com/news/design-census-2019-aiga-google-230919. The nonprofit advocacy organization Where Are the Black Designers? is currently working to "[decolonize] design through education and wellness resources, events, partnerships, and collaborations." "Where Are the Black Designers? 2021: Designing and Organizing for Black Liberation," womenidchi.com/events/2021/6/26/where-are-the-black-designers-2021-conference. See also Cheryl Miller, "Black Designers: Missing in Action," *Print Magazine*, September/October 1987, 58–65, 136, 138.

14 Klara Persson, interview with the author, October 21, 2021. This passage also draws on an interview with Júlia Esqué, October 20, 2021.

Glenn Adamson

Fig. 9. Impressions Ceramics Study, Student Fingerprints (detail), 2020, Berea College Student Craft, Berea, Kentucky.

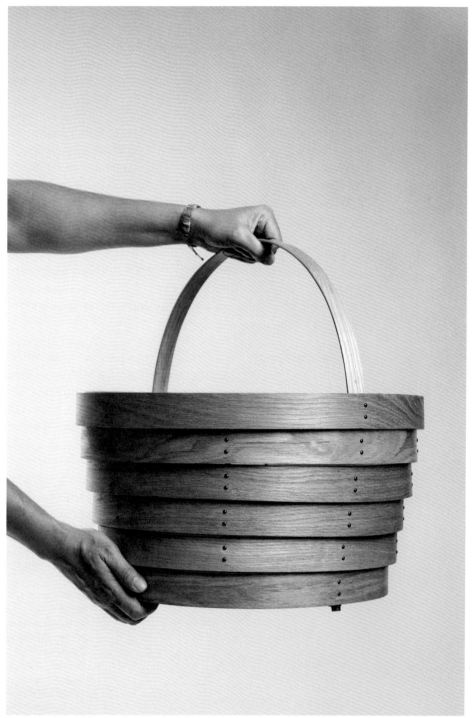

Plate 25. Stephen Burks, Berea College Student Craft, *Community Basket*, 2020.

Another Way

Wherever possible, Burks takes advantage of craft's potential to infuse objects with humanity, warmth, and variation. A recent project undertaken at Berea College in Kentucky afforded him an unusually broad exploration of this theme. Aptly titled *Crafting Diversity* (2018–ongoing), it comprises projects from across the college's student-staffed workshops, including textiles, ceramics, basketry, and broomcraft. Berea, nestled in the foothills of Appalachia, was founded way back in 1855 (so, before the Civil War) as a coeducational and interracial institution, aimed particularly at students in need. This inspiring early history took an ignominious turn with the rise of Jim Crow in the South. The college was forcibly segregated in 1904, and its craft program became an aesthetic expression of White identity politics, with close ties to the revivalism that prospered in the area over subsequent decades.

Today, Berea is once again among the most diverse colleges in America. Tuition is covered on a work-study basis, so students from disadvantaged backgrounds can attend, and while the school recruits many from the region—both Black and White—there is also a sizable group of students from the "majority world," including Africa and Latin America. All these young students commingle at the Berea College Student Craft program. When Aaron Beale arrived as the new head of the program a few years ago, he was struck by the disparity between the college's vibrant contemporaneity and the self-consciously traditional products being made at the workshops. This motivated him to invite Burks to collaborate on a new design collection. The goal was to create objects reflective of Berea today, not the Berea of a century ago.

Over the course of three years—and right through the pandemic—these ideas have found physical form. Participation has been a hallmark of the project from the outset; as Beale comments, "from the very start, Stephen had faith in our students' abilities to make meaningful contributions to the larger world by helping to develop and share their creative power."[15] That principle is reflected in the designs they have come up with, together with Berea College Student Craft's workshop leaders: the striped *Pixel* (2020; plates 2–3) textiles from the collection that vary in sequence and palette, based on individual choices made at the loom; *Community Baskets* (2020; plate 25) in oak, which take the student-maker through basic principles of wood construction; and a range of ceramics (ultimately not put into production) impressed with the students' fingerprints (fig. 9). Different degrees of complexity are designed into the products to accommodate varying skill level and time. The showstopper of the collection, fondly known as the *Broom Thing* (2020; plate 19), is a sun-like, radiant "ambient object," as Burks calls it, made of polychromatic bristles. Again, no two are alike; the design is an individualistic emblem for the Berea program and for the transformative potential of the hand.

At the time of writing, the *Crafting Diversity* collection was being put into distribution through Design Within Reach, with all proceeds benefiting Berea College. Burks is also working with Beale and the textile producer Maharam, who is providing leftover fabric cuttings that can be developed into a collection of quilts. Burks envisions an abstract typography that will allow students to create compositions encoded with their own personal messages. It all adds up to quite a story, evidence of Burks's increasing ability to mobilize latent creative potential.

Optimistic? To be sure. And this, too, is characteristic of Burks's approach to design, a necessary counterpart to his persistence and creativity. Even during the COVID-19 pandemic, when traveling to the workshops of the world was impossible, he found ways to improvise, manag-

15 Aaron Beale, email conversation with the author, September 21, 2021.

Glenn Adamson

ing to develop a series of mirrors in remnant pieces of natural stone, in collaboration with the Italian firm Salvatori. These animated designs, fittingly called *Friends* and *Neighbors* (2021; plate 18), were released to the market just as the lockdown was ending and people were able to be together again—a sort of welcome-back gesture to society at large. "I imagined all of the different faces from all around the world," Burks says, "and tried to bring them together." One could say that this has been his goal all along. Every chance he gets—most recently, as a Loeb Fellow at Harvard's Graduate School of Design, the first product designer ever to hold that position—he has pursued the combination of craft and industry, majority and minority worlds, into a single multidimensional fabric. "Hands have power," he says. "They can organize, build economies, and change culture." And this is the very definition of practice-led research in design.

Despite everything he has achieved, Burks says, "I don't feel like I have achieved the ultimate expression of these ideas." He's now asking himself whether he can't just redraw the development triangle but break out of its restrictive space entirely, perhaps with the aid of a smartphone. He dreams of starting a "hand factory," a dispersed network of artisans translating anyone's vision into designs sold directly to the consumer. It's an inherently exciting idea, informed by Burks's innovative orchestration of craft resources extending all the way back to *Patchwork*. Yet it also raises numerous new issues to consider: What would be the ideal platforms for distribution and visibility? How would quality control work? What would his role as a designer be? These questions point the way toward a dynamic future relation between craft and design, potentially far more elastic and efficacious than the single-studio model that currently prevails in the field's upper echelon. But in the many methodologies that Burks has devised, throughout his career—tactical displacements of craft and industry alike—he has already demonstrated that design innovation need not be top down after all: it can be side by side and hand in hand.

Another Way

Quiet Is the New Loud
Beatrice Galilee

Plate 26. Stephen Burks, The White Briefs, *A Free Man*
Unisex Loungewear Collection, 2013.

"Don't look in the branches for what only appears in the roots."
—Rumi

Quiet Is the New Loud

When I first met Stephen Burks sometime in the mid- to late 2000s, I was working for a magazine called *Icon*, the name of which pretty much sums up everything about the design industry at that time. It was a moment when the global cultural backdrop was all iMacs, injection-molded chairs, and starchitects building museums who did little to challenge the unquestionable dominance of a monocultural White, male, Western design-star system over the rest of the world. At the time, Burks was working at the highest levels of the industry: making it to the inner sanctum of the design world as the first African American to work with his European clients, all while advancing his own revolution, researching and innovating on vernacular craft traditions from across the planet.

Icon is still a word that sums up the design industry today, but Burks's pluralistic practice has played a role in changing its meaning. Since a seminal trip to South Africa in 2005 as a product development consultant for Aid to Artisans, Burks has made space for an exciting twenty-first-century design paradigm that places identity, craft, and communities at its center. Central to his ethos is a belief in the transformative power of design and its ability to uplift economies and transform livelihoods—a sensibility that is fast becoming the conversation about the future of contemporary design. Perhaps, finally, industrial designers are being assessed and understood for what their politics bring to the table, not just the table itself.

The entangled politics of the contemporary design world, from its materials to its sites of production and its channels of distribution, are aspects of the system that Burks's practice has critically engaged with. By strategically positioning himself between the axes of the Global North and South, he has posed provocative questions about what really constitutes design, where it is found, and whom it serves. Visiting and learning from other cultures were fundamental tenets of his practice, so at the onset of the pandemic in a world without travel, and often without company, he was left to consider the practice of design in his own home (see Burks essay).

For nearly two decades, Burks has collaborated with individual artisans and makers who have been crafting objects with extraordinary skill for generations but have not reached the scale of transformation afforded to their Western counterparts. Whether it is a lack of visibility or due to the structural racism that pervades much of society today, from physical infrastructure to access to education, Burks wants to know what it looks like to future-proof these crafts, to create visibility for skills and talent, and to extend the embodied wisdom of the hand into the future. This way of working serves as a model for a much-needed discourse on design that focuses directly on the problem's root rather than the bright berries on its branches.

It comes as no surprise to discover that the ecological impact of industrial design is multigenerational and rooted in colonial, extractive, and often illegal practices. Logging and forest fires in the Global South, for example, have provided materials such as leather and timber to the Global North since the eighteenth century. Indeed, many artists, authors, and filmmakers are focusing their efforts on making visible the impact of industrial production systems on nonhuman living beings. One of the reasons we have a climate crisis today is because we're shielded from the mess that is taking place in other parts of the Anthropocene. In November

Beatrice Galilee

Fig. 1. El Anatsui (Ghanaian, born 1944), *Taago*, 2006, aluminum and copper wire, High Museum of Art, Atlanta, purchase with funds from the Fred and Rita Richman Special Initiatives Endowment Fund for African Art and Joan N. Whitcomb, 2007.1.

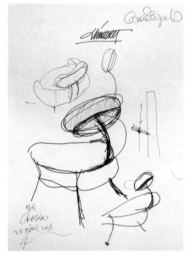

Fig. 2. Stephen Burks and Oscar Tusquets, *Grasso* sketch, 2018, pen on paper.

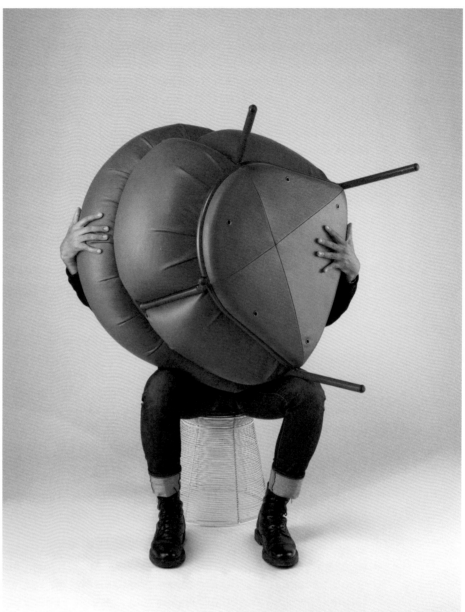

Plate 27. Stephen Burks, BD Barcelona Design, *Grasso* Lounge Chair, 2018.

Quiet Is the New Loud

2021, a news article showed an image of the Atacama Desert strewn with clothes manufactured in China and Bangladesh.[1] When the garments are not purchased, they are brought to Chile's Iquique port to be resold to other Latin American countries; more than half of this, some 39,000 tons, is moved into landfills in the desert every year.

It gives some insight that Burks embarked on his training as an architect, and perhaps more still that he left the discipline to take some control and authorship, to work at the scale of bodies, of matter, and of hands. Burks believes the transformative capacity of design is embodied in artists he admires, including Ghanaian artist El Anatsui (fig. 1). Working with discarded materials—bottle caps, copper wire, plastic—El Anatsui's artistic practice engages with skilled artisans to create extraordinary sculptures, magnificent tapestries of architecture. This intriguing point of comparison is emblematic of the immediacy of making that reinforces Burks's belief in the capacity of craft. Both artists use different calibrations of community and structure, literal and metaphorical, to inform and create space and objects that are fundamentally of a place, that are touched by the hand but no doubt belong to a global mainstream conversation.

Today, the next iteration of Stephen Burks Man Made's expansive vision is taking shape in the Brooklyn Navy Yard located on the edge of New York's East River Bay. Within this warehouse-like space, I walked between rows of industrial shelving threaded with bright white strip lights, stacked three rows high with prototypes, materials, samples, and commercial works. I saw ideas at various stages of development—from accessories, to furniture, to lighting. In this hybrid of exhibition and storage space, Burks invited me to sit in his award-winning *Grasso* Lounge Chair (fig. 2; plate 27) and swing freely in the skeletal organic form of *Kida*, a hanging lounge chair hand wrapped in multicolored extruded polyethylene cord (plate 23).

During the pandemic, with only the four or so walls of his own living space to reflect upon, Burks turned his home into a laboratory of thoughtful, often deeply personal inventions responding to domestic objects (see pages 78–97): an armature that invites TVs to become "creatures" or members of the household, hung with objects, memories, and personality. Another work is simply a totem, inspired by an African artifact, and explores the literal and spiritual distance that Burks and many African Americans feel from their ancestral home. This theme of collaboration and connection is explored in miniature platforms designed to be altars: spirit homes for those who have passed to be remembered in perpetuity in the domestic environment instead of an abstract grave.

Thinking deeply about issues that lie outside of the design brief, Burks is often doing more for his clients than simply considering the domestic environment. The *Traveler* armchair for Roche Bobois is a case study in applying international knowledge to the space around an industrial product, not just the product itself. The *Traveler* offers an oversized luxurious seat that creates its own space: it is an architectural space, a seat of power and privacy that alludes to faraway places through its woven canopy (figs. 3–4; plate 28). Burks picked up a tiny maquette made of sticks, showed it to me, and described its improvised structure: "Imagine a designer lost and stranded in the jungle," he said. "What would they make if they

1 "Chile's Desert Dumping Ground for Fast Fashion Leftovers," *Al Jazeera*, November 8, 2021, aljazeera.com/gallery/2021/11/8/chiles-desert-dumping-ground-for-fast-fashion-leftovers.

Beatrice Galilee

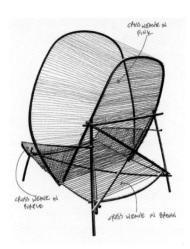

Fig. 3. Stephen Burks, *Traveler* sketch, 2013, pen on paper.

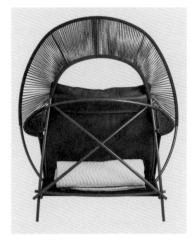

Fig. 4. Stephen Burks, Roche Bobois, back of *Traveler* Indoor Armchair with Hood, 2014.

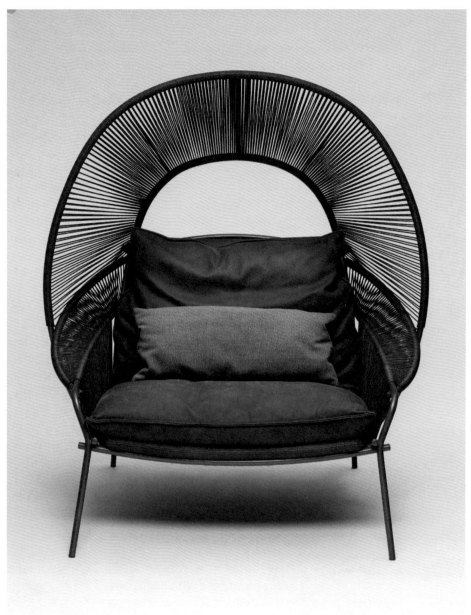

Plate 28. Stephen Burks, Roche Bobois, *Traveler* Indoor Armchair with Hood, 2014.

Quiet Is the New Loud

Plate 29. For Burks, this series transported him to a place where he was able to create the *Traveler*, imagining improvised connections and the idea of the designer in the wild. Thomas Struth, *Paradise 19*, 2002.

Beatrice Galilee

only had what they could find to make a chair?" Fittingly, Thomas Struth's *Paradise* series of photographs was the inspiration for the *Traveler*, showcasing Burks's ongoing connection to contemporary art as a constant source for broadening the discourse of design (plate 29).

Besides formal improvisation, consistent in Burks's practice throughout his work is an underlying interest in the beauty of a simple, legible structure. Perhaps Burks's modernist use of color, form, and pattern goes back to his education in Chicago, where he studied architecture and design in Mies van der Rohe's masterful Crown Hall at the Illinois Institute of Technology (see page 42, fig. 1), home of the Institute of Design or the New Bauhaus. In his Brooklyn studio, I found myself looking no further than his *Dala* outdoor seating and accessories collection for DEDON to understand this playful Bauhausian synthesis of craft and technology.

Since the breakout moment of his career in the early 2000s, Burks's path has been marked by his passion for foregrounding the roles of peoples and places in developing more inclusive, interesting, and original contemporary design through technology and craft. Here in the round forms of *Dala* seating made for informal gatherings, he explained the variation possible in the recycled extruded polyethylene weaving patterns, designed to give creative voice to the Filipino artisans producing thousands of pieces per year (plate 22). The result is not only stunning to look at and sit on; Burks received a patent with DEDON for the first outdoor furniture ever woven through expanded aluminum.

Suspended there in the cocoon-like comfort of the *Kida* Swing, it hit me: Burks and his studio, Stephen Burks Man Made, were quietly defining a new kind of practice, one that has consistently been speaking in a language that is slowly being heard rather than shouting for attention. His mantra was then and is now that design cannot be disconnected from culture and that, fortunately for us, culture is beautiful, communal, and global.

Quiet Is the New Loud

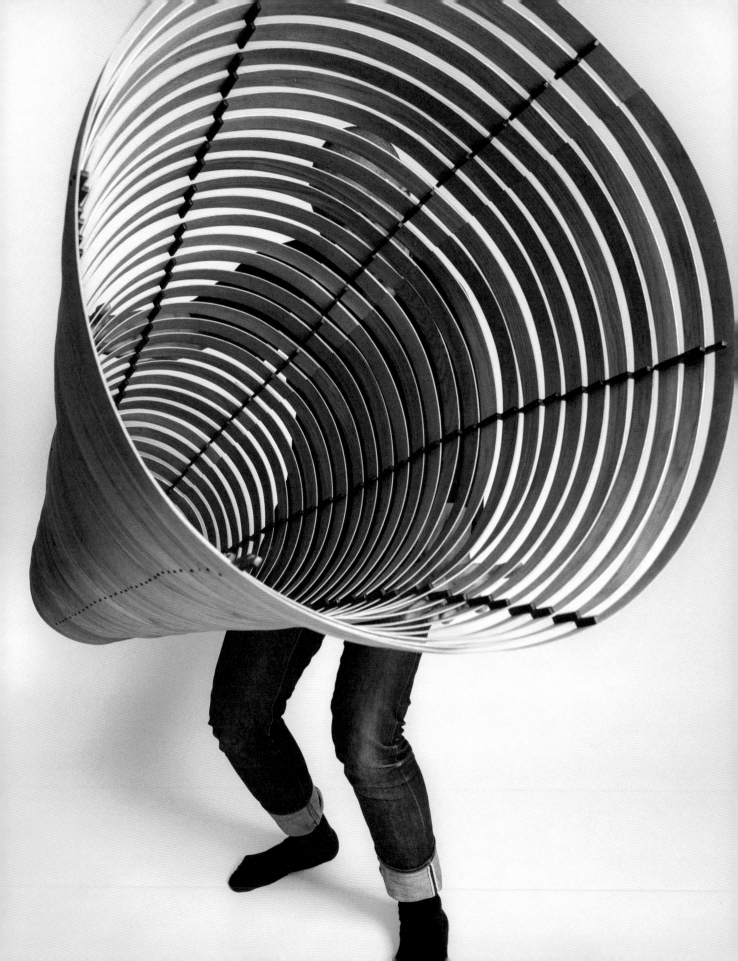

Critique and Complexity: In Conversation with Stephen Burks bell hooks

"Design can be both a beginning and an end."
—bell hooks

Critique and Complexity

Recorded over several days in August 2021 in Berea, Kentucky, this conversation between Stephen Burks and the late cultural critic bell hooks is the final published piece of work in her prolific career. While bell had taken a significant step back from the public sphere at this point in her life, her affinity for art, craft, and beautiful objects from all over the world created the space for this conversation while Stephen was consulting at Berea College, home of bell hooks and the bell hooks institute.

bell approached this conversation as a way of situating Stephen's perspective within the larger artistic and cultural context that she flowed freely in. With humor and curiosity, she shares her personal relationship to design, architecture, art, and place. Her genius was her ability to see the everyday world through the lens of critical inquiry, which she acknowledged was sorely lacking in the field of design today.

While we cannot help but confront the end of a brilliant life, perhaps we can seek comfort in the potential of beginnings and in design's ability to help us find more space within the ever-expanding field of cultural production.

Thank you, bell.

Fig. 1. Cover of bell hooks, *Art on My Mind: Visual Politics* (New York: The New Press, 1995).

Fig. 2. Cover of Kwame Anthony Appiah, *Cosmopolitanism: Ethics in a World of Strangers* (New York: W. W. Norton and Company, 2006).

Stephen Burks

I'm Stephen Burks. I'm here with bell hooks. It is *the* bell hooks. I'm blown away! You're just a woman like I'm just a man, right?

bell hooks

No, I'm a goddess!

SB

I'm certain of that!

bh

[laughs]

SB

So, bell, I've been reading *Art on My Mind* again, which I love. That whole chapter on "Beauty Laid Bare" is a revelation.

bh

The cover of the book (fig. 1) was my grandmother's house, and someone was smoking crack, and they caught the house on fire. I was thinking about that because, when the house was on fire, people called my mother to say, "The house of your childhood is burning." So, my mother went there, and she had very deep things to say about her sorrow—that at first, I didn't know what to do. My mother had such a sense of despair. It was all her childhood stuff.

SB

That's so sad and fascinating at the same time.

bh

I'm fascinated by the fact that Stephen hasn't gotten more attention. I'm raising the question of why that is. Why do you think, Stephen?

Critique and Complexity

SB

I wonder why design, in general, isn't a topic of cultural criticism. I'd like to ask, why hasn't design gotten more attention? To answer your question, twenty years ago, there were very few Americans working abroad, working in Europe, working in Italy, in the contemporary design context, and I was one of them. And as a Black man from Chicago, I was the first African American that many of my clients had ever encountered. I came across more ignorance than blatant racism, and stereotypes, of course. I remember once being described as tall like a basketball player or elegant like a jazz musician. I was even on German television once, and the presenter thought he saw me on the cover of a magazine, when in fact, it was Barack Obama. He went on to call me the Barack Obama of design!

bh

The Barack Obama of design!

SB

I quickly came to realize that they saw my identity before they saw my work. And that's part of what I think the conversation is, you know? How we, as African Americans working in cultural production, are seen first as Black and seen second as artists or architects or designers. There's always that conversation with race that has to be overcome before people can understand our work, and many people are uncomfortable with themselves for needing to have that conversation, which gets in the way of the art. That's been my experience.

bh

Have you tried to promote understanding through your work?

SB

Of course, but you know, in 2005, my work really shifted. I spent the first five years of my career, let's say, not seeing myself through my own identity. Then, at a certain point, that the mirror was turned back on me, which happened to coincide with me working on the continent for the first time in South Africa. I was forced to confront the power of this kind of singular position and wondered whether it could work for me or against me. I acknowledged that I could and would have a very different path than my European counterparts. If I was seen as different, then how could I use that to my advantage, and how could my work proudly speak for the language of this difference from my own point of view, not theirs? I'd clearly been given the opportunity to have my voice heard, through the medium of design, and I wanted to share that voice with other people around the world, in the "majority world," that I collaborated with along my travels. And so, my work quickly became about creating more space, opening doors, trying to take this kind of monoculture of European design and make it more pluralistic, more hybrid, which I think is the reality of the world. In learning from the artisan villages around the world, I became aware that design is a Western concept. Everyone is capable of design, regardless of Western education or access.

bh

What do you mean by that?

SB

I mean that the way we understand design, the way that design is taught in an academic sense, and the way that the "foundations" of design are defined from a European perspective with the designer as a tool for industry, mostly come from early twentieth-century movements like the

bell hooks

Bauhaus and the Wiener Werkstätte that are essentially European history and weren't considering any other context for creative production outside of industry at the time. While in other places in the world, people have been defining material and making useful things for centuries, often without European acknowledgment. So, we fast forward one hundred years, and we're still thinking about design as something that comes from Europe. I remember descriptions of "Euro styling" when I was a kid growing up. Products were described as being "Euro styled," as if that gave it some additional appeal.

But when I began working internationally, and when I began working in non-Western contexts in places like South Africa, or Senegal, or Rwanda, or you know, Ghana, Kenya, Indonesia, Colombia, Mexico, Philippines, and all over the world, it occurred to me that just like I believed everyone is capable of design, everyone was *already* designing. Design is, I believe, the translation of the raw material of the world into useful and meaningful objects through our imagination. It's not about an education; it's not about a particularly Western relationship to industry. Because there is this other kind of industry that I encountered that I later began describing as "hand factories." These were societies where collectives of people were working together with their hands, making things for their communities for generations without written records and passing that wisdom on through the vocabulary of crafting something together.

bh
You sure are cosmopolitan! Have you read Kwame Appiah's *Cosmopolitanism* (fig. 2)? What created for you this international sensibility, though, Stephen? Because you do have that with travel.

SB
I always felt that something about my identity was limiting. And maybe I've never talked about this before, bell, but being from the South Side of Chicago . . . you know, Chicago is a big city with a small-town feel. And it has such a racist history, as we all know. And being a young Black man from the South Side of Chicago, I always felt the limitations of that racial boundary, which was almost a dividing line in the sand in Chicago. There's a certain point where the neighborhood is all Black. And when you go beyond that, there's diversity downtown, but then the neighborhoods are all White. This segregation really felt limiting to me. So as soon as I was able, I wanted to leave. I studied undergrad there because I was fascinated by the Bauhaus and the modern movement. And I wanted to study at Crown Hall; I wanted to study at the New Bauhaus. But as soon as that was over, I was ready to go to New York, where I felt like I could be more a part of the world.

To be cosmopolitan was important to me at a very young age because I just felt limited by that small Chicago context. I've always resisted anyone trying to limit my freedom, trying to limit my freedom of expression or my freedom of identity, my freedom of place and space. So, when I got to Europe, and I began to see them looking at me, through that lens of, you know, Black man from Chicago, I—it was very liberating to go to places around the world and be able to work in design but in a totally different way. In a new way, right? In a way that was my own.

bh
But working in that way didn't provide the connections that you needed . . . to project, Stephen.

SB
Right. Right.

Critique and Complexity

bh

And I think that that's the location that you are in now, where you are now able to project yourself as artist, as thinker. Interestingly, many of the recent written pieces that have focused on you haven't actually focused on race. They focused on the whole question of creativity and form.

SB

And that's refreshing. But even a critique of form can be limiting. When I'm working on something, there are multiple ideas at work. It's not just about shaping something; it's also about trying to communicate how the thing is made. I believe in legibility, which I find is somehow easily reconciled through my work in craft. To be able to read the hand, or to understand the way something is made, I think, engages one's imagination and invites one into the object. I want to dispel the mystery of design somehow. Even though I'm working with all of these brands around the world and with various means of production and manufacturing, I'm interested in the way that we can communicate design's immediacy to people and tell the story of how a thing is made. And that's kind of my connection to craft.

But then I'm also interested in how identity shapes personal expression through form. What does the world look like when more than one type of culture is contributing to the built environment? There just still isn't enough diversity in design. What do we do about that? What can the products we make do or say about that? How do we bring that conversation to the forefront?

bh

Well, I think partially you do bring that conversation to the forefront by being who you are, uniquely "you." Because somebody like me, who didn't know of you, did not associate you with Chicago—with, you know, "Black boy from the wrong side of the tracks." But instead, I thought, "Who is this interesting man creatively?" And I think that this is one of the issues for you, is wanting people to look at who you are creatively, not, you know, your identity as a Black man.

SB

Absolutely. Every opportunity I get to design something is an opportunity for me to express who I am creatively. It's almost like starting from zero. I've never believed I had a particular "formal style." And I've never really been interested in that. But I have been interested in what each of the things I'm working on, each of the things I'm designing, has to say. And maybe collectively, right, they tell a story about who we are creatively.

bh

Well, so what is your place in the design world?

SB

What's been important to me is participation, to have been able to design *anything* and not be limited by the way people might see me or what I've designed previously.

bh

Well, I think, also, that part of what we all want to do is move away from either-or thinking, you know.

SB

Thank you for that. To have permission to be that free, to occupy a space that isn't completely binary—it isn't so either-or, but there's this multiplicity of approaches that can be taken where complexity is welcome.

bell hooks

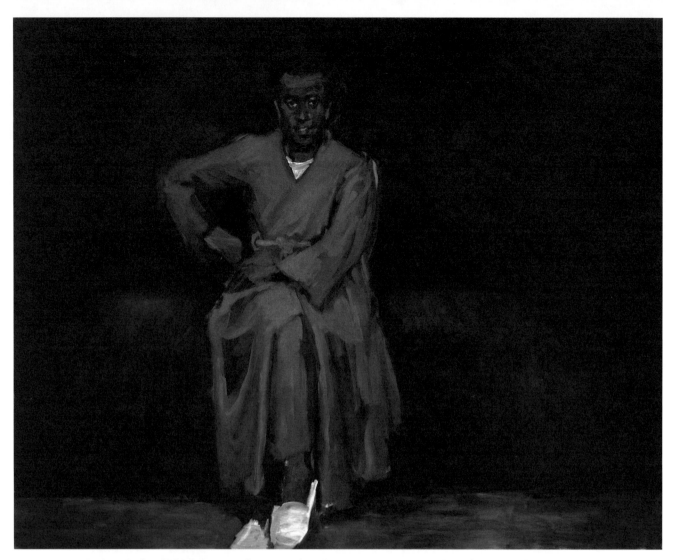

Fig. 3. Lynette Yiadom-Boakye (British, born 1977), *Any Number of Preoccupations*, 2010, oil on canvas, The Wedge Collection | Dr Kenneth Montague, London.

Critique and Complexity

bh

I think it's fascinating that this is a cultural moment where people are really talking about diversity, and part of what makes your work compelling is the diversity of the work. There's Stephen doing a chair. There's Stephen doing baskets. There's Stephen, you know, in the world. And I think that that wasn't always possible, without this larger framework of diversity, you know—that Stephen would always be pigeonholed as "the Black guy doing design," you know? And I think that, at this cultural moment, it's varieties of design.

SB

So, is that what you personally find interesting, bell, this broad range of things I've touched upon?

bh

Exactly. I mean, in a way, it's very similar to how I feel about my work. That part of what made my work unique was the broad range of interests—you know, that I could write about race, but I could also write about beauty, and that beauty could be perceived as an interesting theoretical space.

SB

Yes, and you could also write about love.

bh

Exactly.

SB

And I have to admit, it's interesting that you say that, because that's one of the things I love about your work: that I can pick up bell hooks on almost any subject, I mean, down to the children's book, and have a new window into your mind, right? That the way you see the world is so fascinating. And there's still this kind of arc that connects all of those projects. They're still all bell hooks. But there's that broad range of thinking.

bh

But there's also that difficulty within this sphere of critical work. I wanted to write a children's book that would rival *Goodnight Moon*. And the thing is, as a Black woman writing children's books, I haven't been able to break through that, to reach larger audiences and not just, you know, "oh, this is for Black kids." And I think one of the things that we have to constantly deal with is that while *Be Boy Buzz* uses a representation of Black maleness, it's not about Black maleness.

SB

Not only about Black maleness.

bh

Yes.

SB

Of course, it reminds me of the interview that I read with Lynette Yiadom-Boakye (fig. 3) where she was asked why she only paints Black figures, and her response was, "because that's who I want to paint." It's natural. No one asks a White painter why they only paint White people. There's definitely a double standard.

bh

Well, I think there is a connection between what we produce artistically and how it's marketed. I do think that Black work by Black artists is often not marketed in a larger framework, where, you know—it's like *Be Boy Buzz*; people say, well, that's, that's for Black boys. I was like, no, it uses the representation of Black boy masculinity, but it's really for all boys, about boys.

SB

So, when I did the Studio Museum project (figs. 4–5), it was a real breakthrough for me because my work was being recognized

Fig. 4. Cover of *Stephen Burks: Man Made* (New York: The Studio Museum in Harlem, 2011).

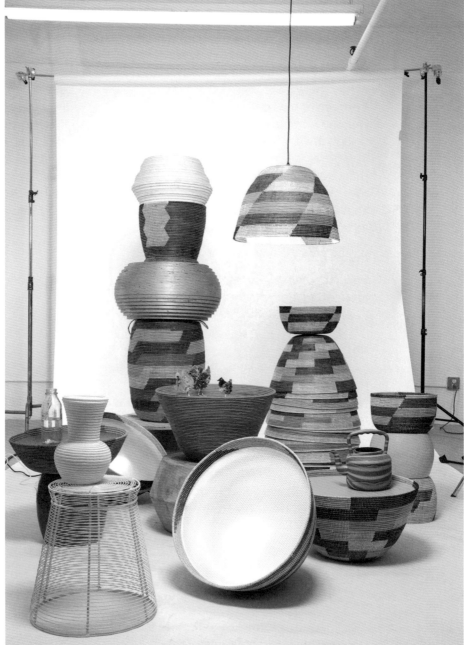

Fig. 5. Material composition studies for the Studio Museum in Harlem *Stephen Burks: Man Made* exhibition.

Critique and Complexity

not only for its kind of design statement but also for its connection to community, and a particular community, and then a particular way of making, so it brought together all of these factors that I'm interested in into one project. But following that, there was this sense that I only worked in Africa. It was as if all of the other work I'd done before didn't exist. And people only saw me as the guy that worked in baskets and the guy that worked in Africa. And so, I felt like I had to kind of resist that in order to do something completely different. Right? To show that, "No, I'm interested in and very capable of designing all these other things."

But I wonder, you know—it makes me ask the question, is there a design of Blackness? What does that look like—in the way that Lynette Yiadom-Boakye is confronted about paintings about Blackness, or you're confronted about books that are, quote, unquote, coming from that space? I'm also being confronted with the question of design for Blackness or design and aesthetics of Blackness. I struggle with that, because on the one hand, I want to give a voice to things that haven't had a voice; I want to give a voice to those topics that didn't have a voice. But on the other hand, I don't want to be stuck there or assumed to agree with those voices all the time.

bh
And that, I think, is why we have to embrace the whole issue of diversity. Because it's within that framework of diversity that we have a variety of movements that we can make, you know—that bell hooks can write a children's book, but then I can write a sophisticated critical essay that deals with race and representation. And that one thing does not cancel out the other. And one of the difficulties of working within our culture is there's always that canceling out.

SB
Right.

bh
You know, it's like we can have one exceptional success story, but only one . . . only one.

SB
As if more people all of a sudden don't exist. Other voices all of a sudden don't exist, because one has been accepted.

bh
Yes. Also, because, you know, we see clearly that any kind of voice that is questioning and challenging what we might call White aesthetics then gets—like, "what's your problem?," you know? You can see that this is where [Whiteness] is the center of it all.

SB
Well, what's interesting in design is that I've found in some cases just the opposite. There becomes a fascination with Afrocentrism or what could be perceived as Black aesthetics because it's trendy, because it has marketing value. So, I've been commissioned by companies that have literally asked me to make it look African or to apply a particular pattern language or color: "What about this, Stephen? Your work is known for color! Where's the color or the pattern?" There's that kind of expectation, which is clearly limiting, that must also be confronted.

bh
Well, should we say *racist* or *racialized*?

SB
Racialized.

Fig. 6. Cover of bell hooks, *Belonging: A Culture of Place* (New York: Routledge, 2009).

bh

I say *racialized* precisely because your work isn't racist. It isn't privileging: "Oh, I'm a Black man doing this creation." It's saying, "I create." And I think that we're so accustomed to everything going through that rubric of racism and similarly gender. I haven't written anything for a while because I got discouraged by all these years of my life working within a critique of patriarchy. And then, you know, kind of like the—what was it? I'm forgetting what it was called.

SB

The "Me Too" movement?

bh

Yeah, the "Me Too."

SB

The "Me Too" movement.

bh

It's like, to me, that was a flattening out. It was not an opening up.

SB

Rightly so, you were discouraged because after all of this work, all of these years writing about the subject and sharing and obviously, with so much acclaim and so many readers, that this kind of moment could happen where we weren't acknowledging decades of critical thinking.

bh

I think it's a kind of strange moment of erasure.

SB

That's why you say that you're taking a break, or you find yourself not writing, but that's why I'm so excited that you're interested in design. Because there's this whole other field that really needs your critical voice.

Critique and Complexity

Why do you think design doesn't reach that level of cultural criticism?

bh
Well, I think it's precisely because we've been raised in a culture that makes us feel that design has nothing to do with Blackness. And so, if you participate, you participate as an exception. You don't participate as if this is a natural playing out of culture.

SB
I feel like we're in this particular moment in time where we're seeing a changing, shifting way of looking at race. There's a real confrontation with Whiteness, which has been described as "unlearning Whiteness." Because of that, there are a lot of people thinking about what Blackness should look like.

bh
Or if, you know, the definitions don't connect to what is perceived to be "the standard." I mean, what are the standards of design? Does anyone ever ask if there's a White aesthetic?

SB
No, of course not. Because the canon is White. The canon is European. And this is what I mean by design is a Western concept. Even the idea of aesthetics is a Western concept, when, in fact, all cultures have a particular point of view with regard to how they see and express themselves visually.

bh
We're still struggling to pass through the doors that have been closed to us, and how do we get through those doors without carrying our identity with us like, "Oh, I'm doing this because I'm Black," not, "I'm doing this because I'm a creator"?

I think of myself when I started. And I didn't get affirmation for writing critical theory. I saw myself as kind of, you know, like a gazelle or, like, leaping. And I was willing to make these leaps. I mean, even in the piece about Blackness, an oppositional framework, those were things that required a leap because they didn't exist as part of the frame. Because the frame was White.

SB
In a way, we come back to challenging that frame and asking, "What does the design of Blackness look like?" What should it look like? Historically speaking, I think about the movement of Afrocentrism, where we were searching for an image for ourselves—to say that we believe in this, and this is what that looks like in a very stylistic way, from the afro to referencing African textiles in fashion, etc.

bh
I'm not into things like "Black aesthetics." What the fuck is that?

SB
Well, I mean, you talk about it in *Belonging* (fig. 6), right? Don't you?

bh
I don't remember talking about Black aesthetic.

SB
The essay's called an "Aesthetic of Blackness."

bh
Yes, "Strange and Oppositional."

SB
"Strange and Oppositional." Right. So, do you see that as different from a Black aesthetic and aesthetics of Blackness?

bh
Yeah.

bell hooks

SB

So, how do we talk about that differently?

bh

I mean, you're a good example of how we can talk about that differently, because I didn't know you existed.

SB

Right.

bh

You have had a profound impact on aesthetics, as a Black man in this culture, where so few Black men deal with issues of vision. Because I think people confuse being an artist with being into aesthetics. But not all art people have a vision, because to me, aesthetics are about a vision. When do we first learn about design?

SB

It's true. I didn't know design existed. I saw a designed environment, which was consistent. It had a very particular vision, let's say, that was outside of my everyday experience. But I never associated that with design until I was older. And when I did, I realized that that was a space I wanted to be in. And I liked the idea of somehow sculpting space. So, I knew about art, and I knew about sculpture, and I knew about architecture. But design was undefined.

bh

It's interesting. For me, design and art was the high school art teacher, the White man, Mr. Harrell. He always wore black. But the one thing that I learned to appreciate about him is that he taught these Black kids, but he didn't condescend to us, you know? He challenged us: "If you're going to design, design! If you're going to do art, do art." It makes me sad, because he said, "Design what you love." So, we all had to design

a house. And I decided that I wanted to design my house like flower petals. So, it was this quirky house. And it's—it's sad, because you don't keep things like that.

SB

It makes me think about the distinction that you make in *Belonging* between the way objects were perceived in your grandmother's house and the way objects are perceived in your mom's house, right? The difference between kind of appreciating a thing that's beautiful and having an understanding of it having a sense of life versus possessing a thing and having it feel dead. So, your grandmother's house was beauty, and your mother's house was possession?

bh

Yes.

SB

It didn't have life. Can you talk a little bit about that, like, what the difference was there?

bh

Well, I think, you know, I was thinking about you and me, and I'm thinking, a major difference in all of this was poverty, you know, and what does one make? What does one design out of poverty?

SB

Or how does one design their way out? I've always thought regardless of who you are, or where you're coming from, or the limitations of your life here, everyone dreams, so everyone can make something from nothing. Design isn't something that's specific to education or cultural background. Clearly design is people expressing themselves through useful physical form.

Critique and Complexity

bh

In my household growing up, art was not appreciated. Because people thought you've got to make a living. You can't make a living with these weird paintings you're doing, you know? It's sad because my family destroyed a lot of my paintings that I did in high school because they thought they were worthless.

SB

I can understand that. There's always that commercial pressure, right? For us to succeed financially, right? When people aren't thinking about, "Do what you love." People are thinking about, "Find a way to live."

bh

They aren't thinking about telling their children, "Express your gifts." My parents were no different, hammering that all the time: "You're not going to be able to make a living with this art."

SB

So, when did they think of your writing as art? Or *did* they think of your writing as art?

bh

I didn't write in high school, but I painted. And I wanted to be an architect. I wanted to design a house.

SB

Wow! Why did you want to design houses?

bh

I'm obsessed with little houses because I think about how our lives would be different, class-wise, if people weren't so obsessed with big houses. I think we've reached a stage of life where we don't want it. Because we see the role of colonialism. And, you know, and it's hard. It's like, my opting out; like, people kept saying,

you need to write about "Me Too." That's not how I work.

SB

That's sort of what I struggle with, with design. Objects that are opaque to me—that don't give me a way in, that I can't understand in terms of manufacturing, etc., that aren't really open to the imagination—aren't interesting to me. I'm interested in what we can design in our own homes. How can we change and design our own way of living? And could that be helpful for other people? And so, it's not just about how we create space but how we use that space.

bh

The need to create space *to* design.

SB

It goes back to belonging, right?

bh

Well, I was thinking about part of what travel gave to me was a sense of a larger scope of life. You know, if I'm sitting in North Africa, on a concrete floor with my brothers from Senegal and other places, we're all there. We're trying to learn Arabic.

SB

Oh, wow.

bh

Which, of course, the pitch of my voice.

SB

It's not happening. [laughs]

bh

But what I remember was that we made food with just like one pot, and then, you know, we ate that food with hands and sharing. And so, you think about what space allows . . .

SB

Yes, the understanding that there are other ways to live. That all of the limitations that we understand from our homelands aren't necessarily present in other places in the world. And there can be conditions that are comfortable being improvised. And we can be comfortable being somewhere temporarily, or we can even be completely portable.

bh

I was thinking about myself and how the first couch that I ever bought was the expression in my imagination of a different way of sitting. But I had no reference in my life for that.

SB

Because you've never encountered it.

bh

Right. I mean, I think about my obsession with design, with architecture, and a real recognition of wondering, "Where are all the other Black people that love design?" It's like, we can become a commodity, but we can't necessarily become a body of eyes that are seeing certain things. And I think because when you grow up around poverty—people had little shacks, but they decorated them. So, people would have a falling-down kind of shack, but it would be decorated. And there'd be flowers and there'd be, you know, a broken pot that you kept and did something with. And I was enchanted by that, you know? Then when I grew up and got a chance to go to the Caribbean, places where people really did take their shack seriously, you know, that just influenced me very much to think that beauty can be found in all kinds of places. Because I do think that here in the US, especially growing up, beauty was always

like a construct. Like you, you have to have the right class position to engage beauty. And it is interesting to think that, particularly as Black people in this society, we've always seen clothing as one space of beauty. You know?

SB

That makes me think about your writing about consumerism, that the poor had access through what they could buy and the kind of confusion that people made between, let's say, what was sold to them as beautiful from kind of an aspirational class and what was made by them. Right? So, in a lot of ways, clothing is more accessible because we can afford it—like sneakers, which have become obsessive symbols of design consumption.

bh

Never had a pair. But I have written about having too many choices. My grandmother believed that we had just too many things available to us. And so, this forced us into a state of confusion, right, almost as if we forgot that we can make things—or that we could value what we make.

SB

We can value what we make. And so, in a lot of ways, that's what craft means to me: that we can create value through objects with our hands. So, I believe that the more times the hand touches something, the more value it can bring to it, which is the opposite of how industry looks at hands getting involved, right?

bh

I think it is specific to poverty, to poverty.

Critique and Complexity

SB

That we take the opportunities where we can find them.

bh

Exactly. I think that definitely coming out of a working-class background as a female, Black female creative, wanting to create but not having a structure where people value creation by a female. I think we're still in that zone of Black female artists. I mean, look at design. Where are the Black females in design?

SB

There are so few.

bh

Well, I think that what's interesting to me about you and your work is its multiplicity. That you're not stopping, you know? You didn't stop at Africa. You didn't stop at baskets.

SB

I guess I'm searching, you know? I'm searching. The reason I haven't stopped is because I see myself as just one of many to come. It's less about a singular position that I'm holding and more about me trying to make more space for others to come. And so, I'm searching for—I want to have an influence, and all the ways that I can participate, and I want to participate in all the ways that are possible. So, you know, give me baskets to work on, I'm going to work on baskets; give me a chair to work on, I'm going to work on that chair; give me lighting, I'm going to work on lighting. But in each case, there's a certain number of concerns that I'm interested in, right? What is the vocabulary that I'm expressing? And what meaning does that vocabulary have? And how does that vocabulary create more space for others to come?

bh

Well, I mean, I've always been obsessed with cool—like, I wanted to be cool. But I didn't necessarily feel like I needed an audience for my coolness. Whereas, for my art, I felt like, "I gotta find a way to get some kind of audience for this art." I mean, even now, I get a little disgusted with myself. Because I make art in the basement of this house, but it never sees the light of day beyond the basement of this house.

SB

Why isn't your art seeing the light of day?

bh

I think it's good. I look at myself and I think, "I'm an intellectual who comes up with these really interesting essays and things," and I think it's part of capitalism, this idea that you have to do everything, you know?

SB

Well, I mean, I don't know; for me, it's about participating. So, not that you have to do everything, but if we—

bh

But you are doing everything, Stephen.

SB

How do you feel about that, bell?

bh

I mean, you're covering a lot of ground. And I think that, you know, that in some ways that to have an audience for your work, you have to cover that ground. Thank you. I know a lot, but I didn't know about you. And now I do.

bell hooks

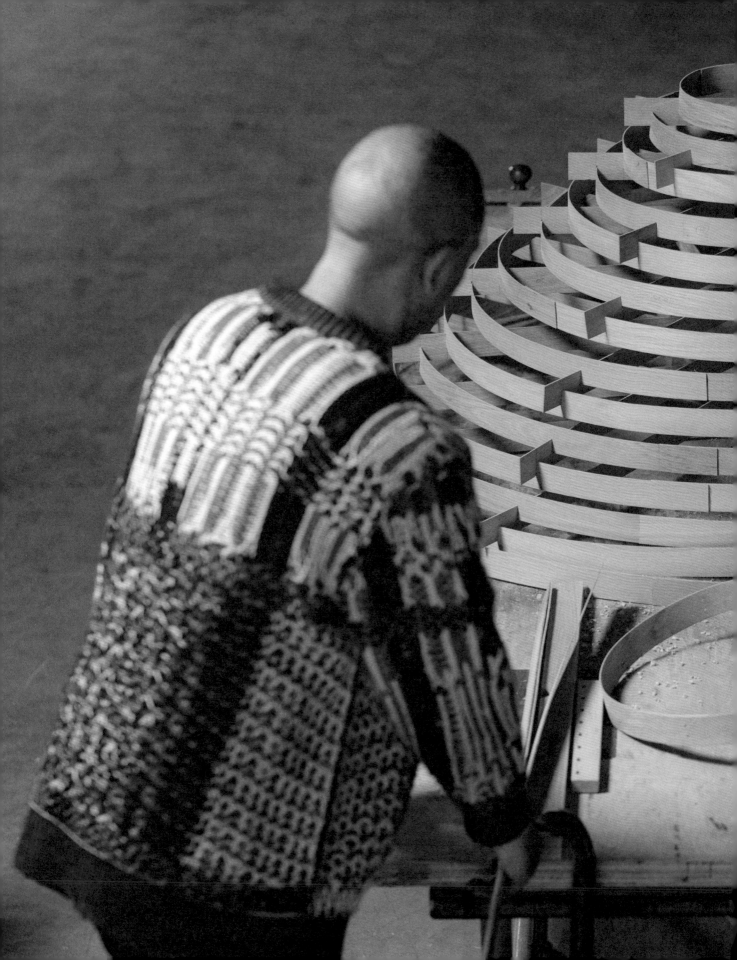

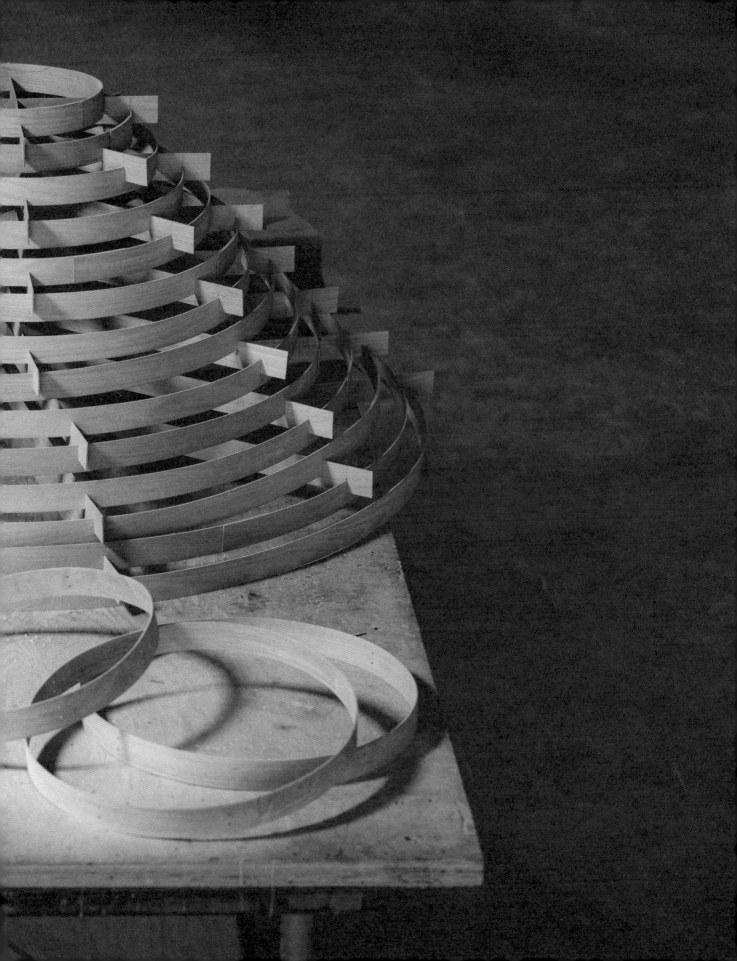

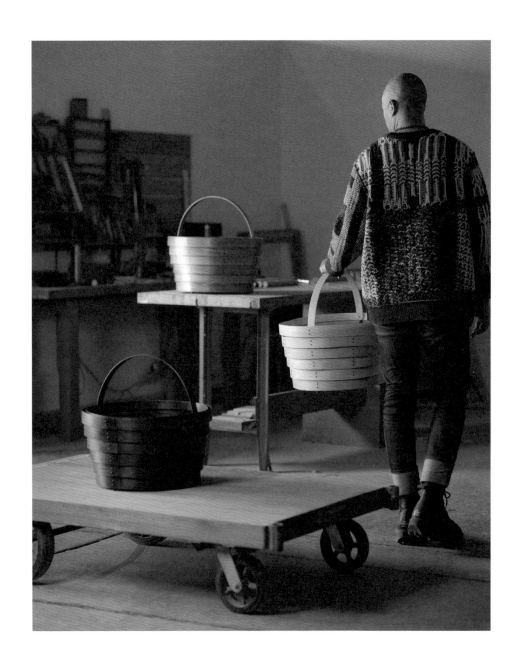

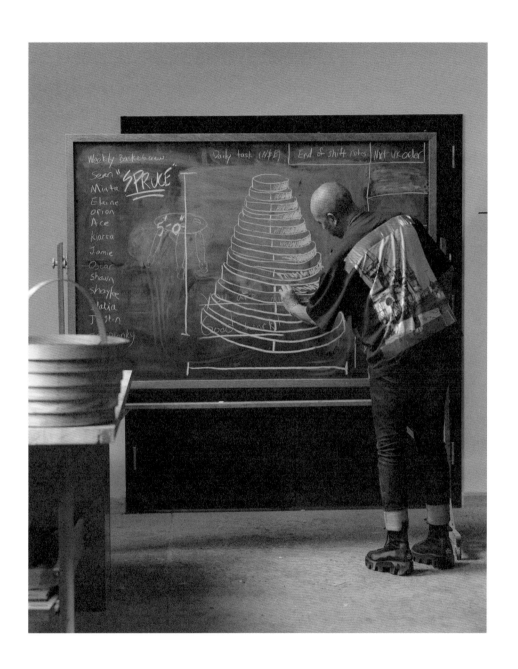

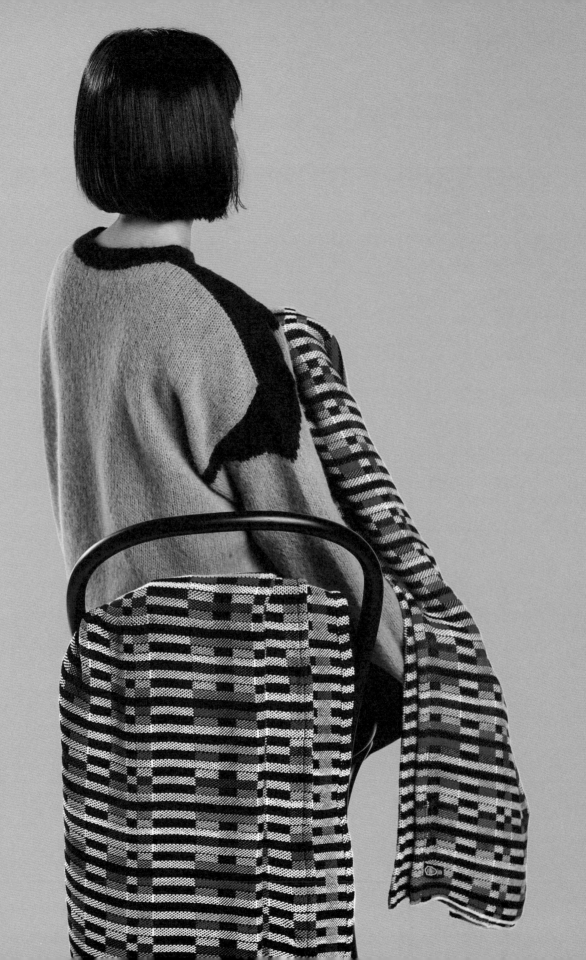

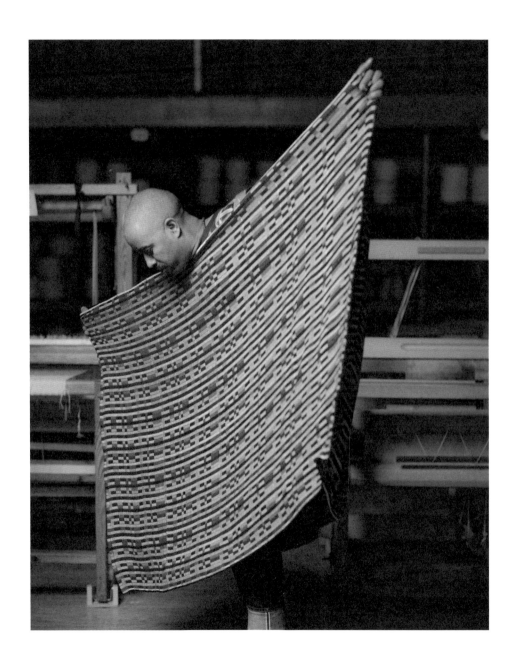

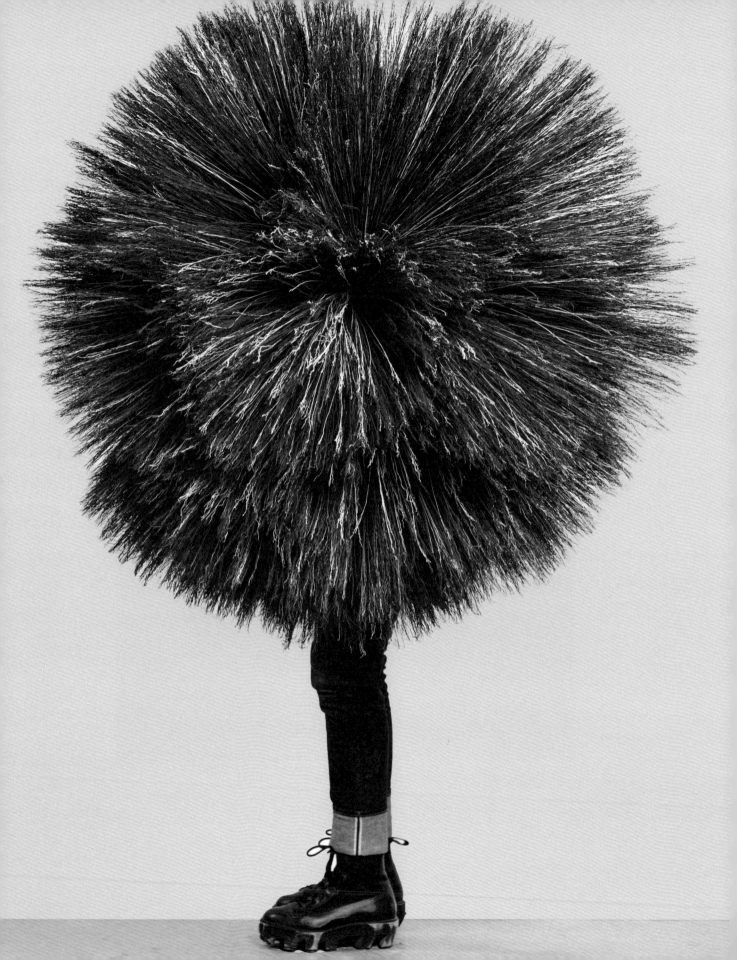

In Conversation photo essay
by Justin Skeens.

Photographed at Berea College Student Craft,
Berea, Kentucky, 2022.

Page 140: Stephen Burks, *The Spruce* (2021–2022,
Berea College Student Craft).

Pages 158–159: Stephen Burks, *The Spanner*
(2021, Berea College Student Craft).

Page 160: Stephen Burks, *Community Baskets*
(2020, Berea College Student Craft).

Page 161: Stephen Burks exploring *The Spruce* on
chalkboard with *Community Baskets* (at left).

Pages 162–163: Stephen Burks, *Pixel* Throws
(2020, Berea College Student Craft).

Page 164: Stephen Burks, *Broom Thing* Ambient
Object (2020, Berea College Student Craft).

Acknowledgments
Stephen Burks

A book is the documentation of a set of ideas at a particular moment. For me, it's the accumulation of several moments with many great collaborators over the past two years that has become the project *Shelter in Place*. It is impossible to think of those moments and not see the people most important to me sharing countless hours alongside me laughing at life's difficulties and thinking deeply about design's role in the new world we seem to be redefining daily.

I'd like to thank everyone on my team at Stephen Burks Man Made, past and present, who helped make our practice and this work what it is today, including Júlia Esqué and Vara Yang, my right and left hands over the years, and Katharina Plath, my outspoken advocate and big sister in design. I'd especially like to thank Malika Leiper for being by my side during the pandemic. *Shelter in Place* was born of all our ideas big and small, some smart, some silly, but all accepted with compassion, inspiration, and depth together.

Of course, those thoughts were culled into cohesion through tireless dialogue with curator and oftentimes friendly ear, Monica Obniski. Monica, your balance, wisdom, and vision have helped give shape to the future of my practice. Thanks to you and all the professionals at the High Museum of Art for such a beautiful presentation of my work both in the galleries and in this book.

I'd also like to thank our contributing authors for making this design catalogue a book worth reading, including Glenn Adamson for his exacting scholarship, Beatrice Galilee for her long-standing friendship, Patricia Urquiola for her brilliance, Michelle Wilkinson for her clear insight, and the late bell hooks for her big personality and immensely influential body of work that brought us into close conversation.

A special thanks to the fantastic creatives who helped translate what we do so beautifully, including photographers Joe Coscia, Justin Skeens, and Caroline Tompkins, and graphic designers Renata Graw and Lucas Reif at the Normal studio.

A sincere thank you to our extended family of clients, colleagues, and friends without whose broad support none of this would have been possible: Jordi Arnau, Aaron Beale, Marc Benda, Carola Bestetti, Bobby Dekeyser, Annica and Marie Eklund, Caterina and Raffaele Fabrizio, Sonja van der Hagen, Hector Mendoza, Eileen Norton, Jan-Willem Poels, Roman Riera, Lisa Roberts, Nicolas Roche, Johan Schwind, Peter Simonsson, and Alfredo Valero.

Lastly, this book is dedicated to Mr. Anwar Burks—because it all matters.

Contributors

Glenn Adamson is a curator, writer, and historian based in New York. He was previously director of the Museum of Arts and Design; head of research at the V&A; and curator at the Chipstone Foundation in Milwaukee. His publications include *Thinking through Craft* (Bloomsbury, 2007); *The Craft Reader* (Berg, 2010); *Postmodernism: Style and Subversion, 1970–1990* (exhibition catalogue with coeditor/cocurator Jane Pavitt; V&A, 2011); *The Invention of Craft* (Bloomsbury, 2013); *Art in the Making* (with Julia Bryan-Wilson; Thames and Hudson, 2016); *Fewer, Better Things: The Hidden Wisdom of Objects* (Bloomsbury, 2018); *Objects: USA 2020* (Monacelli Press, 2020); and *Craft: An American History* (Bloomsbury, 2021).

Stephen Burks is an American industrial designer who believes in a pluralistic vision of design that is inclusive of all cultural perspectives. His studio, Stephen Burks Man Made, has been commissioned by many of the world's leading design-driven brands to develop collections that engage hand production as a strategy for innovation. He studied architecture at Columbia Graduate School of Architecture, Planning and Preservation (GSAPP) and the Illinois Institute of Technology (IIT), where he also studied product design. He is a recipient of several awards, including the Smithsonian Cooper Hewitt National Design Award in Product Design (as the only African American to win this). In 2019, he became the first Harvard Loeb Fellow from the discipline of product design and is adjunct assistant professor of architecture at GSAPP.

Beatrice Galilee is a London-born curator, writer, and cultural adviser who is internationally recognized for her expertise in global contemporary architecture and design. She is the author of *Radical Architecture of the Future* (Phaidon, 2021). She served as cocurator of the 2009 Shenzhen and Hong Kong Bi-City Biennale of Architecture and Urbanism; cocurator of the 2011 Gwangju Design Biennale; chief curator of the 2013 Lisbon Architecture Triennale; and from 2014 to 2019, the first curator of contemporary architecture and design at The Metropolitan Museum of Art. Between 2010 and 2012, she launched and codirected The Gopher Hole, an experimental exhibition and project space in London. Currently living in New York, she is cofounder and executive director of The World Around, a new platform for contemporary design and architecture in residence at the Guggenheim Museum. She is also a visiting associate professor at Pratt Institute, where she lectures on curating.

bell hooks was Distinguished Professor in Residence in Appalachian Studies at Berea College. Born Gloria Jean Watkins in Hopkinsville, Kentucky, she chose the lowercase pen name bell hooks, based on the names of her mother and grandmother, to emphasize the importance of the substance of her writing as opposed to who she is. A writer and critic, hooks is the author of more than thirty books, many of which focus on issues of social class, race, and gender. Among her many books are *Ain't I a Woman?: Black Women and Feminism* (South End Press, 1981), *Breaking Bread: Insurgent Black Intellectual Life* (with Cornel West; South End Press, 1991), *Happy to Be Nappy* (Little, Brown, 1999), *Bone Black: Memories of Girlhood* (Henry Holt, 1996), and *Art on My Mind: Visual Politics* (The New Press, 1995).

Monica Obniski is the Curator of Decorative Arts and Design at the High Museum of Art, where she is responsible for collecting, exhibiting, and programming a global collection of design, which includes a yearly architectural piazza commission. Her curatorial practice engages social issues and is rooted in architecture and design history. Obniski's most recent projects include *Scandinavian Design and the United States, 1890–1980*, *Currents 38: Christy Matson*, and *Serious Play: Design in Midcentury America*. She has held curatorial posts at the Milwaukee Art Museum, the Art Institute of Chicago, and the Metropolitan Museum of Art. She received a master's from the Bard Graduate Center and a doctorate from the University of Illinois at Chicago.

Patricia Urquiola is a Spanish-born designer who trained as an architect in Madrid and later graduated from Polytechnic University of Milan, where she studied with influential lighting designer Achille Castiglioni. Since opening a studio in 2001, she has collaborated with Alessi, B&B Italia, Flos, Haworth, Kartell, and Moroso. In 2015, she was appointed art director of the iconic Italian company Cassina. She has received numerous accolades and awards, including Spain's Order of Isabella the Catholic and the Gold Medal of Merit in Fine Arts.

Michelle Joan Wilkinson, PhD, is a curator at the Smithsonian Institution National Museum of African American History and Culture (NMAAHC), where she is working to expand the museum's collections in design and architecture. In 2018, she served as lead organizer of the museum's three-day symposium, "Shifting the Landscape: Black Architects and Planners, 1968 to Now." In 2019–2020, she was a Loeb Fellow at Harvard Graduate School of Design. She holds a PhD from Emory University and a BA from Bryn Mawr College.

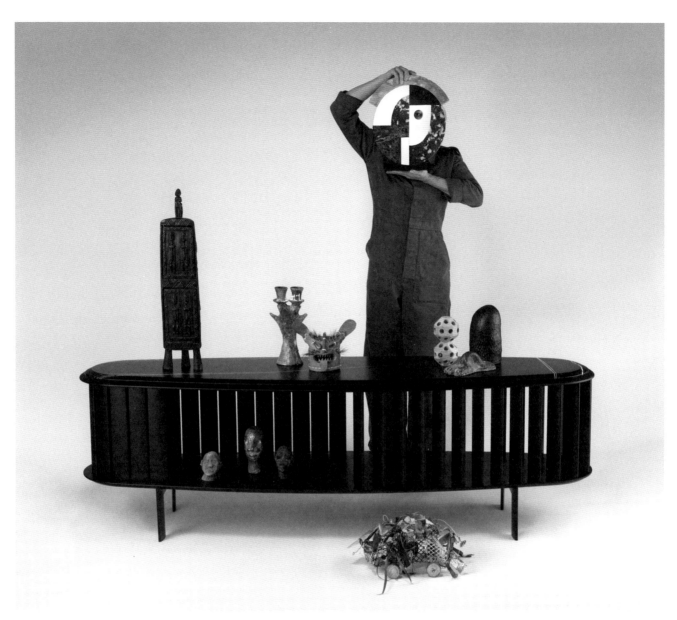

Plate 31. Stephen Burks, Living Divani, *Islands* Large Cabinet, 2019, and Stephen Burks, Salvatori, *Friends* Table Mirror, 2021 (with personal artifacts from designer's collection).

Exhibition Checklist

The most accurate information for the makers and objects (with design dates) known at the time of publication is provided below.

Stephen Burks (American, born 1969), designer
Stephen Burks Man Made, New York, established 1997, maker
Artecnica, California, established 2002, manufacturer
TaTu Stool, 2007
Steel wire
16 × 12 inches
Collection of the designer
Plate 21

Stephen Burks (American, born 1969), designer
Cappellini, Italy, established 1946, manufacturer
Cappellini Love Bowl, 2008
Recycled glass and silicone
8 × 14 inches
Collection of Lisa S. Roberts
Plate 10

Stephen Burks (American, born 1969), designer
Stephen Burks Man Made, New York, established 1997, maker
Horizon Shelving, 2008
Made for Tod's window display
Plastic composite and laminate
30 × 36 × 12 inches (1)
60 × 72 × 12 inches (2)
Collection of the designer
Page 33

Stephen Burks (American, born 1969), designer and maker
Missoni, Italy, established 1953, maker
Missoni Patchwork Vases, 2004
Missoni fabric and glass
21 × 12 inches each
Private collection
Plate 20

Stephen Burks (American, born 1969), designer
Stephen Burks Man Made, New York, established 1997, maker
Artecnica, California, established 2002, manufacturer
Man Made *TaTu* Stool (material composition), 2009
Steel wire and rope
16 × 12 inches
Collection of the designer
Page 24

Stephen Burks (American, born 1969), designer
Modus, United Kingdom, established 2000, manufacturer
Parallel Shelving, 2010
Oak veneer-laminated medium-density fiberboard and plywood
72 × 95 × 17 inches
Collection of the designer
Pages 24–25

Stephen Burks (American, born 1969), designer
Dedar Milano, Italy, established 1976, manufacturer
Stool: Dedar Roping, designed 2011, made 2017
Rope, polyurethane coating; assembled sections of woven polyester, rayon, polyacrylonitrile, and linen ribbon; brade and fringe assembled and stitched together; plastic (zipper)
23 ⅝ × 12 ³⁄₁₆ inches
Cooper Hewitt, Smithsonian Design Museum, Smithsonian Institution, gift of Dedar SpA
Plate 9

Stephen Burks (American, born 1969), designer
Mogollon Studio (Francisco Lopez and Monica Brand), designers
Daniel Håkansson, photographer
A Combination of Two or More Things, 2011
The Hybrid Project
Digitally printed poster
22 × 18 inches
Collection of the designer

Stephen Burks (American, born 1969), designer
Mogollon Studio (Francisco Lopez and Monica Brand), designers
Daniel Håkansson, photographer
Are You a Hybrid?, 2011
The Hybrid Project
Digitally printed poster
22 × 18 inches
Collection of the designer

Stephen Burks (American, born 1969), designer
Mogollon Studio (Francisco Lopez and Monica Brand), designers
Daniel Håkansson, photographer
Are You a Hybrid: Is There a Mongrel in Your Studio?, 2011
The Hybrid Project
Digitally printed poster
22 × 18 inches
Collection of the designer

Stephen Burks (American, born 1969), designer
Mogollon Studio (Francisco Lopez and Monica Brand), designers
Daniel Håkansson, photographer
Hey Half Breed What You Looking At?, 2011
The Hybrid Project
Digitally printed poster
22 × 18 inches
Collection of the designer

Stephen Burks (American, born 1969), designer
Mogollon Studio (Francisco Lopez and Monica Brand), designers
Daniel Håkansson, photographer
Offspring of a Tame Sow and a Wild Boar, 2011
The Hybrid Project
Digitally printed poster
22 × 18 inches
Collection of the designer

Stephen Burks (American, born 1969), designer
Mogollon Studio (Francisco Lopez and Monica Brand), designers
Daniel Håkansson, photographer
Of Uncertain Origin, 2011
The Hybrid Project
Digitally printed poster
22 × 18 inches
Collection of the designer

Stephen Burks (American, born 1969), designer
Mogollon Studio (Francisco Lopez and Monica Brand), designers
Daniel Håkansson, photographer
Characteristically Combined, 2011
The Hybrid Project
Digitally printed poster
22 × 18 inches
Collection of the designer

Stephen Burks (American, born 1969), designer
Mogollon Studio (Francisco Lopez and Monica Brand), designers
Daniel Håkansson, photographer
That's Different, 2011
The Hybrid Project
Digitally printed poster
22 × 18 inches
Collection of the designer

Stephen Burks (American, born 1969), designer
DEDON, Germany, established 1990, manufacturer
Dala Lounge Chair, 2012
Fiber (high-density polyethylene) and aluminum
30 11/16 × 37 13/16 × 38 3/16 inches
Courtesy of DEDON
Plate 22

Stephen Burks (American, born 1969), designer
DEDON, Germany, established 1990, manufacturer
Dala Stool, 2012
Powder-coated aluminum, high-density polyethylene, and recycled food and drink packaging
17 1/4 × 23 1/2 inches
Philadelphia Museum of Art, purchased with funds contributed by Collab: The Group for Modern and Contemporary Design at the Philadelphia Museum of Art, 2016
Plate 8

Stephen Burks (American, born 1969), designer
The White Briefs, Sweden, established 2009, manufacturer
A Free Man Unisex Loungewear Collection, 2013
Cotton
Various dimensions
Courtesy of The White Briefs
Plate 26

Stephen Burks (American, born 1969), designer
Calligaris, Italy, established 1923, manufacturer
Variations Chair, 2013
Polyethylene and elastic cord
30 × 20 × 18 inches
Collection of the designer

Stephen Burks (American, born 1969), designer
DEDON, Germany, established 1990, manufacturer
Ahnda High-Back Wing Chair prototype, 2014
Aluminum and polyethylene fiber
42 1/2 × 36 1/2 × 40 inches
Courtesy of DEDON

Stephen Burks (American, born 1969), designer
Stephen Burks Man Made, New York, established 1997, maker
Parachilna, Spain, established 2014, manufacturer
Anwar x Cork Stool (material composition), 2014
Composed of Parachilna's *Anwar* and Vitra's Jasper Morrison-designed *Cork Family* (model A)
Copper, cork, and rope
34 × 24 inches
Collection of the designer

Stephen Burks (American, born 1969), designer
Stephen Burks Man Made, New York, established 1997, maker
Black Triple Basket Lamp (material composition), 2014
Composed of Senegalese baskets and Artek's Alvar Aalto-designed stool (60)
Basket, bulb, birch, and rubber
36 × 36 × 36 inches
Collection of the designer

Stephen Burks (American, born 1969), designer
Stephen Burks Man Made, New York, established 1997, maker
Confetti Bowl, 2014
Silicone
6 1/2 × 15 inches
Philadelphia Museum of Art, purchased with funds contributed by Collab: The Group for Modern and Contemporary Design at the Philadelphia Museum of Art, 2016
Plate 11

Stephen Burks (American, born 1969), designer
Stephen Burks Man Made, New York, established 1997, maker
Confetti Vase, 2014
Silicone and confetti
15 × 4 inches
Collection of the designer

Stephen Burks (American, born 1969), designer
DEDON, Germany, established 1990, manufacturer
Dala Planters L and M, 2014
Aluminum and polyethylene fiber
32 1/2 × 30 inches (L)
24 3/4 × 24 inches (M)
Courtesy of DEDON
Plate 6

Stephen Burks (American, born 1969), designer
Roche Bobois, France, established 1960, manufacturer
Traveler Indoor Armchair with Hood, 2014
Epoxy-lacquered steel, leather cords, leather upholstery, and plume-feather fill
59 1/16 × 51 3/16 × 49 5/8 inches
Philadelphia Museum of Art, gift of Roche Bobois, 2016
Plate 28

Stephen Burks (American, born 1969), designer
Parachilna, Spain, established 2014, manufacturer
Anwar Lamp, 2015
Copper and steel
19 11/16 × 23 1/2 inches
Collection of the designer
Page 36

Stephen Burks (American,
born 1969), designer
Parachilna, Spain, established
2014, manufacturer
Anwar Lamp, 2015
Brass, graphite, and steel
50 × 35½ inches
High Museum of Art, Atlanta

Stephen Burks (American,
born 1969), designer
Parachilna, Spain, established
2014, manufacturer
Babel T GR, 2016
Lacquered aluminum and LED
57⅛ inches diameter
High Museum of Art, Atlanta
Plate 4

Stephen Burks (American,
born 1969), designer
Mogollon Studio (Francisco Lopez
and Monica Brand), designers
One for Hundred, Austria,
established 2015, maker
Triadic Totems, 2016
Lacquered oak wood
Collection of the designer

Stephen Burks (American,
born 1969), designer
Bolon, Sweden, established
1949, manufacturer
Floats Texile, 2017
Vinyl and wood
6½ × 6½ inches
Courtesy of Bolon
Plate 24

Stephen Burks (American,
born 1969), designer
Stephen Burks Man Made, New
York, established 1997, maker
Dining Chair, 2017
Irregular Weaving project,
from A/D/O residency
Metal and polyethylene fiber
34 × 24 × 22 inches
Collection of the designer
Plate 5

Stephen Burks (American,
born 1969), designer
Stephen Burks Man Made, New
York, established 1997, maker
Irregular Weaving Workshop
Study, 2017
Irregular Weaving project,
from A/D/O residency
DEDON fiber
35 × 23 inches
Collection of the designer

Stephen Burks (American,
born 1969), designer
Stephen Burks Man Made, New
York, established 1997, maker
Hardoy Chair, 2017
Irregular Weaving project, from
A/D/O residency
Steel tubing and polyethylene fiber
35½ × 32½ inches
Collection of the designer

Stephen Burks (American,
born 1969), designer
DEDON, Germany, established
1990, manufacturer
The Others (Lanterns S, M, and
Statue Lika), 2017
Aluminum, polyethylene fiber,
marble, acrylic, and LED solar panels
23¼ × 17¾ × 17¾ inches (S)
29¼ × 17¾ × 17¾ inches (M)
49½ × 17¾ × 17¾ inches (Statue Lika)
High Museum of Art, Atlanta,
gift of DEDON
Plate 17

Stephen Burks (American,
born 1969), designer
BD Barcelona Design, Spain,
established 1972, manufacturer
Grasso Lounge Chair and
Ottoman, 2018
Leather, steel, and urethane foam
Chair: 29½ × 34½ × 32 inches
Ottoman: 15¾ × 29½ × 13¾ inches
Courtesy of Design Within Reach
Plate 27

Stephen Burks (American,
born 1969), designer
BD Barcelona Design, Spain,
established 1972, manufacturer
Grasso Vases, 2018
Glazed ceramic
12 × 11 inches and 24 × 11 inches
Courtesy of BD Barcelona Design
Plate 7

Stephen Burks (American,
born 1969), designer
Luceplan, Italy, established
1979, manufacturer
Trypta, 2018
Acoustic fiber, aluminum,
3D knitted fabric, and LED
27½ inches diameter
Courtesy of Luceplan

Stephen Burks (American,
born 1969), designer
Living Divani, Italy, established
1965, manufacturer
Islands Large Cabinet, 2019
Aluminum, marble, and wood
24 × 78 × 22 inches
Courtesy of Living Divani
Plate 31

Stephen Burks (American,
born 1969), designer
DEDON, Germany, established
1990, manufacturer
Kida Swing, 2020
Fiber (high-density polyethylene)
and aluminum
47 × 39 × 41 inches
High Museum of Art, Atlanta,
gift of DEDON
Plate 23

Stephen Burks (American,
born 1969), designer
Berea College Student Craft,
Berea College, Kentucky, established
1855, maker
Broom Thing Ambient Object, 2020
Dyed broomcorn and
sugar maple wood
4 feet diameter
High Museum of Art, Atlanta, gift of
Berea College Student Craft
Plate 19

Stephen Burks (American,
born 1969), designer
Berea College Student Craft,
Berea College, Kentucky, established
1855, maker
Community Baskets, 2020
Oak and aluminum
11 inches diameter (each)
Courtesy of Berea College
Student Craft
Plate 25

Stephen Burks (American, born 1969), designer
Berea College Student Craft, Berea College, Kentucky, established 1855, maker
Impressions Vase, 2020
Ceramic
12 × 6 inches
Collection of the designer
Page 27

Stephen Burks (American, born 1969), designer
Berea College Student Craft, Berea College, Kentucky, established 1855, maker
Pixel Table Placemats, 2020
Cotton
20 × 14 inches (each)
Courtesy of Berea College Student Craft
Plate 3

Stephen Burks (American, born 1969), designer
Berea College Student Craft, Berea College, Kentucky, established 1855, maker
Pixel Throws, 2020
Bamboo yarn
61 × 40 inches (each)
Courtesy of Berea College Student Craft
Plate 2

Stephen Burks (American, born 1969), designer
Stephen Burks Man Made, New York, established 1997, maker
Going Nowhere rendering, 2020
Shelter in Place project
Paper
8½ × 11 inches
Collection of the designer
Plate 1

Stephen Burks (American, born 1969), designer
Stephen Burks Man Made, New York, established 1997, maker
Private Seat rendering, 2020
Shelter in Place project
Paper
8½ × 11 inches
Collection of the designer
Plate 13

Stephen Burks (American, born 1969), designer
Stephen Burks Man Made, New York, established 1997, maker
Spirit House rendering, 2021
Shelter in Place project
Paper
8½ × 11 inches
Collection of the designer
Plate 16

Stephen Burks (American, born 1969), designer
Stephen Burks Man Made, New York, established 1997, maker
Supports rendering, 2020
Shelter in Place project
Paper
8½ × 11 inches
Collection of the designer
Plate 12

Stephen Burks (American, born 1969), designer
Stephen Burks Man Made, New York, established 1997, maker
Woven TV rendering, 2020
Shelter in Place project
Paper
8½ × 11 inches
Collection of the designer
Plate 15

Stephen Burks (American, born 1969), designer
Salvatori, Italy, established 1946, manufacturer
Friends Table Mirror, 2021
Recycled marble and glass
13 × 15 × 4¹¹⁄₁₆ inches
Courtesy of Salvatori
Plate 18

Stephen Burks (American, born 1969), designer
Salvatori, Italy, established 1946, manufacturer
Neighbors Wall Mirror, 2021
Recycled marble and glass
31½ × 26 × 1⅜ inches
Courtesy of Salvatori
Plate 18

Stephen Burks (American, born 1969), designer
Stephen Burks Man Made, New York, established 1997, maker
Woven TV prototype, 2020
Shelter in Place project
Collection of the designer
Plate 14

Stephen Burks (American, born 1969), designer
Stephen Burks Man Made, New York, established 1997, maker
The Ancestors maquette, 2021
Shelter in Place project
Collection of the designer
Page 96

Stephen Burks (American, born 1969), designer
Stephen Burks Man Made, New York, established 1997, maker
Spirit House maquette, 2021
Shelter in Place project
Collection of the designer
Page 88

Stephen Burks (American, born 1969), designer
Stephen Burks Man Made, New York, established 1997, maker
Supports maquette, 2021
Shelter in Place project
Collection of the designer
Page 93

Stephen Burks (American, born 1969), designer
Stephen Burks Man Made, New York, established 1997, maker
Woven TV maquette, 2021
Shelter in Place project
Collection of the designer

Stephen Burks (American, born 1969), designer
Berea College Student Craft, Berea College, Kentucky, established 1855, maker
The Spruce, 2021–2022
Oak and aluminum
64 × 37 inches
Courtesy of Berea College Student Craft
Plate 30

Stephen Burks (American,
born 1969), designer
Stephen Burks Man Made, New
York, established 1997, maker
Private Seat, 2022
Shelter in Place project
Collection of the designer

Stephen Burks (American,
born 1969), designer
Stephen Burks Man Made, New
York, established 1997, maker
Spirit House, 2022
Shelter in Place project
Collection of the designer

Stephen Burks (American,
born 1969), designer
Stephen Burks Man Made, New
York, established 1997, maker
Supports, 2022
Shelter in Place project
Collection of the designer

Stephen Burks (American,
born 1969), designer
Stephen Burks Man Made, New
York, established 1997, maker
The Ancestors, 2022
Shelter in Place project
Collection of the designer

Stephen Burks (American,
born 1969), designer
Stephen Burks Man Made, New
York, established 1997, maker
Woven TV, 2022
Shelter in Place project
Collection of the designer

Personal Artifacts
Collection of Stephen Burks

Other Artists

Alvar Aalto (Finnish, 1898–1976),
designer
Artek, Finland, established
1935, manufacturer
Screen, designed 1936
Pinewood (with marker
additions by Stephen Burks)
59 × 78¾ inches
Collection of the designer

Thomas Struth
German, born 1954
Paradise 19, 2002
Dye coupler print
70 $^{11}\!/_{16}$ × 87 $^{13}\!/_{16}$ inches
High Museum of Art, Atlanta,
purchase with funds from
the H. B. and Doris Massey
Charitable Trust, 2002.262
Plate 29

Zanele Muholi
South African, born 1972
Somandla, Parktown, 2014
Set of two gelatin silver prints
19½ × 26 inches (each)
Collection of the designer

Image Credits

Figures

Monica Obniski, Fig. 1: Courtesy of Chicago History Museum. Photo by Hedrich Blessing Collection/Chicago History Museum/Getty Images. Fig. 2: Courtesy of the High Museum of Art, Atlanta. Fig. 3: © Chicago Historical Society, published on or before 2015, all rights reserved. Photo by Hedrich Blessing Collection/Chicago History Museum/Getty Images. Figs. 4, 6, 8, 9, 12, 14: Photos courtesy of Stephen Burks. Fig. 5: © 2022 Estate of Anni Albers/Artists Rights Society (ARS), New York. Fig. 7: Photo by Mike Jensen/courtesy of the High Museum of Art, Atlanta. Fig. 10: Photo by John R. Glembin. Fig. 11: Photo by Joe Coscia. Fig. 13: Photo by Hiroyuki Hirai/ Shigeru Ban Architects. Stephen Burks, Figs. 1–3, 6: Photos courtesy of Stephen Burks. Fig. 4: Courtesy of Malike Sidibe. Fig. 5. Digital image © The Museum of Modern Art/licensed by SCALA/Art Resource, New York. Michelle Joan Wilkinson, Fig. 1: Photo courtesy of Richard Hutten. Fig. 2: Photo courtesy of Friedman Benda and Stephen Burks. Fig. 3: © Steve Schapiro. Glenn Adamson, Figs. 1, 3, 8: Photos courtesy of Stephen Burks. Fig. 2: Photo by Joe Coscia. Fig. 4: Photo by Dan Whipps. Fig. 5: Photo by Stephen Michael. © The Isamu Noguchi Foundation and Garden Museum/Artists Rights Society (ARS), New York. Courtesy of The Noguchi Museum Archives, Queens, New York. Fig. 6: Courtesy of Harvard Art Museum. Photo © President and Fellows of Harvard College. Fig. 7: Courtesy of Studio Urquiola. Fig. 9: Photo by Justin Skeens. Beatrice Galilee, Fig. 1: Photo courtesy of the High Museum of Art, Atlanta. Figs. 2, 3: Photos courtesy of Stephen Burks. bell hooks, Fig. 1: © The New Press. Fig. 2: © W. W. Norton and Company, Inc. Fig. 3: Courtesy of the artist, Jack Shainman Gallery, New York, and Corvi-Mora, London. Fig. 4: © 2011 The Studio Museum in Harlem, New York. Fig. 5: Courtesy of The Studio Museum in Harlem, New York. Fig. 6: © Routledge, Taylor and Francis Group.

Photo Essays

Pages 3–10, 20, 24–36, 68, 78–97: Photos by Caroline Tompkins. Pages 140, 158–164: Photos by Justin Skeens.

Plates

Plates 1, 12, 13, 15, 16: Photos by Mike Jensen/courtesy of the High Museum of Art, Atlanta. Plates 2, 3, 19, 25, 30: Photos by Justin Skeens. Plate 4: Courtesy of Parachilna, Barcelona, Spain/photo by Santi de Pablo. Plate 5: Courtesy of Bolon. Plates 6, 7, 14, 17, 18, 21–24, 26, 27, 31: Photos by Joe Coscia. Plates 8, 11, 28: Photos courtesy of Philadelphia Museum of Art. Plate 9: Photo by Matt Flynn/courtesy of Smithsonian Institution. Plate 10: Photo by Daniel Håkansson. Plate 20: Photo by Max Zambelli, courtesy of Stephen Burks. Plate 29: © Thomas Struth.

Published in conjunction with the exhibition *Stephen Burks: Shelter in Place*, organized by the High Museum of Art, Atlanta.

Stephen Burks: Shelter in Place
High Museum of Art
September 16, 2022–March 5, 2023

Published in 2022 by
High Museum of Art, Atlanta,
1280 Peachtree Street, N.E.
Atlanta, Georgia 30309
high.org

Distributed by
Yale University Press
302 Temple Street
P.O. Box 209040
New Haven, Connecticut 06520
yalebooks.com/art

Publishing, the High Museum of Art
Angela Jaeger, Senior Manager of Creative Services
Laura Malone, Production Coordinator
Emma Simmons, Associate Editor

Designed by Renata Graw and Lucas Reif at the Normal studio
Proofread by Heather Medlock
Printed on Fedrigoni Arena Smooth 120gsm
Printing, separations, and bindery by Verona Libri, Italy

ISBN: 978-0-300-27085-3

A catalogue record is on file with the Library of Congress.

Major funding for this exhibition is provided by
William Banks Jr. Trust

Funding for this exhibition is provided by

rochebobois
PARIS

Graham Foundation

This exhibition is made possible by

Premier Exhibition Series Sponsor
▲DELTA

Premier Exhibition Series Supporters
ACT Foundation, Inc.
Sarah and Jim Kennedy
Louise Sams and Jerome Grilhot

wish
FOUNDATION

Benefactor Exhibition Series Supporters
Robin and Hilton Howell

Ambassador Exhibition Series Supporters
The Antinori Foundation
Corporate Environments
The Arthur R. and Ruth D. Lautz Charitable Foundation
Elizabeth and Chris Willett

Contributing Exhibition Series Supporters
Farideh and Al Azadi
Sandra and Dan Baldwin
Mr. and Mrs. Robin E. Delmer
Marcia and John Donnell
Mrs. Peggy Foreman
Helen C. Griffith
Mrs. Fay S. Howell/The Howell Fund
Mr. and Mrs. Baxter Jones
Joel Knox and Joan Marmo
Dr. Joe B. Massey
Margot and Danny McCaul
The Ron and Lisa Brill Family Charitable Trust
Wade A. Rakes II & Nicholas Miller
The Fred and Rita Richman Fund
USI Insurance Services
Mrs. Harriet H. Warren

Generous support is also provided by
Alfred and Adele Davis Exhibition Endowment Fund
Anne Cox Chambers Exhibition Fund
Barbara Stewart Exhibition Fund
Dorothy Smith Hopkins Exhibition Endowment Fund
Eleanor McDonald Storza Exhibition Endowment Fund
The Fay and Barrett Howell Exhibition Fund
Forward Arts Foundation Exhibition Endowment Fund
Helen S. Lanier Endowment Fund
Isobel Anne Fraser–Nancy Fraser Parker Exhibition Endowment Fund
John H. and Wilhelmina D. Harland Exhibition Endowment Fund
Katherine Murphy Riley Special Exhibition Endowment Fund
Margaretta Taylor Exhibition Fund
RJR Nabisco Exhibition Endowment Fund